KT-215-205

WID

LIBRARY

791.

essential guide

to business in the

PERFORMING ARTS

LIBRARY

essential guide
to business in the
PERFORMING ARTS

Vivien Freakley • *Rachel Sutton*

HODDER
EDUCATION
AN HACHETTE UK COMPANY

Orders: please contact Bookpoint Ltd, 130 Milton Park, Abingdon, Oxon OX14 4SB. Telephone: (44) 01235 827720, Fax: (44) 01235 400454. Lines are open from 9.00–5.00, Monday to Saturday, with a 24-hour message answering service. You can also order through our website: www.hoddereducation.co.uk

British Library Cataloguing in Publication Data

Freakley, Vivien
 Essential guide to business in the performing arts
 1. Arts - management 2. Performing arts - Management
 I. Title II. Sutton, Rachel
 790.2'068

ISBN-10: 0 340 65525 9
ISBN-13: 978 0 340 65525 2

First published 1996
Impression number 14 13
Year 2011

Copyright © 1996, Vivien Freakley and Rachel Sutton

All rights reserved. No part of this publication may be reproduced or transmitted in any form or by any means, electronic or mechanical, including photocopy, recording, or any information storage and retrieval system, without permission in writing from the publisher or under licence from the Copyright Licensing Agency Limited. Further details of such licences (for reprographic reproduction) may be obtained from the Copyright Licensing Agency Limited, of 90 Tottenham Court Road, London W1T 4LP.

Typeset by Fakenham Photosetting Ltd, Fakenham, Norfolk.
Printed in India for Hodder Arnold, an imprint of Hodder Education, a member of the Hodder Headline Group, 338 Euston Road, London NW1 3BH by Replika Press Pvt. Ltd.

CONTENTS

Acknowledgements

We are very grateful to everyone who has given us advice, support and encouragement in the preparation of this book, including students and colleagues at Coventry University Performing Arts. We should like to thank the following people who have read and commented on various sections of the text: Lucy Anderson Jones, Freelance Arts Manager, Paul Bull, Freelance Theatre Sound Designer, Debbie Kingsley, Arts Officer, Coventry City Council, John Robb, Freelance Production Manager, Duncan Sones, Business Development Officer, West Midlands Arts Board. We should also like to thank Barry Jackson for the cartoons, Paul Russell at the Bush Theatre for the Production Schedule, David Semple for the Prompt Script, and Elisabeth Tribe and Llinos Davies at Hodder and Stoughton.

INTRODUCTION

It is not easy to get started in the performing arts and entertainment industries. The sector contains a wealth of diverse organisations, serving a wide variety of purposes from 'High Art' to pure entertainment. Moreover, people working in the industry have to be flexible, multi-skilled and entrepreneurial to survive. Often they have to create their own work opportunities through time-limited performance projects. Certainly they could find themselves working as freelancers or on a series of short term contracts. Even as performers they need good administrative skills and knowledge about funding systems.

Our purpose in writing this beginner's guide to arts administration is to support students who are training to go into the performing arts and entertainment industries by studying the Performing Arts on GNVQ, BTEC National Diploma, BTEC Higher National Diploma and even degree level Performing Arts courses. Tutors will find that the material covered is directly relevant to the GNVQ in Performing Arts, both Intermediate and Advanced levels, and the BTEC National Diploma Arts Administration module. Higher education students and artists just beginning their professional careers will also find the book of practical use when dealing with their first projects.

We have tried to focus our attention on those areas where there is little published material to guide student and lecturer. Where there are good specialist textbooks, for example in areas such as stage management, directing, lighting and sound and the design and construction of costumes, sets and props, we have covered only the main points and then provided additional references at the end of the chapter.

We strongly recommend that students undertake the practical tasks given in each chapter, as our own experience has shown that students find it easier to understand the theory if they can apply it in their practical projects and assignments.

THE PERFORMING ARTS, ENTERTAINMENT, AND CULTURAL INDUSTRIES

*T*he performing arts play an important part in most people's lives. People watch plays, listen to records, go to concerts, watch ballet, sing in choirs, play in bands, watch or make films, take dancing lessons, create videos and so on. They might prefer to take part actively or they might prefer to watch or listen. They might be makers, creators, performers or appreciators. Yet when most of us think of the performing arts we tend to only think of plays being performed in theatres or on television, orchestras playing in concert halls, dance companies performing in arts centres or rock bands on video. When we think of the people who work in the performing arts we tend to think of actors, singers, musicians and dancers. In other words, we are seeing only one small but highly visible aspect of the performing arts profession, the performer in the large performance venue, or in the media.

But, for every performer there are hundreds of others working in some other way to support or create the performance itself. There are people working to make those records, teach those dance classes, sell those tickets, direct that play, make the set for that ballet, and so on. These people are much less visible than the performers but without them there would be no performance. And for every performer in a large company or on a television contract, there are hundreds working independently or in small groups to create their own performance opportunities and supplementing their performance work with additional teaching, community and administration work.

This chapter aims to:
- look at what is meant by 'the performing arts, entertainment, and cultural industries' and how these relate to each other, before introducing you to the organisations who form the major employers in the sector
- give you some idea of what it is like to work in the sector as a whole.

What are the performing arts, entertainment and cultural industries?

'Cultural industries' is an umbrella title which includes both the performing arts and the entertainment industries as well as other types of employment. Figure 1.1 on page 5 shows how the areas relate to each other.

THE CULTURAL INDUSTRIES

The term 'cultural industries' seems to have originated with the European Union, who use it to describe the whole of the arts, media, publishing and entertainment industries, together with leisure, sports and tourism. These industries are highlighted as being areas of economic growth when most other industries are declining. Many European funding initiatives are providing money to support people setting up arts businesses as a way of regenerating the environment and the economy of urban areas. It is interesting to see how many people are actually employed in the cultural industries once leisure, sport and tourism are removed.

The National Campaign for the Arts (NCA) presents useful data about the range and size of employment in the cultural industries. It quotes a survey by *Cultural Trends 1993: 20* which found that in 1993, 175,400 people were employed in the classifications of film production and distribution or exhibition, radio and television services, theatres etc., libraries, museums and art galleries, etc., and as authors or composers and own-account artists. NCA recognise that this is very likely to be an underestimation, since the British Film Institute's *Film and Television Handbook 1995*

gives a figure of 209,500 employed in film, television and video alone, in 1994; and the *Cultural Trends* figures do not include the music industry.

A recent publication by the Arts Council of England, *Employment in the Arts and Cultural Industries – An Analysis of the 1991 Census* (1995), Jane O'Brien and Andy Feist, gives us a useful table which identifies the numbers of individuals with cultural occupations: see Figure 1.2.

However, these figures do not take account of everyone working in support of the specified cultural occupations. These would include categories such as front of house staff, theatre and sound technicians, recording industry support staff, printers and publishers, people working in film production and distribution, radio and television support staff and musical instrument technicians. These add a further 228,346, which makes a total of 650,046 people employed in the arts and cultural industries.

The figures also do not take account of those who consider themselves self-employed or who work in small businesses.

THE PUBLICLY-FUNDED PERFORMING ARTS

This is the area that most people tend to imagine when they think of the live performing arts. It comprises the following types of organisations, events and individuals, all of whom

Figure 1.1 *The performing arts, entertainment & cultural industries*

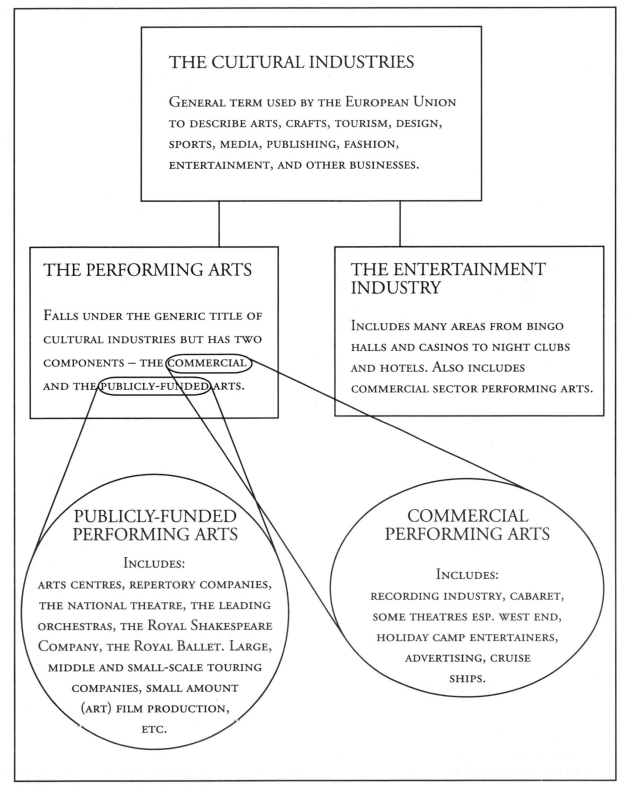

THE CULTURAL INDUSTRIES

GENERAL TERM USED BY THE EUROPEAN UNION TO DESCRIBE ARTS, CRAFTS, TOURISM, DESIGN, SPORTS, MEDIA, PUBLISHING, FASHION, ENTERTAINMENT, AND OTHER BUSINESSES.

THE PERFORMING ARTS

FALLS UNDER THE GENERIC TITLE OF CULTURAL INDUSTRIES BUT HAS TWO COMPONENTS — THE COMMERCIAL AND THE PUBLICLY-FUNDED ARTS.

THE ENTERTAINMENT INDUSTRY

INCLUDES MANY AREAS FROM BINGO HALLS AND CASINOS TO NIGHT CLUBS AND HOTELS. ALSO INCLUDES COMMERCIAL SECTOR PERFORMING ARTS.

PUBLICLY-FUNDED PERFORMING ARTS

INCLUDES:
ARTS CENTRES, REPERTORY COMPANIES, THE NATIONAL THEATRE, THE LEADING ORCHESTRAS, THE ROYAL SHAKESPEARE COMPANY, THE ROYAL BALLET. LARGE, MIDDLE AND SMALL-SCALE TOURING COMPANIES, SMALL AMOUNT (ART) FILM PRODUCTION, ETC.

COMMERCIAL PERFORMING ARTS

INCLUDES:
RECORDING INDUSTRY, CABARET, SOME THEATRES ESP. WEST END, HOLIDAY CAMP ENTERTAINERS, ADVERTISING, CRUISE SHIPS.

Figure 1.2 *Individuals with cultural occupations in Great Britain, 1991*

Occupations	Number	Percent
Entertainment and sports managers	48,500	12
Architects	35,500	8
Librarians	16,000	4
Archivists and curators	6,500	2
Authors, writers, journalists	82,000	19
Artists, commercial artists, graphic designers	93,000	22
Industrial designers	11,600	3
Clothing designers	8,100	2
Actors, entertainers, stage managers, producers & directors	53,400	13
Musicians	21,700	5
Photographers, camera, sound & video operators	41,000	10
Musical instrument makers, piano tuners	4,300	1
Total	421,700	100

(Reproduced by courtesy of the Arts Council of England from *Employment in the Arts and Cultural Industries – An Analysis of the 1991 Census* (1995))

would depend upon public funding (from the Arts Council, Regional Arts Boards and local authorities – see Chapter 2):

Building-based organisations

- arts centres
- theatres

Companies

- large, medium and small-scale theatre companies
- orchestras
- large medium and small-scale dance/mime companies
- opera companies
- ballet companies
- arts development agencies

Events

- festivals
- performance or participatory projects

Individuals

- independent artists
- community arts workers
- animateurs (see page 20)

- arts-in-education workers
- arts-in-health workers

These areas of the performing arts are financially supported by national and local government because they are seen to be of value in improving the quality of people's lives, and because any civilised nation is proud of the quality of its arts. For this reason, the authorities expect the work they fund to be innovative – they are supporting artists to make good art, which often entails taking risks. Since it is often the case that good innovative art is not always recognised by audiences in its time, this can mean that sometimes seats are empty in theatres. Everyone working in the funded performing arts walks a tight rope between experimentation and keeping the audiences in their seats.

THE ENTERTAINMENT INDUSTRIES

The majority of British people experience the arts as entertainment within the commercial sector: film and television drama, popular music on the radio or on CD/cassette, dance on pop videos or television shows, pop/rock concerts, and West End musicals. This sector is not subsidised through the arts funding system because it is popular enough to make a profit from its audiences. The media of film, video, television, audio recording, and radio, are prominent features in the entertainment sector, as are the musicals and popular plays of the West End theatres, and other commercial theatres around the country. Many people often only experience live entertainment when on holiday. Large hotels, cruise ships, night-clubs and holiday camps such as Butlins and Pontins all organise cabaret shows for their guests which might include stand-up comedians, singers, dancers, bands of all kinds (to listen or dance to) as well as cabaret acts such as jugglers or acrobats. Hotels, restaurants and bars sometimes employ stand-up comics and pianists or other musicians to entertain their clientele.

The employers in the entertainment industries are varied. They include:

- music recording companies
- West End theatres
- regional commercial theatres
- chains of hotels (international)
- individual hotels (national and international)
- cruise lines
- night clubs
- TV production companies
- video production companies
- radio stations
- radio production companies
- film production companies
- disco/cabaret dance companies
- holiday camps
- makers of film, television, video and radio advertisements
- promotional events companies.

These employers are not interested in innovative or experimental performing arts because they have no public subsidy and cannot afford the risk of poor audiences.

TASKS

With a partner select one of the following organisations in your area:

- disco
- hotel with entertainment
- arts centre
- local recording studio
- TIE (Theatre in Education, see page 19) or small-scale theatre company
- festival organiser
- orchestra
- band

Find out what kind of performing arts they make use of and why. Present your findings to the rest of the group and keep a record of everyone's results for your file.

Working in the arts and entertainment sector

ARTS AND ENTERTAINMENT

Although the worlds of the subsidised arts and the commercial sector seem so very different – after all, the subsidised arts seek to challenge people and make them think in different ways and the commercial sector seeks to amuse and entertain – there are many cross-overs for those who work in the two sectors. Actors who work in television might also work in local repertory theatre, and contemporary dancers might take on television adverts or pop video work. There is even more cross-over for those working in the non-performance areas of the performing arts. Jobs in technical presentation or administrative/management support are largely the same whether in the subsidised or the commercial sector and people can transfer between the two as the opportunities occur. Technical presentation would include lighting, sound, set design, stage management, and might include video or special effects. Administrative and management support might include marketing and publicity, event organisation, dealing with the public/audience, programming, managing finances, fund-raising and clerical/secretarial support. These tasks are broadly similar whether the presentation is a Shakespeare play or a fashion show, a cabaret or a conference, a disco and light show or a classical concert.

CHARACTERISTICS OF WORKING IN THE SECTOR

As Britain approaches the millennium, the prospects for stable, secure, and long-term employment in any sector are not secure. This is true for engineers, health workers, and retailers, as well as arts workers. However, work in the arts has never been particularly secure, especially for the performer. A very few performers become 'stars' and make a lot of money, but the vast majority do not. Unless they are lucky enough to secure work with one of the larger companies (and there are fewer and fewer of these), they will work on a short term basis – from project to project. Performers work because they have a passion for what they do, not for the financial reward. Even the most successful find themselves with periods of unemployment or 'resting' and most will work for example in shops, offices and restaurants, to earn enough money to live in between projects. Performance work is characterised by:

- short-term contracts
- self-employment
- work in small businesses
- project work
- combinations of performing, teaching, directing, composing/choreographing, and administrating.

Performers who have a broad range of skills are more likely to be successful in finding work related to their interests and avoid taking manual jobs unconnected to their profession.

But performers are only the highly visible tip of the iceberg of employment in the arts and cultural industries. For every performance event there are teams of people, whom the audience never see, working away to create and present it. Many of these people will also work on short-term contracts or projects, and they may well be self-employed or work in small

businesses. They also will be more successful in finding employment if they have a wide range of skills at their disposal.

There are two things which maximise working opportunities within the cultural industries:

- being self-sufficient and making your own performance opportunities.
- having a broad range of skills and understanding.

Self-sufficiency and creating performance opportunities

Artists need to be entrepreneurial in today's economic and cultural climate. They have to be prepared to create their own opportunities by setting up projects and activities since work with larger companies and organisations may not be forthcoming, or might be of a short-term nature. It is unrealistic to go into the business believing that the West End, the Royal Ballet or the City of Birmingham Symphony Orchestra will snap you up as a star performer. There are very few opportunities for 'stardom' and such 'success' is rarely long-term. Real success means *staying* in work, maintaining a career, even a performing career, in the arts and cultural industries. There are

opportunities for setting up your own business, either as a solo artist, arts worker, or with a group of others. This will enable you to create performance projects and/or take part in those created by others (see Chapter 8).

A broad range of skills and understanding

'Multi-skilling' is jargon for having a wide range of skills and knowledge, being flexible and able to use them according to need. Traditional performance training has tended to focus on techniques and performance skills. These are essential, but for the majority of arts workers, so are the following:

- self-employment skills
- knowledge of arts funding bodies
- business management skills (sole trader or small business)
- marketing skills
- basic technical knowledge and skills for presentation
- project management skills
- knowledge of the arts infrastructure
- communication and negotiation skills
- fund-raising skills
- teaching skills
- creative skills.

WORKING AS A PERFORMER

It is almost impossible to obtain work *as a performer* with the larger employers without having an agent, although some employers will advertise in the *Stage* newspaper. Actors have to become members of the union *Equity* and unless they wish to specialise totally in TIE (Theatre in Education, see page 19), other small-scale touring, or health/special needs work, they will have to have an agent. Musicians need to become members of the *Musicians Union* and will also benefit from having an agent and from knowing about

fixers. Dancers who want to work in the acceptable areas of dance entertainment will also need an agent.

Agents

West End theatres, many repertory theatres and all film and television production companies, including television commercials, will cast through a list of their preferred agents. They send out casting lists for their latest production to their chosen agents, who then send

details of their relevant clients. The potential employers will then select from these for audition. It is impossible for an individual even to get to hear about casting opportunities without an agent, let alone get an invitation to audition.

Lists of agents can be found in the *Spotlight Directory*, and prospective actors should select a shortlist to send CV and photographs, and an invitation to see a performance. Agents will 'audition' their clients by attending their drama school/degree shows or other performances. If they like the performance, they will invite the prospective client to interview. Even then, the agent may not be prepared to take the actor on straight away. S/he has to be sure that the actor will be thoroughly reliable and consistent or s/he may not have room on the books for that particular age/type of actor at that time.

After taking an actor on to the books, the agent will handle all the administration, finding work and negotiating all the contracts, and will take 10%–12.5% as a fee. A good agent is very important in a performer's career, and needs to be:

- very active in finding work opportunities
- keen to push the client's interests
- an excellent negotiator.

The only way a performer can find out the agent's worth is through word-of-mouth and reputation. It is essential to do some homework before signing up with an agent. The best agents will hand-pick their clients. They have to be convinced that the performer has outstanding talent and all the personal qualities it takes to succeed in the business.

Agents also operate in the commercial music business but their role is slightly different. They may represent an individual or a band and their primary function would be to set up and organise touring. Bands sometimes bypass the agent in setting up a tour and do it themselves, but there is such lot of work involved

that an agent can be invaluable. The agent will already have contacts with promoters and venues, so s/he will be able to set up the gigs. These are very expensive and frequently money is only made through the associated merchandising. The agent will be able to negotiate appropriate contracts so that the band makes money on the tour – and is therefore able to pay the agent's percentage.

Equity

Those wishing to work as actors in the West End, the regional repertory theatres, television or film will need to be members of the professional union *Equity*. This is a complicated 'catch 22' task which says you cannot work in the profession unless you have an *Equity* card and you cannot get an *Equity* card unless you have worked in the profession. However, there are many ways around this which are beyond the compass of this book. The bibliography gives an indication of further reading on the subject.

Fixers

Individual musicians who want to work in a theatrical context such as a West End show or in television and who are members of the *Musicians Union*, will find a *fixer* useful. These elusive characters can normally only be found through contact with other musicians working in the profession. However, they play a role similar to that of the theatrical casting agent. A fixer would be contacted by the producer or musical director of a show and asked to find a specific group of musicians, for example two saxophone players, a drummer, a bass player and three guitarists. The fixer will keep a list of musicians s/he has worked with before and who have proved talented and professional and put them in contact with the potential employer. More often than not s/he will bring a group together for a specific job of work and then negotiate the rate of pay with the employer. Naturally, s/he takes a percentage cut

for providing the service. The fixer's reputation stands or falls by the quality of the musicians s/he recommends and therefore will be very careful when taking on new clients. The fixer does not usually have an ongoing formal contracted relationship with his/her clients.

The Musicians Union

Musicians wanting to work in theatres or with orchestras will need to be members of the *Musicians Union*. Musicians working in other areas will find membership of this or another professional association very helpful in terms of providing access to a wide range of information about contractual issues.

Broadcast and Entertainment and Cinematographic Trades Union (BECTU)

Although best known as the trade union for theatre technicians who are not members of *Equity*, *BECTU* also recruits members from theatre administrative staff.

TASKS

1 In groups, brainstorm all the work possibilities you can think of in the cultural industries. After discussion with other groups in your class, begin a list to keep in your folder for future reference.

2 Collect six job advertisements from Monday's *Guardian* newspaper (The Creative and Media Section) and from the *Stage* newspaper, and take into class for discussion with your tutor. Find out from your tutor the type and level of skills and experience s/he thinks would be needed for those jobs.

3 Ask your tutor to arrange a series of presentations/discussions with local artists/arts workers to find out what kind of skills they use on a day-to-day basis.

CONCLUSION

The message is clear: there are plenty of work opportunities in the arts as long as we understand the breadth of what is meant by the 'cultural industries', have a sound knowledge of the arts and entertainment infrastructure and are prepared to develop and use a broad range of administrative and management skills. Teaching and creative skills are beyond the scope of this book but the following chapters should help you come to terms with all the other areas.

BIBLIOGRAPHY

How to Become a Working Actor, Sarah Duncan, The Cheverall Press, London, 1989.

An Actor's Guide to Getting Work, Simon Dunmore, Papermac, Macmillan Publishers Ltd., London, 1991.

The Musicians Handbook, edited by Trevor Ford, Rhinegold Publishing, 1991.

Information Pack from the Musicians Union, Musicians Union, 60–62 Clapham Road, London, SW9 OJJ. Tel. no: 0171 582 5566.

Facts About the Arts, 3rd edition, National Campaign for the Arts, 1995.

Employment in the Arts and Cultural Industries – An Analysis of the 1991 Census, Jane O'Brien and Andy Feist, Arts Council of England, London, 1995.

c h a p t e r t w o

A BRIEF HISTORY OF PUBLIC FUNDING FOR THE ARTS

Throughout history governments have given money to fund the arts. They have done so for reasons largely to do with impressing other countries, nations and states, with their wealth and civilised values. The princes and dukes in Italy in the fifteenth and sixteenth centuries were patrons of the visual arts, and without their support, the work of Leonardo da Vinci, Raphael and Michelangelo would not be around for us to see today. These Renaissance princes set a precedent. A ruler could not be considered successful without also being a cultured supporter of the arts. Likewise without Louis XIV of France, the Sun King classical ballet would not exist. There are many examples of governments being patrons of the arts for the glory of the state. After the Russian revolution, the Soviets continued the tradition of supporting state orchestras, theatre, ballet and opera companies. They wanted to prove they were as cultured as the Tsars. In Britain, we have a well-developed system for funding the arts which was set up in its current format after the Second World War.

This chapter

- traces the history of Britains' arts funding system
- introduces you to the organisations which make up the British arts funding system.

It should also help you to understand what types of organisations and individuals have received public funding for their performing arts work over the years and how policy changes by the Arts Council created growth and development in selected areas of the performing arts.

The history

Figure 2.1 summarises the key events in the development of the British arts funding system, from 1940 to the present day.

Figure 2.1 *Key events in the development of the British arts funding system*

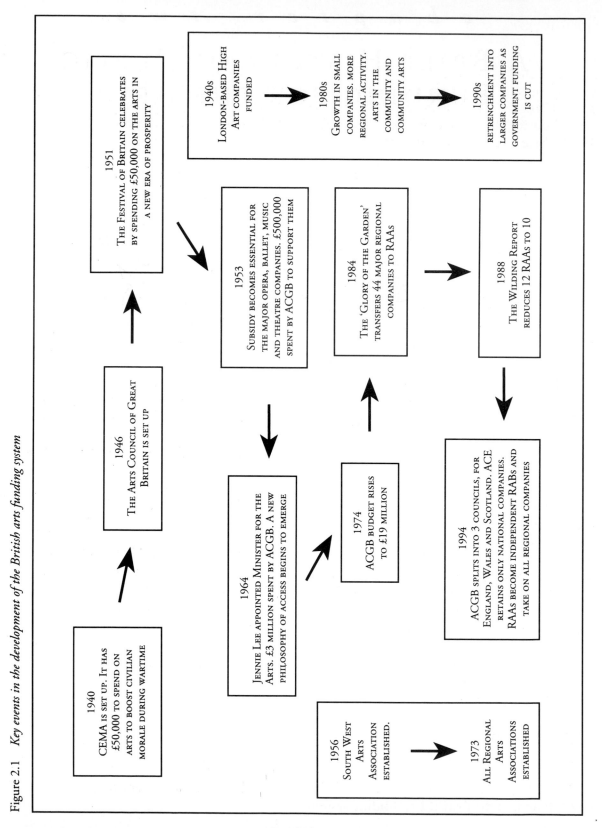

1940
CEMA IS SET UP. IT HAS £50,000 TO SPEND ON ARTS TO BOOST CIVILIAN MORALE DURING WARTIME

1946
THE ARTS COUNCIL OF GREAT BRITAIN IS SET UP

1951
THE FESTIVAL OF BRITAIN CELEBRATES BY SPENDING £50,000 ON THE ARTS IN A NEW ERA OF PROSPERITY

1940s
LONDON-BASED HIGH ART COMPANIES FUNDED

1980s
GROWTH IN SMALL COMPANIES. MORE REGIONAL ACTIVITY. ARTS IN THE COMMUNITY AND COMMUNITY ARTS

1990s
RETRENCHMENT INTO LARGER COMPANIES AS GOVERNMENT FUNDING IS CUT

1953
SUBSIDY BECOMES ESSENTIAL FOR THE MAJOR OPERA, BALLET, MUSIC AND THEATRE COMPANIES. £500,000 SPENT BY ACGB TO SUPPORT THEM

1984
THE 'GLORY OF THE GARDEN' TRANSFERS 44 MAJOR REGIONAL COMPANIES TO RAAs

1988
THE WILDING REPORT REDUCES 12 RAAs TO 10

1964
JENNIE LEE APPOINTED MINISTER FOR THE ARTS. £3 MILLION SPENT BY ACGB. A NEW PHILOSOPHY OF ACCESS BEGINS TO EMERGE

1974
ACGB BUDGET RISES TO £19 MILLION

1994
ACGB SPLITS INTO 3 COUNCILS, FOR ENGLAND, WALES AND SCOTLAND. ACE RETAINS ONLY NATIONAL COMPANIES. RAAs BECOME INDEPENDENT RABs AND TAKE ON ALL REGIONAL COMPANIES

1956
SOUTH WEST ARTS ASSOCIATION ESTABLISHED.

1973
ALL REGIONAL ARTS ASSOCIATIONS ESTABLISHED

THE ROOTS

Although the current system for providing state subsidy for the arts in Britain has developed since 1946, its roots lie in the arts activities started during the Second World War. Before 1939, there were arts activities which existed solely on a commercial basis including touring theatre companies, orchestras, and ballet companies. Some rich individuals were patrons of the arts but generally speaking audiences paid the full cost of their tickets and any company or organisation which failed to attract support would soon go out of business. For this reason many ordinary people did not have easy access to affordable tickets to performances.

Local authorities had been authorised to spend money raised through the rates on the provision of public libraries since 1855; from 1919 they were permitted to spend money on museums and art galleries but the performing arts were not considered eligible for such support.

Entertainment National Services Association

In the first few weeks after the declaration of war in September 1939, theatres, cinemas and other places of entertainment were closed. However, in the following months, it became clear to a number of influential people that methods of sustaining civilian morale throughout the hostilities would be needed. Since the First World War there had been an organisation called ENSA (Entertainment National Services Association) which had responsibility for keeping the troops entertained, and for maintaining morale. There were close links between ENSA and the commercial producers of theatre and light entertainment. Although ENSA was disbanded in 1945, the work of entertaining military personnel continues to the present day. From Vera Lynn in the 1940s to popular comedians in the 1990s, the stars of the light entertainment business have toured the world to provide shows for British troops: their services were employed during the Falklands War and the Gulf War.

Council for the Encouragement of Music and the Arts

While ENSA looked after military morale, in 1940 a sister organisation CEMA (Council for the Encouragement of Music and the Arts) was formed to provide a similar service for British civilians. CEMA received a grant from an organisation called the Pilgrim Trust and, more significantly, the sum of £50,000 of Government money from the Treasury for its work. From the beginning, CEMA concentrated on the so called 'high arts' rather than on light-entertainment, with productions of Shakespeare and concerts of classical music featuring heavily in its work.

As a direct result of this initiative professional theatre companies and orchestras toured the country and through a network of Regional Offices amateur dramatic societies and music groups were also able to receive Government help for their work. This work proved to be immensely popular with audiences in factories and former holiday camps, as well as theatres and concert halls. Many of these war-time audiences had not previously had easy access to orchestral concerts or professional theatre or ballet. CEMA had found a role in both the preservation of the arts as an aspect of the national culture, which was under direct threat from enemy hostilities, and after the war it was acknowledged that it had raised public consciousness of the arts as well as helping to raise morale. Although CEMA was only ever intended to be a temporary undertaking, its success led to the founding of the Arts Council of Great Britain.

> ## TASK
>
> See if you can find out what happened to one of the following during the Second World War:
>
> - a large theatre company
> - a large ballet company
> - an orchestra.
>
> Work with a partner and report back to the whole group.

Arts Council of Great Britain

We need to look at the social context of the 1940s in order to understand public acknowledgement of spending government money on arts activities to improve the quality of people's lives. The newly elected Labour government of 1945 established the National Health Service and the provision of Welfare Benefits, including Child Allowance. For the first time the role of government in providing for the population 'from the cradle to the grave' was acknowledged. The role which government could play in the improvement of the quality of peoples' lives through the arts was seen alongside the task of improving standards in housing, health and welfare.

The Arts Council of Great Britain (ACGB) was established in 1946 by Royal Charter. Its stated aims were:

- to increase and widen the distribution of the audiences of the arts
- to improve the standard of execution in the arts
- to encourage and aid an adequate system of professional training.

John Maynard Keynes, who had been the chairman of CEMA, outlined the purpose of ACGB in a BBC Radio broadcast, reported in the *Listener,* of 12 July 1945 (p 31):

The purpose of the Arts Council of Great

Britain is to create an environment, to breed a spirit, to cultivate an opinion. To offer a stimulus to such purpose that the artist and the public can each sustain and live on the other in that union which has occasionally existed in the past at the great ages of a communal civilised life.

To the idea that the arts were the badge of a civilised society, was added the idea of community – of sharing. These ideas were picked up by the Labour party when they came into government after the Second World War. It was a time of optimism and growth. After participating in the fighting or in the war effort at home, in factories or on the land, people wanted to rebuild the country in a different way. They wanted everyone to participate in the growth and new prosperity. The ACGB was to be the vehicle which created greater access to the arts for everyone. The aim was to use the arts to improve the quality of people's lives and lift their spirits.

In establishing the Arts Council of Great Britain, the government made a decision not to fund the arts organisations directly itself, but to hand the grant over to another organisation with the necessary expertise to distribute the money. This reflects its resolve to separate the politicians at Westminster who make policy decisions, and the Whitehall civil servants who administer and enforce them. This

method of putting distance between the politicians who give grant aid for the arts, in the form of the annual grant to the Arts Council, and those who decide which arts organisations and initiatives should receive funding, is known as the *arms-length principle*. The Arts Council, which was created by government and which is wholly dependent on the government for its funds, operates as a QUANGO (a quasi-autonomous non-governmental organisation), inasmuch as it is wholly responsible for its own decisions about who should receive funds. At the same time, the Arts Minister is protected from questions in the House of Commons about the reasons for the granting or the refusal of grant aid to individual arts organisations. In practice there have always been questions about how truly independent the Arts Council can be when the Chairman and members of the Council are themselves government nominees.

Another aspect of CEMA policy which continued into the new body was the network of regional offices. In 1940 there were twelve, based on the civil defence areas designated at the start of the Second World War. Each of these regional offices had a small team of people who knew their own area, and who could respond to its particular local needs through liaison with amateur and professional artists and groups in their area. The regional offices existed until 1952, when three were closed down in order to save money and because there had been a steady decline in directly promoted tours organised by the Arts Council. By 1955 they had all been closed. The Arts Councils of Scotland and Wales, with their own committees and budgets, main-tained their own headquarters in Cardiff and Edinburgh, but the loss of the English regional offices caused widespread concern about the loss of a service geared to a particular area and serving its specific needs. These protests eventually led to the establishment of a number of Regional Arts Associations (RAAs).

The Festival of Britain

The Festival of Britain in 1951 was an expression of the idea that the arts could improve the quality of peoples' lives and lift their spirits after a period of war and austerity. Robert Hewison gives an indication of the size and scale of the event in his book *Anger, Culture in the Cold War 1945–60* (p 57):

> Two thousand cities, towns, and villages in the U.K. organised a Festival event of some kind, with no more than encouragement (for there were no resources) from the Festival Office. Eighteen million people visited officially-sponsored Festival events, and the BBC found material for 2,700 broadcasts.

A major exhibition was presented on the South Bank to celebrate the work of British artists and designers. There were commissions for 50 painters and 24 sculptors (including Jacob Epstein, Barbara Hepworth and Henry Moore). The ACGB was responsible for co-ordinating the cultural aspects – it supported 12 new festivals and incorporated 11 established ones under the Festival banner. It had £400,000 to spend, which it used to commission opera, ballet, choral and orchestral works and theatre.

TASK

See if you can find out what happened in your area during the Festival of Britain.

THE 1950S AND 1960S – YEARS OF GROWTH

By 1953 the ACGB had begun to establish the concept of public subsidy for opera, ballet, music and drama. Its investment in Britain's large cultural institutions was now up to half a million pounds. Without the subsidy these institutions would not have been able to exist.

The subsidised arts received an additional boost in 1964, when Jennie Lee was appointed Britain's first Minister for the Arts. On 27 April 1965 she made a strong and persuasive statement of her philosophy, which can be found in *Hansard* 27:4:65 Col 268:

> In any civilised community the arts and associated amenities, serious or comic, light or demanding, must occupy a central place. Their enjoyment should not be regarded as something remote from everyday life ... Beginning in the schools and reaching out into every corner of the nation's life, in city and village, at home, at work at play, there is an immense amount that could be done to improve the quality of contemporary life.

Lee is voicing a philosophy which does not see the arts as a means of impressing other nations. She is suggesting that the government put money into the arts, not for display, but because the arts can improve the quality of everyday life. At this time many people shared the view that with automation taking place in industry, everyone would have greater leisure time and therefore greater time to engage in self-improving pursuits such as the arts. In 1964 the Government gave the ACGB £3 million per annum to spend and by 1974 this had risen to an astronomical £19 million. However, there was an equally important shift of emphasis from London to the regions, with the setting up of the Regional Arts Associations and from the 'high arts' to more accessible arts.

Regional Arts Associations

In 1956 the first Regional Arts Association (RAA) was set up to cover the South-West. Other regions followed suit until by 1973 there was a network of Regional Arts Associations which broadly reflected the old pattern of regional offices under CEMA. They received, and still receive now, the bulk of their funding in the form of a grant from the Arts Council of Great Britain. From the earliest days there had been individuals in the regions who considered that too much emphasis had been placed on funding projects in London and the South-East of England. The intention was for each new RAA to support and help develop arts organisations and artists working in its region. The RAAs were helped in this by the Local Government Act 1948, which for the first time permitted local authorities to spend the proceeds of up to a sixpenny rate on the arts in their area. This allowed them to increase the funds available for arts spending, by raising money from local authorities to supplement the grants they received from the ACGB.

In 1984 the ACGB published a report called *The Glory of the Garden.* The intention was to address the recurring accusations from the regions that too much emphasis was placed on London and the South-East; and to deal with the abolition of the Greater London Council and the metropolitan county councils (all of whom had become generous funders of the arts).

One of the main proposals of *The Glory of the Garden* was the announcement of the ACGB's intention to transfer responsibility for 44 Arts Council clients directly to the appropriate RAA, and at the same time transfer sufficient funds to the RAAs to allow them to take on the additional responsibilities. It also announced that some 25 organisations funded by the

ACGB would lose their funding. This process of transferring companies to the RAAs was called devolution, and its announcement caused protests from a number of the companies involved who stated their wish to remain as clients of the ACGB. Despite these protests, and those of the RAAs who wished to take on the new responsibilities but maintained that they would not have the resources to take over the new clients, the plans went ahead.

The next major change to affect the structure of the RAAs was the *Wilding Report*, which was set up by the then Arts Minister, Richard Luce, in 1988. The purpose of the report was to look at the relationship between the Arts Council and the 12 RAAs in England. It concluded that there was a great deal of costly duplication within the system which could be reduced by handing over responsibility for more Arts Council clients to the RAAs which were to be reorganised into Regional Arts Boards and reduced from 12 to 10.

The Regional Arts Associations were able to develop close working relationships with the artists and arts organisations in their regions. They developed partnerships with the local authorities and could be more responsive to the needs of the people in their regions. In other words, they were in a far better position to fulfil the aim of Jennie Lee to make the arts more a part of everyday life. They began to talk about Arts in the Community and Community Arts.

ARTS IN THE COMMUNITY AND COMMUNITY ARTS

The 1960s was a decade of experimentation in the arts. Small-scale touring theatre companies like *The People's Show* took experimental theatre to small-non-theatre venues. The trend continued through the 1970s as the Arts Council developed its touring policy and the Regional Arts Associations worked with smaller, non theatre-based venues to develop audiences for the performing arts. Schools, community centres, colleges and even church-halls were used to take professional performances by theatre companies such as *Shared Experience* and *Trestle,* and dance companies such as *Extemporary Dance Company* and *Janet Smith and Dancers.* Very often these companies would lead workshops with local young people, pupils, students or interested adults, as a way of enabling people to learn about their work. In the 1970s *London Contemporary Dance Company* undertook pioneering residencies and workshops in different parts of the country and enabled many people to realise that dance was not just for the young and super-fit. They demonstrated that it was not necessary to have taken ballet classes from the age of five to enjoy dancing.

Theatre in Education

Likewise, the 1970s saw the growth of *Theatre in Education* (TIE), a movement which began at the Belgrade Theatre, Coventry in 1965. The Belgrade TIE company, and those which followed, employed a group of actor/teachers to devise and perform plays and workshops, often supported by extensive teachers' workpacks with suggestions for preparatory and follow-up work to be used in the classroom. The purpose of this work was to use drama and theatre methods to teach about subjects other than drama. The use of performances, often in conjunction with 'hot-seating', where students can question the characters they have met in the play, can allow teachers to deal with sub-

jects which might otherwise be difficult, for example racism, the nuclear arms debate, or mental illness. Students were often involved in role-play work during workshops, allowing them to test their own ideas and opinions about sensitive and controversial issues in a safe environment. The major dance companies tended to work differently. Their aims were to educate people about dance itself and about the works in their repertoires.

Gradually all the major dance and theatre companies began to realise the value of education and community work, and with a little coercion from the arts funders, they started to appoint education officers and workers. Companies developed programmes of lecture demonstrations and participatory workshops and when a company was due to appear in a region, the education worker/s would move into that region in advance, teaching workshops in local schools, community centres and colleges. This proved to be a highly successful way of increasing audience numbers and of developing their understanding. Its success led some Regional Arts Associations to develop their own regional theatre and/or dance companies. Companies such as *Emma Dance Company* in the East Midlands, *Spiral Dance Company* in the North-West and *Hull Truck (Theatre)* in the Eastern region, were able to develop a long-term relationship with their audiences and even to engage in the training of young people through their workshops and shared performances.

Community Arts

The phrase 'Arts in the Community' began to be used about this type of activity which was essentially artist-led. At the same time another movement was beginning which could be more accurately described as 'Community Arts'. The philosophy which underpins the latter is people-led rather than artist-led. Organisations such as *Jubilee Arts* in the West Midlands, have pioneered a way of working in which a group of people decide the type of artistic expression they want to engage with, and then the 'artist' guides and facilitates the process. The outcomes are often in the form of community plays, murals, videos, or street festivals.

The 'Dance Animateur' movement grew up in the early 1980s at the same time as Regional Arts Associations began to cease funding the regional dance companies. The latter were very expensive, in a climate of virtually static arts funding from the government, and to an extent duplicated the performance work of the larger companies who undertook extensive regional touring. 'Animateurs' were professional dance artists who combined the roles of dance educator, trainer and administrator by teaching workshops, directing youth dance companies and leading the technique training in an area, as well as raising funds for performances and workshops by other professional artists.

THE CURRENT SITUATION – AFTER WILDING

Since April 1994 the Arts Council of Wales and the Scottish Arts Council have been separately constituted in their own right, rather than acting as sub-committees of the ACGB. The new Arts Council of England retains only the national companies, the Royal Shakespeare Company, the Royal National Theatre, the Royal Opera House which includes the Royal Ballet and English National Opera, the South Bank Centre in London, the major orchestras and those companies with a national remit, as its clients. The ten new Regional Arts Boards have now taken on responsibility for all of the former ACGB clients in their respective areas: see page 25 and Figure 2.4.

TASKS

1 Find out which companies the Arts Council has funded over a long period of time, and make a list for your file.

2 Draw up a chart which shows the changes in the Arts Council's budget during its lifetime. What conclusions can you draw? Write them up for your file.

3 Choose one of the following to debate in your group:
 • The arts are better funded in London and the South-East than in the rest of the country.
 • Britain needs a Ministry for the arts.
 • If the people don't want to come to see the arts we should save our money and not worry about it.

Share the results of your debate with the rest of the class.

4 Imagine that your local Member of Parliament has spoken out against taxpayers' money being spent on the arts. Write a letter which expresses the view of your group on the subject.

The present structure of British arts funding

There are four areas of responsibility within the structure as a whole:

• the government's Department of National Heritage

• the Arts Councils of England, Wales, Scotland and Northern Ireland
• the Regional Arts Boards
• the local authorities.

DEPARTMENT OF NATIONAL HERITAGE

Immediately after the general election in April 1992, the creation of a new Ministry, the Department of National Heritage was announced. It would have responsibility for the arts, sport, tourism, National Heritage, the film industry, and the Millennium Fund. The Minister in charge, called the Secretary of State for National Heritage, would have a Cabinet post. This was a significant development in several ways. It brought together a number of different areas, all of which had been part of different government departments, and it set up the Millennium Commission which will fund projects designed to commemorate the start of the new century. The department is headed by a Cabinet Minister. Previous Ministers for the Arts had only been junior posts and there was limited scope for them to argue directly for increased levels of funding for the arts. Now for the first time the arts have

someone to speak for them at the most senior level of government decision making.

The new department is organised in three Directorates with responsibility for:

- heritage and tourism
- broadcasting, film and sport
- arts (including museums, galleries and libraries).

This new Ministry has also presided over the legislation to introduce the National Lottery, launched in 1994. The Arts Councils of England, Wales, and Northern Ireland, and the Scottish Arts Council, act as distribution agencies for the proportion of Lottery funds given to the arts. There have been four Secretaries of State for National Heritage since 1992:

1992 (April–September)	David Mellor
1992–1994	Peter Brooke
1994–1995	Stephen Dorrell
1995–	Virginia Bottomley

THE STRUCTURE OF THE ARTS COUNCIL OF ENGLAND

The Arts Council of England (ACE) is accountable to the Secretary of State for the Department of National Heritage. Figure 2.2 on page 23 shows its current structure.

The Council is effectively the management board. It is led by the Chair (Lord Gowrie since 1994) and comprises several chairs of the Regional Arts Boards together with others selected for their standing and experience within the arts. The Council members are not paid for their service and are not employed by the Arts Council. They have ultimate responsibility for the staff, the building, and the funding decisions.

The most senior employee of the Arts Council is the Secretary General (Mary Allen since 1994). She is responsible to the Council and is present at Council meetings. She also manages all the staff.

The Departmental Directors form the next layer of management. Each in turn has a number of officers and assistants to help devise policies and strategies, liaise with artists and arts organisations and give guidance to the panels to enable them to make decisions.

Each department has a group of Advisers to help make the decisions on funding applications. These people are unpaid volunteers of some experience in the specific art form or area. They come together to form the Panel or Advisory Committee, for example there is a Drama Panel, a Dance Panel, a Literature Panel, a Visual Arts Panel. The Advisers will go to see the work of the client and then write a report to help the decision making process. Reports are also written by Assessors, other unpaid volunteers, who do not necessarily belong to one of the Panels. Figure 2.3 on page 24 shows the Advisory structure in more detail.

The names of the committees show how over the last few years, the Arts Council has come to recognise the importance of certain cross art-form issues and has created groups of specialists to advise and develop policy.

N.B. The Audit, Budget, and Presentation Committees are Council committees, set up by the Council to deal with the overall policy and operation of the Arts Council, rather than to advise on clients.

THE SCOTTISH ARTS COUNCIL

The Scottish Arts Council is one of the principal channels of government funding for the arts in Scotland. Since 1994 it has operated as an autonomous organisation under its own Royal Charter. The Scottish Arts Council is responsible to and financed by the Scottish Office. It also receives funding from local authorities in Scotland. Its stated aim is 'to create a climate in which arts of quality flourish and are enjoyed by a wide range of people throughout Scotland'. The Scottish Arts Council provides funding grants to approximately 1,300 individuals and organisations each year, including the four national companies: Scottish Opera, the Royal Scottish National Orchestra, the Scottish Chamber Orchestra and Scottish Ballet. It also distributes National Lottery funds to the arts in Scotland.

THE ARTS COUNCIL OF WALES

Since 1994, the Arts Council of Wales has operated under a new Royal Charter as the national organisation for the funding and development of the arts in Wales. In the process it has taken responsibilities previously held by the three Regional Arts Associations in Wales. It receives funding from the Welsh Office, to whom it is responsible, and also from various local authorities. The Arts Council of Wales has offices in Cardiff, Bangor, Carmarthen, Cwmbran and Mold and it works through the medium of both the Welsh and English lan-

Figure 2.2 *The structure of the Arts Council of England*

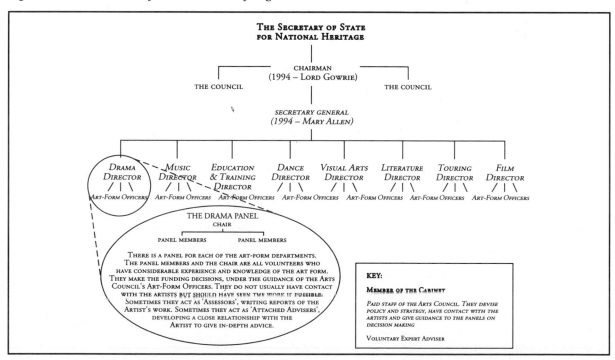

guages. Its aims are 'to improve standards of creativity in the arts', 'to increase the number and the range of people attending and participating in the arts in Wales' and 'to increase the funds going into the arts'. It also administers the distribution of the National Lottery arts funds in Wales.

The Arts Council of Northern Ireland

Unlike the Scottish Arts Council and the Arts Council of Wales, the Arts Council of Northern Ireland has been an independent organisation with its own Royal Charter since 1946. It receives all of its funding from the Department of Education for Northern Ireland, to whom it is responsible. It distributes grants to organisations and individuals throughout Northern Ireland as well as administering the National Lottery arts funds in Northern Ireland. It operates in a similar way to the Arts Council of England, with art-form panels to make decisions on funding.

Figure 2.3 *Advisory structure for the Arts Council of England*

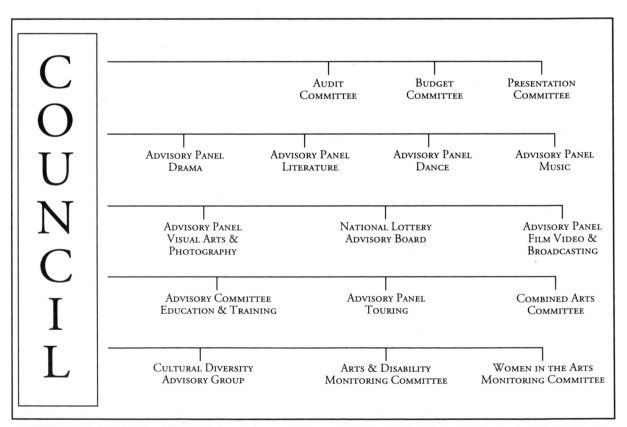

THE STRUCTURE OF THE REGIONAL ARTS BOARDS

The Regional Arts Boards (RABs) receive their funding from the Arts Council of England, the British Film Institute, the Crafts Council, and from those local authorities in their region who wish to support the development of the arts. As well as providing grant aid to arts activities in their region, the RABs offer information and support in a wide range of areas including publicity, business planning, and raising funds from the National Lottery. Figure 2.4 on page 26 shows a map of the Regional Arts Boards and the areas they cover. Each RAB operates independently and their budgets and funding schemes will reflect the needs in their own area. *The Regional Arts Funding Handbook* gives a detailed explanation of each of them. It should be available in libraries.

The Regional Arts Board operates with an almost identical structure to that of the Arts Council, except that it has different names for its constituent parts. It has a board of management which operates like the Council of the Arts Council, with a Chair and voluntary members selected for their expertise and experience. Instead of a Secretary General it has a Chief Executive. Like the Arts Council it will have a departmental structure but its departments are unlikely to be single art-form responsibility. Most will have a Department of Performing Arts with art-form officers. It is also likely that there will be a senior manager responsible for partnerships with local authorities, since these are very important to the RABs.

TASKS

1 Find out where the headquarters of your Regional Arts Board is. Write to them and ask for information about which artists, venues and companies they support.

2 Choose someone else to ask your RAB about its departmental structure.

3 Next time you see a live performance, act as an Adviser and write a report on it. Keep this for your file.

4 Discuss with your group whether the Regional Arts Boards should be controlled by the Arts Council of England.

LOCAL AUTHORITIES

There are different kinds of local authorities (county councils, city councils, borough councils and district councils), which vary according to where you live. Local authorities receive money from central government as well as raising money by collecting Council Tax from the people who live in their area. There are some statutory services which local authorities must provide, such as education, social services and refuse collection. There are other services which a local authority may choose to provide, if it wishes to. Funding for arts activities is one of the second group of non-statutory responsibilities. The decision whether to support the arts or not will depend on the political composition of the council. Those authorities which fund the arts will usually do this via a department called Leisure Services, Recreation and

Figure 2.4 *Map of Regional Arts Board areas*

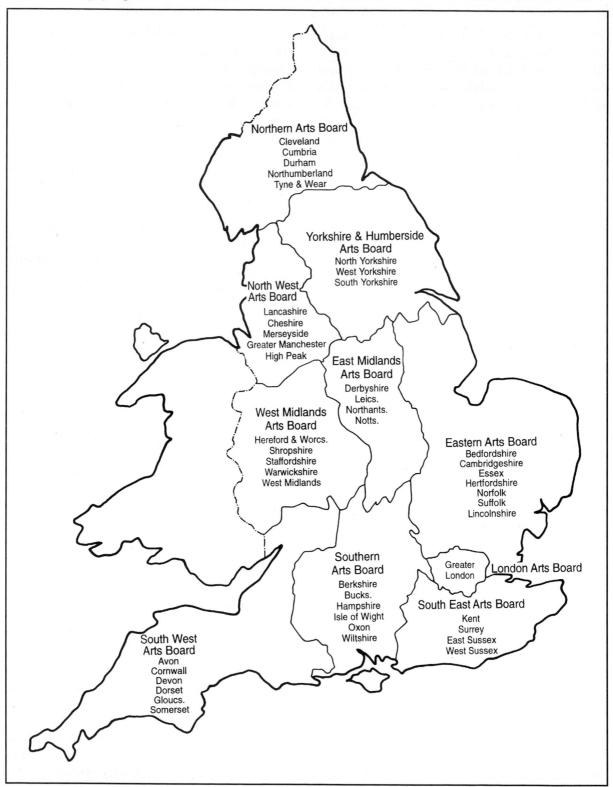

Arts or something similar. Some authorities have Arts Development Officers who administer arts funding and provide information and support for arts activities in their area. There may also be access to funding from other local authority departments; for example, a project taking work into day centres for senior citizens may be supported by the Social Services department.

Although local authorities have been entitled to spend money on the arts in their area since 1948 not all of them choose to do so; for instance, Birmingham City Council has been a major funder of the arts for a number of years. It gives a generous annual grant to the City of Birmingham Symphony Orchestra and was instrumental in the building of Symphony Hall as its main venue. It also facilitated the move of the Birmingham Royal Ballet to the Midlands; in addition to these major projects, it gives grant aid to numerous smaller local arts groups and projects. Birmingham City Council and many others believe in the importance of the arts as a way of improving the quality of people's lives but they have also shown that the arts can be instrumental in attracting businesses to the city, and in so doing, help to create jobs and stimulate the local economy.

Another local authority which believes in the importance of the arts is Coventry City Council. In 1958 it built the Belgrade Theatre as part of the reconstruction of the city centre, most of which was destroyed during the war. This was the first civic theatre to be built in Britain and it reflects the vision of the city councillors of that time in acknowledging that the spiritual and cultural welfare of its citizens was as important as their physical well-being.

Since 1948 local authority funding for the arts has increased steadily and today it is the largest provider of financial support for the arts, from the smallest local projects to the major theatres and orchestras.

Tasks

1 Find out which is the local authority for your area. Where is it based?

2 In consultation with your teacher, arrange for someone to write to, or telephone your local authority to ask if they have an arts policy. Which department deals with the arts? Is there an Arts Officer?

3 If your local authority has an Arts Officer find out if s/he will come and talk to your group about her/his work.

Bibliography

The Culture Gap – An Experience of the Government and the Arts, Hugh Jenkins, Marion Boyars Publishers, London, 1979.

In Anger – Culture in the Cold War 1945–60 Robert Hewison (revised paperback edition), Methuen, London, 1988.

The Glory of the Garden. The Development of the Arts in England, ACGB, 1985.

The Regional Arts Funding Handbook, Angus Broadbent, Boundtech Ltd, London, 1993.

Culture and Consensus. England, arts and politics since 1940, Robert Hewison, Methuen, London, 1995.

The Wilding Report – Supporting the Arts: a Review of the Structure of Arts Funding, Richard Wilding, 1989.

Arts and Cultures. The History of the 50 years of the Arts Council of Great Britain, Andrew Sinclair, Sinclair-Stevenson, 1995.

THE WORK OF THEATRES AND ARTS CENTRES

*B*ritain's largest and most common cultural organisations are theatres and arts centres. These are the places where most performances by professional artists and companies take place. They may be in purpose-built accommodation, or in buildings taken over and converted for use as performance venues. This chapter describes the different types of venue, their methods of operating and their funding status. It then examines the different organisational structures, and identifies the roles of the people working in the organisation. But such is the history and diversity of arts provision in this country that there are no hard and fast rules, and you will almost certainly come across venues which do not sit neatly in these categories. This rich diversity of both venues and arts events available for creative artists and audiences means that thorough background research and planning are necessary if you are to run successful projects in the most suitable venues.

Different types of venue

The venues fall into two broad categories, depending upon whether they receive public funding or not. These are:

- commercial venues
- subsidised venues.

COMMERCIAL VENUES

These operate on a purely commercial or profit-making basis, where all the funds needed to run the business have to be raised from ticket sales and any other income generating activities like bars, shops, restaurants. There is little or no subsidy from either local

authorities or from arts funding bodies like the Arts Council or the Regional Arts Boards, and the venue will fix its ticket prices accordingly. You will generally pay more for your ticket at a commercially run venue than at a subsidised one. West End theatres and the Alexandra Theatre in Birmingham operate on a commercial basis. These venues need to make money to survive and therefore their programming tends to focus on the popular plays and musicals.

SUBSIDISED VENUES

These differ from the commercial sector venues in that they receive a grant or subsidy from an arts funding body, such as a Regional Arts Board, and possibly from one or more of the local authorities in the area as well. This grant aid enables them to subsidise their ticket prices and so reduce the cost for their audiences. It also allows them to programme events or performances which would not otherwise be economically viable on a purely commercial basis. As a general rule you will pay less to see a performance at a subsidised venue than you would at a commercially run venue. The vast majority of regional repertory theatres like Nottingham Playhouse and the Duke's Theatre, Lancaster are subsidised venues.

The venues can be broken down still further according to whether they present more than one art-form, whether or not they create their own productions, and whether or not they take touring shows. Broadly speaking, a theatre tends to present plays and musicals, and an arts centre tends to present music, dance, and drama. Both organisations can buy in touring productions and both can in theory create their own productions, although it tends to be the regional repertory theatres who specialise in creating their own productions. There are three categories to consider:

- arts centres
- producing theatres
- non-producing theatres.

ARTS CENTRES

These are subsidised venues who usually 'buy-in' work from a wide variety of sources to make up a mixed programme of events representing several different art forms. They will book a ready-made production from a touring company and they take no part in the rehearsal and production period before the tour begins. Some of the larger arts centres have several auditoria, each suitable for different kinds of events. Warwick Arts Centre has a concert hall which is large enough to present a symphony orchestra, a 573 seat theatre, a flexible studio seating up to 200, and a cinema. It also occasionally commissions new productions. On a much smaller scale Phoenix Arts in Leicester presents a mixed programme of music, theatre, dance and films in the same 256 seat auditorium. Arts centres may be either commercial or subsidised venues.

PRODUCING THEATRES

These are often called regional repertory theatres, which produce their own shows and operate in the subsidised sector. They will vary in size, in age and in the range of work which

they present. The Royal National Theatre in London dates from the mid 1970s and has three separate theatres within the same building. Many regional repertory theatres have a main stage and a studio theatre under the same roof and they range from new modern theatres like the West Yorkshire Playhouse built in 1990 to the Bristol Old Vic which was built in the 19th century.

NON-PRODUCING VENUES

These tend to be in the commercial sector (but not exclusively). They tend to 'buy-in' shows, rather than employing the staff and performers to rehearse and produce the show themselves. There are a large number of theatres around the country which operate in this way. The shows may be on for one or two weeks, or for a season, and they will often be tours of popular musicals or plays which have recently completed a run in the West End. These non-producing venues may also put on performances by major opera and dance companies to make a balanced programme. Some are very old traditional theatres like the Liverpool Empire or the Grand Theatre in Leeds, and others, like the Derngate in Northampton, have been opened in the last twenty years. West End theatres are non-producing theatres.

Although there are clear differences between the commercial and the subsidised sectors of the arts business, there are strong links between them. There are numerous examples of plays and musicals which were originally produced as part of the work of a subsidised repertory theatre being taken up by the commercial sector after their original run has been completed.

Examples of this include the production of *Return to the Forbidden Planet* which was staged at the Belgrade Theatre in Coventry before moving to the West End, and then on to a series of national tours to commercial non-producing theatres. The Leicester Haymarket Theatre's production of *Mack and Mabel* moved to the West End.

This arrangement benefits both the repertory theatres and the commercial managements which 'buy' the production and take over the management of the show on a commercial basis. The commercial producer can see what s/he is getting in advance and although there is still an element of financial risk involved, the producer will not have to bear the start-up costs such as casting, rehearsal, and the construction of set, props and costumes. The theatre which staged the show originally benefits from additional publicity from a transfer and they will be able to negotiate royalty payments, which can be lucrative on a popular and long-running show. The royalty income generated in this way can then be used to subsidise the other work of the theatre such as new writing or studio shows.

TASK

In groups, find out about the venues in your area. Are they repertory theatres, arts centres or non-producing venues?

Make notes to keep in your file.

A typical regional repertory theatre

There is no such thing as a typical regional repertory theatre. Each one reflects the area in which it is located and the needs it has grown to meet. Nevertheless there should be sufficient common features to enable you to recognise your own regional repertory theatre in the following case study.

Figures 3.1 and 3.2 show the key staff employed in this kind of theatre.

The New Elizabethan Theatre

The New Elizabethan Theatre is in the centre of Dunwich City. It was built in 1963 and has a Main House which seats 750 with a thrust stage, and a flexible studio space, which seats 150. It programmes and produces two seasons of work each year, one running from autumn until early spring, and the other from spring to summer. There is usually a short break in the summer for building and equipment maintenance. During the year it presents a varied programme of plays and performances and it aims to offer something for everyone in the course of a year so it will have a mixture of musicals, both modern and classic plays, and children's shows. There will also be dance companies, and concerts, and local amateur groups, performing there at some time during the year. It receives grant aid from its Regional Arts Board and from the local City and County Councils; this makes it a *subsidised venue*. It produces most of the shows it presents, which means that it is a *producing theatre*.

Figure 3.1 *The theatre staff*

The Senior Managers
 Artistic Director
 Administrative Director

The Front of House Team
 Front of House Manager
 Box-Office Manager
 Box-Office staff
 Ushers

The Education Team
 Community and Education worker
 Part-time Community and Education
 workers

The Publicity and Marketing Department
 Head of Marketing
 Marketing and Publicity Assistants

The Production Staff
 Head of Production
 Stage Manager
 Deputy Stage Manager
 Assistant Stage Manager
 Chief Electrician
 Head of Sound
 Chief Carpenter
 Head of Wardrobe
 Head of Paintshop

Finance Department
 Finance Officer
 Finance Assistant

Figure 3.2 *The key staff roles in the organisation*

Artistic Director – chooses what kind of work will be presented, how and when. Directs most of the in-house productions.

Administrative Director – responsible for the management of finances, personnel and administration, including the Front of House, Box-Office, etc.

Head of Marketing – Responsible for the team who produce the season's brochures and additional publicity, and write all the press releases.

Front of House Manager – responsible for the box-office staff, the ushers, and the security people. Has to make sure that everything runs smoothly from the public's point of view. Has to take charge if there is an emergency during a show.

Box-Office Manager – manages the box-office system, selling tickets to the general public.

Head of Production – responsible for the technical and backstage stage staff. Needs to ensure that all shows come in on budget, that all correct procedures are carried out backstage and that the making of sets, costumes etc., and the running of shows operates smoothly.

Community and Education worker – responsible for developing workshops to support the productions and for youth theatre and other community activities based at the theatre.

Finance Officer – responsible for ensuring that all accounts are kept in order, that bills are paid and invoices sent out, and that staff are paid.

HOW THEY WORK TOGETHER

The Artistic Director

The most senior staff in the theatre are the Artistic Director and the Administrative Director (see page 34). Between them they are responsible for programming the season of plays several months ahead. The Artistic Director will be chiefly responsible for this but s/he will work closely with his/her senior colleagues to make sure that the season takes into account budget targets and that it can be built and staged by the theatre staff. As far as it is possible, the theatre organises its programme to include as many of its own 'home-produced' shows as it can afford. Each of the 'home-produced shows' will usually run for about 3½ weeks. Some of the shows included in the season will be 'bought-in' from visiting/touring companies. There are several reasons for this:

• it can help to make additional time for the theatre staff who can then build sets and make costumes for the next home-grown production
• it can help to balance the budget: touring productions are cheaper to stage
• it can give its audience access to work not available at other venues in their area like ballet, opera, contemporary dance, or the work of overseas companies.

The Artistic Director will direct most of the selected plays and will organise for freelance directors to come in for the others. Part of the process of selecting the plays involves checking that the necessary licences to perform it are available if the play is still in copyright (see Appendix, pages 154–57). Once the play has been chosen, the Set and Costume Designer will be hired and the director will start to cast the show from actors s/he already knows and from those to be auditioned.

The publicity and marketing department

When the season has been chosen, the publicity and marketing department will make arrangements for the design and production of a brochure which will cover the whole season, and will organise the printing and distribution of several thousand copies. They will also plan the strategy for selling seats for each individual show according to their assessment of the best target audience. They will work with the box-office staff to plan the best time to announce the new season. For example, the spring/summer brochure could be available immediately after the Christmas period when attendances to the musical are high. They will also liaise with the local and national media to provide information about the shows, the directors and the cast. They will, in consultation with the director and designer of the show, arrange for a graphic designer to produce a poster design. And they will arrange for the posters and flyers to be printed and distributed around the area in the six weeks before the show opens.

The Box-Office Manager

The Box-Office Manager will make sure that his/her staff have information about the new season before tickets go on sale so that they can answer questions from potential patrons. They may be involved in selling special season tickets or priority booking schemes before sales open to the general public. On a day-to-day basis they will keep records of the number of tickets sold which are passed to both the finance and the publicity and marketing departments.

The Production Manager

Meanwhile the Production Manager will be organising a schedule which allows sufficient time for the making departments (workshop, paintshop, wardrobe and props) to plan and construct the various sets, props and costumes. In the performance departments (electrics and stage crew), arrangements will be made to work with the designers of the set, the lighting and the sound on the necessary preparations for providing the people and equipment to run the shows. There may need to be extra casual staff employed if it is a large production like a musical or a pantomime. There will be a series of meetings with designers, directors and all the production heads of department to make the necessary arrangements before rehearsals start, and during the rehearsal period, to monitor progress. The Production Manager must make sure that all the shows arrive on stage, on time, and on budget.

The Deputy Stage Manager

In Stage Management, a Deputy Stage Manager (DSM) will be allocated to be 'on the book' for the show. This means that they will work with the actors and the director in rehearsal to record the decisions made about the action of the play and to write them into the prompt script. At the end of every rehearsal they will send messages to the appropriate departments about changes made in rehearsals. These might be requests for additional props, or special requirements for pockets on costumes, for example. When the show moves into the theatre they will give the cues to all the other technical staff to ensure that the show runs smoothly every performance. Other members of stage management will be working closely with the props department to find and borrow items for use in the show. The Company Stage Manager will liaise with the director and the actors to provide information about the local area, allocate dressing rooms and generally to look after the acting company.

The Technical and Back-Stage staff

When the show moves from the rehearsal room into the theatre for the performance, there will be a production week when everything comes together on stage for the first time. There is a fit-up when the set is put up, lighting and

sound equipment is rigged, props are set, and last-minute painting done. In a hectic few days' time there will be a technical rehearsal, the first time the actors work on the real set in the theatre. Then there will be two or more dress rehearsals and finally, the first night.

Publicity and marketing will have arranged for a photographer to attend a dress rehearsal so that there are pictures for the local press and for the foyer. They will have issued invitations to critics and will arrange for them to looked after on the first night. They will have set up press interviews with the leading actors and/or director and possibly visits by the actors to local events, schools and local groups to generate interest in the show. They will also have produced the programmes and, in consultation with the box-office and Front of House, have ordered enough for the run of the show and these will be delivered prior to the first performance. They will also have organised for advertisements to appear in the local press.

The Education Department

The education department will have planned and organised a series of activities and events around the chosen plays for that season. There will probably be special schools' matinees including talks from the director and designer about the staging of the show. There may be a series of workshops aimed at youth groups and talks for community groups about the work of the theatre; there may also be a Youth Theatre to provide acting and technical experience for those interested in gaining practical experience.

The Front of House Manager

The Front of House Manager will have organised a team of ushers for all performances, and will arrange for programmes to be sold, the cloakroom to be staffed, and for refreshments and merchandise to be sold before and after the performance and during any interval(s). Prior to each show they will check all the public areas to make sure that they are safe and tidy and that the public will be able to spend a comfortable evening in the theatre. Any information about patrons with special needs will be collected from the box-office prior to the performance, and the necessary arrangements made, such as removing seats for wheelchair users.

The finance and administration department

From the selection of the season onwards, the finance and administration departments will have organised the payment of wages and fees to all the staff and company involved. The invoices for goods and services relating to the production will be checked with the Production Manager and paid. The actors, and any casual staff needed for the show, will have been supplied with contracts. The income from ticket sales will be monitored by the publicity and administration departments. After the show the income will be checked against the predicted income in the budget and, if necessary, changes will be made. A calculation of royalties due to the writer of the play will be made and a cheque sent off.

This explanation relates to one show from a season of five or six individual productions, but the system is the same for each in turn. It is clearly important for senior members of the theatre staff like the Production Manager and the Publicity and Marketing Manager to be involved in discussions with the Administrative Director and the Artistic Director about the season they plan, in order to make sure that it can be achieved, and that it can be sold to the public. All the heads of department will work out who will work on each production and, if necessary, will arrange for extra staff to cope at the busiest times.

The Administrative Director

At the same time there will be other necessary work for the Administrative Director, who will

be concerned with the organisation of theatre licences and licences to sell alcohol at the bars. S/he will arrange for Employer's Liability Insurance to cover the staff and for Public Liability Insurance to cover the audience and other visitors to the theatre. S/he will liaise with the funding bodies to ensure their continued support and will be involved in any special projects, such as the submission of bids for National Lottery Funds. A large repertory theatre will usually be constituted as a company, limited by guarantee, with a Board of Directors who meet to monitor the theatre's progress both financially and artistically. The Administrative Director ensures that they are kept informed and have their questions answered at board meetings. The theatre will almost certainly be a registered charity and the requirements of the Charity Commissioners are dealt with by the administration department. In consultation with the finance department, budgets have to be monitored and possibly adjusted throughout the current year, and next year's budget will have to be planned well ahead.

A large repertory theatre like the example stated above is a major business which employs 100 or more staff and operates for up to 48 weeks of the year, at certain times giving three or more shows a day for six days a week. There may be some shows which are co-productions with other repertory theatres, where a play is rehearsed and built in one theatre, and after a run of several weeks, it moves to the second theatre. The costs of rehearsing and staging are divided between the two theatres in order to cut down on the costs. For those theatres with a separate studio theatre, the work of the two auditoria will have to be even more carefully planned to ensure that the production schedules do not overlap and that the staffing rota can service both shows at once.

TASKS

1 Pay a visit to your nearest repertory theatre. Pick up the brochures and try to get a feeling for the type of work they present. Go and see a show.

2 Ask your tutor to arrange a series of talks by people who work in the theatre. Try to construct an organisational tree of the personnel who work there, with a summary of their roles and responsibilities.

3 With a partner, carry out in-depth research into the role of one member of staff in the theatre. Report your findings back to the group.

A typical arts centre

The typical arts centre does not exist. All arts centres will operate in slightly different ways and will provide different work according to the needs of their local communities. Nevertheless you should be able to recognise your own local arts centre in the following case study.

The Bus Station Arts Centre

The Bus Station Arts Centre is in the centre of Plymfield. It was converted from an old bus depot in 1975. It has a 300 seat auditorium and it operates as a non-producing venue. It is funded by the local city council and for certain education projects by the Regional Arts Board which makes it a *subsidised venue*. It presents a mixed programme of events which includes theatre, music of various kinds, contemporary dance, and a film programme. The programme consists of a mixture of one night stands, two or three night runs, or a week of performances, depending on how popular the director feels each event will be. The range of work staged attracts widely differing audiences. There is a small gallery space where exhibitions are held. It is open all the year round, with the exception of a fortnight in the summer, when essential maintenance work is carried out.

Figure 3.3 shows the key staff who would work in this arts centre.

Figure 3.3 *The arts centre staff*

The Senior Managers
 Director
 Deputy Director (Finance)
 Clerical/Finance Assistants

The Theatre Management Department
 Theatre Manager
 Box-Office Manager
 Coffee Bar Manager
 Box-Office Assistants
 Ushers

The Publicity and Marketing Department
 Marketing Manager
 Publicity Officer

The Technical Department
 Technical Manager
 Technicians

Figure 3.4 describes the senior staff roles in the organisation.

Figure 3.4 *The key staff roles in the organisation*

> **Director** – chooses the work which will make up the programme, recruits staff, liaises with funding bodies.
> **Deputy Director** – deals with budgets, issues contracts, supervises accounts, settles bills and invoices, and pays staff and visiting companies.
> **Marketing Manager** – responsible for production of bi-monthly brochure, works with incoming companies to publicise each event.
> **Technical Manager** – liaises with incoming companies to supply and obtain details of technical and staffing requirements. Hires casual staff when required.
> **Theatre Manager** – responsible for box-office staff and ushers. Has to make sure that everything runs smoothly for the public. Takes charge if there is an emergency during a performance.

HOW THEY WORK TOGETHER

The Director

The Director selects suitable shows from companies whose work s/he has seen in the past, from the information sent in by companies looking for bookings for their work, and from work recommended by other contacts in the arts world. Contract details will be negotiated and sent as soon as agreement is reached between venue and company.

The Marketing Manager

The programme is planned several months in advance and the Marketing Manager organises and arranges for the printing of a bi-monthly brochure with details of all the forthcoming events including artwork, pictures, and information, supplied by the visiting companies. Part of the Marketing Officer's job is to work with the incoming groups on a co-ordinated and effective publicity campaign in the weeks leading up to their visit.

The Marketing Manager does not produce the publicity for each event but liaises with the incoming companies who supply an agreed number of posters and flyers which the arts centre staff can over-print with venue details and distribute around the area. They will however work with the companies to produce press releases in order to generate press interest and to set up interviews or special photo-calls whenever they can. Press advertisements will be placed on a weekly basis with extra space being given to the shows which are not selling fast enough. They may be able to organise linked offers with other shows in the season. The company will also supply photographs so that a foyer display can be organised before they arrive.

The Technical Manager

When the Technical Manager receives notice of the companies who will be performing, s/he contacts them to obtain details of their technical requirements for staging, lighting, and sound equipment, and sends out a groundplan and a lighting plan of the venue so that the company can arrive well-prepared. There is a small technical team of three who share the duties of Stage Manager, Lighting and Sound Technician between them. Where necessary, the Technical Manager can call on the services of a pool of casual staff to supplement the permanent crew. Unlike the repertory theatre, the

arts centre has no part to play in the rehearsal and production of the performances it stages. The work is 'bought-in' as a complete show which will be touring to a number of venues. For this reason the technical team is smaller; as much, if not all, of the work of running the shows is done by the technicians with the touring company.

The box-office staff

The box-office staff sell tickets and account for their sales on a daily basis to the finance department and the publicity department who use the information to help make decisions about budget adjustments and the necessity for extra publicity.

The Theatre Manager

The Theatre Manager will have organised the team of ushers for each performance and will have checked the public areas of the buildings to ensure the comfort and safety of patrons throughout their visit. Before each show s/he will have checked with the box-office to make sure that any patrons with special needs can be catered for. This includes wheelchair users, or those with hearing difficulty who will make use of the hearing loop in the auditorium. S/he will find out the running time of the show and whether there is an interval, and will inform the ushers and bar staff. After the show any un-sold programmes will be returned to the company along with the income from programmes and merchandise sold.

The Technical team

On the day of the performance the visiting company will arrive early to start their get-in assisted by an agreed number of the arts centre's technical team. In the afternoon they will do a short technical run to allow the performers to get used to the new space. After the show, the set, costumes and equipment are loaded into the van and the stage is left empty and ready for the next group. The next day the finance department will check the box-office income and calculate the fee or percentage due to the company. In due course this will be sent to them.

The finance department

Like their counterparts in the regional repertory theatre, the finance department will have to organise insurance, obtain licences, liaise with funding bodies, and work on meeting budget targets this season, as well as making budget plans for the next one. The arts centre also will have a board of directors who need to be kept informed, and the director will have to spend some of his/her time seeing the work of new and developing, as well as established, companies.

TASKS

1 Visit your local arts centre. Pick up the brochures and decide which art-forms the programme concentrates on. Go and see a performance there.

2 Ask your tutor to help you to arrange a visit from someone in the marketing department. Ask them about the different audiences who attend the arts centre.

3 In pairs draw up a chart which compares the work of the different departments in the venues in these case studies. Explain the similarities and differences to the rest of your group.

CONCLUSION

In this chapter we have looked at examples of a regional repertory company and an arts centre. It is important to emphasise that all arts organisations will be slightly, and in some cases very, different. Each will respond to the needs of its own catchment area and, if our two examples were in the same city, the senior staff from both would probably meet fairly regularly to talk about their future plans and make sure that their different programmes complemented each other, rather than being in competition. For instance the repertory theatre might stage a Christmas musical and a daytime show for children in the five–nine years age group. This would leave the arts centre free to book a company which offered a show suitable for the nine–fourteen years age group during the day, with a programme of evening shows designed to appeal to a young adult audience. It would provide theatre-goers in the area with the maximum amount of choice about what to see, and allow both venues to maximise ticket sales.

Repertory theatres which supplement their 'home-grown shows' with visiting companies will also look at the needs of its audiences. The Leicester Haymarket Theatre may include a ballet company like English National Ballet (ENB) in its programme, as there is no other suitable venue in the area where audiences can see classical ballet. The Birmingham Rep, which is similar in many ways, would be unlikely to book ENB because the Birmingham Royal Ballet are based in the nearby Hippodrome Theatre, and provide opportunities for ballet audiences in the area.

chapter four

PRODUCING AND PRESENTING THE ARTS

R.B. JACKSON

LIGHTING DESIGNER DIRECTOR CHOREOGRAPHER PROPS

Chapter 3 dealt with the work of theatres and arts centres, whose primary function is to present the arts, usually as performances. This chapter will deal with the process of mounting a performance. It examines the production and presentation processes in a theatre or arts centre venue and then looks at some of the issues surrounding the presentation of performance in a non-standard venue.

In a theatre or arts centre, the environment is carefully controlled so that the performers and the technical staff all work in a safe and healthy environment. The audience is taken care of by the front of house staff who sell them tickets at the box-office, answer their queries, show them where the toilets and the fire exits are, show them to their seats, and deal with any disturbance caused by illness, behaviour problems or an emergency. In short they ensure that the audience can watch the event comfortably and safely. Even the simplest production is actually very complicated to mount, which is why theatres use tried and tested methods to get the show up and running.

There are many people involved and each has a clearly defined role to play — it may seem hierarchical but if everyone sticks to the tasks they have to do and communicates effectively with the others, then everything works smoothly. If they do not, at best, the performance can be ruined; at worst, there can be injuries. From the previous chapter you will have learned that there are three clearly defined groups of people involved with producing and presenting the show:

- the Director/s and performers
- the Production team
- the Front of House Management team.

It is not possible to present a live performance without these three groups of people. In a small project performance, people may double up on roles; for example a director may also be responsible for lighting the show or for ushering. An actor may have made the props. But all the roles need to be fulfilled. It would be impossible for the actors to operate the lights and sound and it would be illegal not to have the appropriate number of ushers for a public performance. If the performance is taking place in a non standard venue (possibly even outside), it is much more difficult to control the environment effectively so as to meet health and safety requirements for performers, technical crew and audience. As far as possible the processes used in a producing theatre should be applied.

The production process in a producing theatre

In a repertory or other producing theatre, the production and the artistic processes can develop together. This is the ideal situation. Once the Artistic Director has made the basic decisions about which script (if any), which performers, which art-forms and what type of design to use, s/he can begin the consultation process which will result in the set, costumes and props being made, the production being mounted on the stage with lighting and sound, and the actual performances proceeding smoothly from a technical point of view. The production department of a repertory theatre is responsible for the entire making process from budgeting and purchasing of materials to scene shifting and ensuring the performers are on stage at the right times. These are their main responsibilities but since every production is different, there are bound to be others as well:

- budgeting for costume, set, props and special lighting or sound effects
- purchasing materials, purchasing or borrowing props, costumes or furniture
- assisting at rehearsals and auditions
- writing down everyone's cues (for lighting changes, actor's entrances/exits, music or sound effects and set changes)
- blocking the stage area for lighting design
- marking up the stage for the performers and the placing of the set
- prompting

- the production schedule
- building the set
- making the props
- making costumes

The Build Period

- designing the lighting
- making of sound tapes

The Technical Preparation

- setting up of scenery
- setting up lights
- setting up of sound system

The Fit Up

- preparing stage
- placing props
- calling the performers
- calling the audience
- operating sound
- operating lighting
- scene shifting
- managing the backstage area

Running the Performance

- removing all the lights
- removing the sound equipment
- striking the set and props

The Get Out

- producing the final account
- returning/storing costumes, set, props and furniture.

Of course there are many additional responsibilities if the show goes on tour after its run in its home theatre.

THE PRODUCTION TEAM

Given the number and range of technical and other production responsibilities, it is not surprising that in a large producing theatre, there is a large technical/production staff. Not everyone would work on every production and there can be some flexibility of roles. For an individual production, the team might consist of the following staff:

The Production Manager, usually a senior theatre appointment, oversees all production aspects, from budget to staffing rotas for the performance run; creates the Production Schedule.

The Designer works with the director to design the environment for the performance, especially set and costumes.

The Technical Director liaises with the director (and designer if there is one) to research and implement the designs. Runs the Fit Up and the Get Out, deploys technical staff. Ensures that budget targets are met.

The Stage Manager (SM) first point of communication between the director and the rest of the production staff. Manages stage staff in rehearsals and performances, manages the procurement/making of props, set and costume. Looks after the performers' needs throughout the rehearsals and the run.

The Deputy Stage Manager (DSM) prepares prompt script, attends rehearsals, cues the show. Communicates with all the technical departments.

Chief Electrician works with the director to design and rig the lights, plots the lighting states, and operates them using cue sheets prepared under guidance from DSM.

Chief Sound Technician works with the director to design and make working and performance sound tapes, fits up microphones and sound system, and operates sound using cue sheets prepared under guidance from DSM.

Head of Wardrobe works with director and designer (if there is one) to agree what is required, then makes (or arranges the making), hires, or selects, items from stock.

Head Carpenter supervises and builds the set.

Head of Paintshop supervises the painting of the set and backdrops.

It is essential to have good communication between the artistic and the production teams and it is very much a partnership of equals. A good production team holds a wealth of valuable knowledge and experience of the craft and technical aspects of theatre which they will use to realise the director's vision. They will give advice to prevent expensive mistakes from being made if the director is unrealistic in his/her expectations and will find creative practical solutions to problems of new materials or construction methods. The main vehicle for communication between the artistic and the production teams is the production meeting. A series of these will be held, starting before the rehearsal period with the pre-production meeting, to discuss the initial design concepts and continuing throughout the rehearsal and production periods.

TASKS

1 Ask your tutor to arrange a visit to your nearest theatre to talk to the production staff.

2 In pairs, research and write up a job description for one member of a production team.

3 Write up your experiences of undertaking one of the technical jobs on a production.

PRODUCTION MEETINGS

From the performance side, it would normally be the directors who attend; the Artistic Director, the Designer, the Choreographer and Musical Director and the Rehearsal Director if there is one. The performers would only attend if there were specific problems to be solved in relation to costumes, set or props, or to the production schedule. On the production side, the Production Manager, Stage Manager, Deputy Stage Manager, production heads of department such as Props, Wardrobe and Carpentry and the Technical Director would certainly attend all meetings; the Chief Lighting and Sound Technicians would attend from the beginning if they were also designers, otherwise they would only attend meetings closer to the production week.

Figure 4.1 shows the production meetings as central to the production process. For example, following an early meeting, the SM might go back to the prop makers with a list of objects that need to be made up. S/he might also take away drawings which will enable the construction of a scale model of the set so that the Production Manager can then cost it out. The lighting designer might go back to the lighting department with a request for a special gobo to be made or for the hire of a smoke machine. The Artistic Director might return to rehearsals knowing that he can continue working with the idea of a revolving set or that the construction of a huge gauze maze is possible. As the production meetings continue throughout the rehearsal period, the problems are solved and the practical environment for the performance takes shape. An important function of the production meeting is to fix deadlines and goals, and report on progress so that everyone can feel confident that the production will be ready on time and within the budget allocated.

Figure 4.1 *The production meeting*

TASK

Write up the minutes of one of your production meetings.

THE PROMPT SCRIPT

The DSM is responsible for producing the prompt script. This document is a special version of the script. The text – amended with the director's changes is separated into single pages and placed in a ring binder with blank sheets facing each page for the cues to be written on, so that they can appear as close as possible to the point in the text at which they occur. Although there are many different ways of annotating the prompt script it should always include the script, with all its amendments, the 'blocking' (the movements of the cast about the stage), lighting and sound cues, cues for scenery changes, the calls for actors and technical crew (and what they have to do), as well as setting lists, cast lists, cue sheets and any other useful information about effects. Basically, the prompt script contains a complete and definitive record of everything that should happen during a performance. It is used at rehearsals (usually by the DSM) to prompt the actors and is continually updated throughout the rehearsal period. During the performance itself, the DSM sits in the prompt corner and uses the prompt script to ensure that everything happens as it should, when it should. S/he is in contact with the other technical staff through an intercom system (with headphones) and/or cue lights. For example, the lighting operator may be alerted to the fact that a cue is coming up by the DSM giving him/her a red light. When the light goes green s/he activates the change. Unfortunately, cues do not usually happen one at a time; a piece of scenery might be flown in at the same time as a lighting change occurs and music is heard. The DSM has to be able to communicate with different members of the stage crew at the same time.

Figure 4.2 below shows an extract from a prompt script. The 'blocking' of the moves is shown in the first column (see stage positions in Figure 4.3, page 47). Lighting and sound cues are shown in the second column and the text is shown in the third column. The play is called 'A Child's Voice'. It was written by students from Coventry University Performing Arts under the direction of tutor David Semple and is based on the lives of Anne Frank and Adolf Hitler. The extract is taken from the first scene, in which a tour guide is showing a group of present day tourists around Auschwitz.

Figure 4.2 A *prompt script extract*

Moves	Calls	Cues	Text
TG moves CS Group DSL		LX 4	TOUR GUIDE: Welcome to Auschwitz, the final home for over one million Jews, political dissidents, Jehovah's witnesses, homosexuals, gypsies and people with disabilities. This was the home of the great I G Farben, which produced synthetic rubber. Ten per cent of the inmates were employed in the manufacture of rubber. The other ninety per cent were poisoned by the fumes that the rubber gave off. Some people have objected to the conversion of Auschwitz into a museum. Some, because they believe in the ideals of the Nazis, but do not wish to be reminded of the terrible suffering they

Moves	Calls	Cues	Text
			caused. Others, because they believe that by bringing these horrors to light, you encourage them to happen again. The first group of people are beneath contempt. To the second, I would say: I believe you are mistaken. The plague has run its course. Now is the time to examine the bacteria that caused it so that it may never infect us again.
			Everything has been left exactly as it was fifty years ago when the camp was liberated by the Allies. If you think you will find the journey disturbing, please do not go through the door. Otherwise, that is the entrance to the chamber.
TG moves DSR Group moves through CS to USR		LX 5	*[THE VISITORS BEGIN THEIR JOURNEY THROUGH THE GAS CHAMBERS. THEY ARE INSTANTLY OVERWHELMED BY THE ATMOSPHERE OF THE PLACE; YOU INSTINCTIVELY KNOW SOMETHING AWFUL HAS HAPPENED HERE. THE SILENCE IS TERRIBLE. A DEAFENING SILENCE. THE TOUR GUIDE STANDS ON THE EDGE AND STARES AT THEM ALL, CURIOUS TO KNOW WHAT THEIR REACTIONS WILL BE. THE VISITORS ARE ALSO*
S puts hand to mouth		Fade in SQ 2	*OVERWHELMED BY THE TERRIBLE SMELL. STEVE HAS TO PUT HIS HAND OVER HIS MOUTH TO STOP HIMSELF FROM VOMITING. AS THEY WALK FURTHER, WE HEAR SUBTLE DRUMMING, THE SOUND OF A PRESENCE, A PULSE STILL LIVING WITHIN THE WALLS. MICHAEL SEES A FAT STAIN ON THE WALL]*
			MICHAEL: What's that?
			[HIS WORDS ARE ECHOED BY THE REST OF THE CAST]
			TOUR GUIDE: It is a human fat stain.
Visitors regroup CSR			*[HER WORDS ARE ALSO ECHOED. THE VISITORS REACH THE END OF THEIR JOURNEY.]*
		LX 6	JOANNE: Was that really blood on the walls?
		LX 7	*[THE VISITORS FREEZE. ADOLF HITLER STEPS OUT OF THE SHADOWS AND WALKS TO THE FRONT OF THE STAGE. WITH EVERY STEP HE TAKES, THERE IS A DRUMBEAT, AS IF HIS SHOES HAVE MALEVOLENT MAGIC POWERS.]*

Moves	Calls	Cues	Text
A at DSC			OLD ADOLF: I caused all this. Six million dead. I did that. But the World created me. I wasn't farted out of Satan's arse. I used to be a baby once.
			Three things you never knew about Adolf Hitler. One. I was not German. I was in fact, an Austrian. Two. My mother was a maidservant, employed by my father, before she became his third wife. He was a top civil servant, fifty-two years old when I was born.
			Three. I did not have only one ball. I did in fact have both my testicles and neither of them was ever in the Albert Hall.
			This is me. The way I was then.
		LX 8	*[YOUNG HITLER TEARS ACROSS THE STAGE PRETENDING TO BE AN AEROPLANE. HE PUSHES HIS WAY THROUGH THE FROZEN TOURISTS AND FINALLY KNEELS AT THE FRONT OF THE STAGE. SHOOTING AT THE AUDIENCE WITH AN IMAGINARY GUN. WHEN HE HAS RUN OUT OF BULLETS, HE STOPS, PAUSES, NOT KNOWING WHAT TO DO NEXT. HE LOOKS AT THE AUDIENCE.]*
			YOUNG ADOLF: Hello.
			[BOTH THE HITLERS EXIT. THE PARTY OF TOURISTS AND TOUR GUIDE COME BACK TO LIFE, BUT THIS TIME PLAYING SLIGHTLY DIFFERENT CHARACTERS.]
TG & Visitors regroup DSR		LX 9	TOUR GUIDE: Welcome to the house of Anne Frank, the little girl who has inspired the world. Her story has been made into a stage play, a film starring Katherine Hepburn, and we believe, Andrew Lloyd-Webber is currently in development on the musical. It was in this attic, above a warehouse, where Anne and her family lived for over three years and where Anne wrote her famous diary. Notice the movie star postcards on the wall, including a picture of Queen Elizabeth as she is now called, Princess Elizabeth as she was then. Notice also the pencil marks on the wall over there where the children used to measure themselves in captivity.

Moves	Calls	Cues	Text
			[THE TOURISTS BEGIN TO WANDER AROUND]
			ELAINE: It's a bit poky, isn't it?
			STEVE: They could provide better facilities.
			ELAINE: Or extend it up the top.
		LX 10	*[ANNE FRANK ENTERS, THROUGH THE SECRET ANNEXE ENTRANCE. AT FIRST, THE TOURISTS DON'T APPEAR TO SEE HER, BUT AS SHE BEGINS TO SPEAK, THEY FREEZE.]*
		LX 11	ANNE: This is the house where I grew up. But I never grew higher than five foot two. And now I'm trapped.
		LX 12	Trapped in these walls. Trapped in these movie star postcards. A museum piece. Trapped in the pages of my diary. Always being watched. Always waiting for the knock in the night. Always running away. Running away from search lights.
		Fade in SQ 3	*[SOUND OF VIOLINS PLAYING A WORLD WAR TWO SIREN. THE LIGHTS GO DOWN AND SEARCHLIGHTS CROSS THE STAGE. ALL THE CHARACTERS CROSS FROM ONE END OF THE STAGE TO THE OTHER, DESPERATELY SEEKING A SAFE PLACE. FROM NOW ON IN THE PLAY, WE ARE BACK IN TIME.]*

Column 1 Blocking – the stage is broken down into named areas so that positions can be referred to simply and clearly. Downstage (DS) is towards the front, upstage (US) is towards the back, left and right are from the performer's point of view, and centre stage is obviously at the centre. This enables the stage to be broken down in to nine areas: see Figure 4.3 below.

Figure 4.3: *Stage positions*

UPSTAGE RIGHT (USR)	UPSTAGE CENTRE (USC)	UPSTAGE LEFT (USL)
CENTRE STAGE RIGHT (CSR)	CENTRE STAGE (CS)	CENTRE STAGE LEFT (CSL)
DOWNSTAGE RIGHT) (DSR)	DOWNSTAGE CENTRE (DSC)	DOWNSTAGE LEFT (DSL)

AUDIENCE

Column 2 The Calls – the actors would be called at the beginning of the performance and at the beginning of each scene.

Column 3 LX and Sound Cues – all lighting cues are numbered. The prompt copy records that there is a change in the lighting state. The cue number is used on the separate cue sheets which show in detail which lanterns are brought up, which taken down, and how quickly the changes take place. Each lantern is numbered according to its place on the lighting rig so the information is very detailed, far too detailed to be contained in the prompt copy alongside the text. This is why a system of numbers cross-referenced to cue sheets is used.

TASK

Prepare and present a prompt script for assessment.

THE PRODUCTION SCHEDULE

The production schedule is usually put together by the Production Manager, following the first production meetings. It will identify the tasks which need to be done and the deadlines for their completion. In the early stages of the project, the schedule will include the acquisition of props, the building of the set and the making of the costumes. As time goes by it will include the creation of the special lighting effects, the assignment of technicians to tasks like the making of the sound tape. As production week approaches, the work becomes very detailed. The Production Manager must plan this week with great care. In consultation with the Artistic Director and Stage Manager s/he will decide how long the set and lighting fit ups will take, how many dress rehearsals can be allowed, how many technical run throughs will be needed and how many staff it will take to accomplish everything in the time available. Many theatre crews will work through the night during production week in order to avoid leaving the theatre dark (without a performance) for too long.

PRODUCTION WEEK

The production week falls broadly into three sections:

The Fit Up – in which all the major set items are erected and finished. The lights are rigged to cover the areas of stage action and any special effects. The sound system is rigged, setting up the tape players, amplifiers and speakers together with any microphones, for additional amplification from the stage.

The Plotting – in which props are set, scene changes rehearsed, lighting states agreed and practised with cues, and sound levels are set and practised with cues.

The Technical and Dress Rehearsals – in which sections of the performance are run so that everyone can practise; the actors get used to the stage, the set and the props; the scene shifters get used to handling the scenery; the lighting and sound operators practise the cues; and the DSM practises the cueing.

The production schedule for production week would look something like Figure 4.4 on page 49.

Fig. 4.4 *Production schedule*

Date	Time	Action	Staff Required
SAT 2nd Sept	1200	Load transport with set	Driver/Carpenter × 3
	2230	Get-out (and save?) *Congratulations*	PM/SM × 3/Cas × 2
		Some LX rigging, if possible	
SUN 3rd Sept	0400	All crew break	
	1400	Get-in *Cosmetic Surgery*	PM/SM × 3/Cas × 2
	1800	SUPPER BREAK	
	1900	Continue set work on stage	
	2300	All crew break	
MON 4th Sept	1000	Actors to rehearse in rehearsal studio	DSM
		Continue set work on stage	PM/SM × 1/Cas × 2
		Rig remaining LX	LX × DES/SM × 1/ Cas × 1
		Rig sound system	Sd DESIGNER
	1300	LUNCH BREAK	
		Sound system check	Sd DESIGNER
	1400	Continue set work on stage	PM/SM × 1/Cas × 2
		Rig remaining LX	Lx DES/SM × 1/ Cas × 1
	1600	Focus LX	Lx DES/SM × 1/ Cas × 1
		Rig projectors	PM
	1800	SUPPER BREAK	
	1900	Focus LX	Lx DESIGNER/SM × 1/ Cas × 1
	2100	LX Plotting session	Lx DES/DIR/Board Op/SM to walk
	2300	All crew break	
		Overnight paint call	Painters × 3
TUE 5th Sept	0900	Set-up for TECH REHEARSAL	SM × 3
	0930	Sound plotting session	Sd DES/DIR/Sd Op
	1030	Actors call to get into costume	
	1100	TECHNICAL REHEARSAL	
	1400	LUNCH BREAK	
	1500	Continue TECHNICAL REHEARSAL	
	1900	SUPPER BREAK	
	2000	Set up for DRESS REHEARSAL	
	2010	Half hour call	
	2045	FIRST DRESS REHEARSAL	
	2300	Actors break	
		Technical work can continue if necessary	
WED 6th Sept	0930	Technical work on stage	
	1230	Actors called for notes	
	1330	LUNCH BREAK	
	1430	Set up for DRESS REHEARSAL	
	1455	Half hour call	
	1530	SECOND DRESS REHEARSAL	
	1800	Actors to break	
		Stage and auditorium to be set	
	1925	Half hour call	
	2000	PREVIEW	

Date	Time	Action	Staff Required
THU 7th Sept	1000	Technical work as required on stage	
	1230	Press photocall (provisional)	
	1400	Actors call on stage TBC	
	1700	Actors break	
	1925	Half hour call	
	2000	PRESS NIGHT	

Abbreviated titles:

PM	Production Manager	Sd Des	Sound Designer
SM	Stage Manager	Board Op	Lighting Board Operator
Lx Des	Lighting Designer	Sd Op	Sound Operator
		Cas	Casual(s)

It is the Production Manager's job to oversee all the work of production week. Naturally the specific tasks will vary from production to production, depending on the nature of the set, how complicated the lighting and sound plots are, whether there are elements such as dance and music, and also other technical components involved such as back screen projection, video or even lasers. The model shown above is for a very traditional theatrical performance.

TASK

Devise and present a production schedule for the production week of one of your performances.

PLOTTING THE LIGHTING AND SOUND

Thorough preparation can keep these sessions short and efficient. The director and DSM will have produced preliminary cue sheets so that the lights and sound will be rigged appropriately and any special effects can be set up in advance. This means that by the time the plotting session takes place, the lighting designer will have already worked out preliminary ideas for the lighting states and can demonstrate them for the director's approval, using other members of the stage crew onstage in place of the actors. Even so, this is a time consuming exercise. Each scene will have to be worked through, checking the lighting states and timings with the director and against the prompt copy.

THE TECHNICAL REHEARSAL

The technical rehearsal finally reveals whether the plans all work. It is usually a stop-start affair. The SM will be watching out backstage for props and scenery in the wrong places. If there are difficulties s/he may stop the rehearsal until it is sorted out and new notes are made on the prompt script. The designer and the Heads of Props and Wardrobe will be watch-

ing with the director and if there are problems with lighting and sound or any other area, the show will have to be stopped while it is sorted out. If the run has been stopped, everything will have to be re-cued before it can be started again by the director at a specific point of his/her choosing. The DSM will use his/her prompt script to make sure that everyone is ready to start at the right place. The performers will try to muddle through but will inform the SM if things are wrong. If time is short, then the director may decide to cut out dialogue or movement where there are no technical cues and simply 'top and tail' scenes. Everything *must* be tested and practised in the technical rehearsal, especially any special technical effects such as smoke or dry ice machines. Nothing should come as a surprise in the dress rehearsal since this is supposed to be treated as a performance.

THE DRESS REHEARSAL

There will be at least one, probably several dress rehearsals. They are treated like performances and nothing, bar a major emergency, should stop a dress rehearsal. Scene changes, fast costume changes, and all the other technical effects, are run as they will be in the actual performances. The director and designer(s) will watch from the auditorium and afterwards there will be a notes session where corrections and amendments are given to the people operating the show as well as to the actors. In many theatres there will be one or more preview performances which are public performances with cheaper tickets before the press night, when the critics and official guests are invited.

THE PERFORMANCE

By the time of the first performance, the director has handed over responsibility for the show to the actors and the stage crew. The Stage Manager must oversee the running of the performance. S/he will have copies of everyone's cue sheets and running notes so that if there is a need, s/he can take over any one of the jobs during the show. Before every performance, the SM will check to make sure the stage area is set correctly, that all scenery, props and furniture is in place and that everything is in good working order. If anything is in need of maintenance or repair, it is the SM who must ensure appropriate action is taken. If the theatre is a large one, there will be other Assistant Stage Managers to look after the setting of props but the SM must still oversee the work to ensure it is done properly. Everything must be ready by the time the performers receive their half hour call.

The Deputy Stage Manager plays the same role in the performance as s/he has in rehearsal. Sitting with the prompt script in the prompt corner or the control box, s/he gives all the cues and prompts the actors if necessary. Before the performance s/he will follow through a pre-performance checklist to make sure everything is ready. After the performance s/he must write up a *Show Report*, noting anything which went wrong and giving reasons. S/he also records the timing of the show and notes the size of the house in broad terms.

THE STRIKE/GET OUT

The *Get Out* is the dismantling of the set and the de-rigging of the lights and sound. It is called a Get Out if the set is to be used for further performances elsewhere. If the show is finished and the scenery is to be scrapped, it is called a *Strike*. Getting a show out is never as exciting as Fitting Up. Nevertheless, the production team must give the same attention to dismantling as they did to building. The production manager organises the Get Out schedule and all available technical crew will be on hand to speed up the process. Broadly speaking, the stage crew will remove, store or return, all props and carry-off objects. All electrical equipment will be removed from the stage and the wings before the set is dismantled and transported away for storage or re-use.

Touring

A TOURING SHOW

The production planning for a touring show must take account of the following:

- portability: the set must be transported easily
- spatial flexibility: the set must be adapted for different stage sizes and shapes
- a simple adaptable lighting plot; not all theatres are equally well endowed with resources
- the need to arrange for staff to run the show; the venue may not be able to provide technical or backstage support.

It would be impossible to have to build the set anew for every performance space and a set of free standing units (as far as possible) is a good idea.

LIAISING WITH THE VENUES

It is essential to acquire clear, accurate information from each of the venues, well in advance. The Production Manager would write initially, asking for a ground plan of the performing space and the auditorium and possibly for a list of available lighting and sound equipment. In addition, it can be useful to send each venue a questionnaire which covers the specific needs of the touring production. If the venue is a non-standard performance space such as a school hall or community centre then the questionnaire should encompass even basic elements such as intercoms, wing space and black-out facilities. Ideally, this early written communication should be followed up with a visit. This is especially important for a non-standard performance space. A visit may show that items of set cannot be used or that special effects are impossible, or even that sections of the show have to reworked because they simply

will not fit in the space available. If it is a non-standard space you should make sure the doors are wide enough to get the set in and that *there are no particular rules about what cannot be hung from the ceiling or secured to the floor.*

It is also important to get a firm agreement on which items of the venue's equipment will be used and which need to be transported or hired and whether the venue has sufficient of its own staff to operate as stage or technical crew. You may have to take quite a lot of your own equipment and provide staff as well.

THE PRODUCTION SCHEDULE FOR TOURING

A tour is a continuous process of Get Ins and Get Outs, of Fit Ups and Striking and can be very demanding for all concerned, especially for single performances or short runs. Every new venue means a new set of problems, to say nothing of items that are lost or broken in transit or left behind at the last venue. A system and checklist are needed for packing and unpacking and all skips, boxes and packing cases should be labelled with their contents. Once again the Production Manager will draw up a production schedule to ensure that everyone knows what jobs they have to do, and when, and make sure that there is enough time for the essential technical rehearsal. The production schedule for a touring performance is similar to that of production week, but there is usually even less time available and the production team are working with unfamiliar equipment in unfamiliar surroundings. The schedule must allow time for the performers to 'space out' their moves in the unfamiliar space. The technical rehearsal would probably be a matter of running through the cues for exits and entrances (topping and tailing) rather than running the whole show, since by now everyone should by now be sufficiently familiar with the performance.

Performing in non-theatre venues

TAKING THE ARTS TO THE PEOPLE

There are very good reasons why the arts should be presented in venues other than theatres. Some people cannot afford to buy theatre tickets, while others associate theatres with white, middle-class, middle-aged, attitudes. Television is so much more accessible: you do not pay for each individual programme, you switch it off if you do not like it, you can eat and drink while you watch, and you can be very comfortable in your own home. It is very difficult to convince people to abandon this kind of comfort and control in order to go out on a cold wet night to be 'trapped' in a theatre for two hours when perhaps they have come straight from work. People need to experience good quality, live performance to be convinced of its immediacy, relevance, and power. This was recognised in the 1970s when the arts funding system began to encourage the growth of small-scale, re-

gionally-based theatre and dance companies, who would perform in schools and community centres. The intention was to 'take the arts to the people', if they were reluctant to go to the theatres and arts centres. A development of this idea follows up on the strategies of public art. In other words, it looks at where people do go, for example, shopping precincts and parks, and takes art to that place. This is relatively easy with sculptures – less easy with performance. In a sense it has led to a different kind of performance art which has to create a performance environment without the usual trappings of theatre. Making a virtue out of necessity means using simple storytelling techniques; or making dance about the movement itself, so that it can hold the audience's attention without spectacular lighting and set; or even devising performance which is about the non-standard venue itself – a travelling dance on a railway platform, a factory drama in a factory space. However innovative and imaginative the artistic intention and style, there are still practical constraints involved in non-standard venue presentation which must be carefully worked through by the production team.

THE SPACE – ARTISTIC ISSUES

Performance spaces shaped like corridors, or with triangular floor plans, are difficult but by no means unknown. If the performance is tailor-made for such an oddly-shaped space, the director and production team can have fun designing the environment to make the most of all possibilities. More often, though, a small-scale touring performance company will have to present the same show in a variety of differently-shaped spaces. It is a test of ingenuity, sometimes, to fit the show in and still give the audience a good theatre experience. In a non-standard venue without fixed seating and lighting rig, there are often choices to be made as to which way to present the show. The following guidelines might help in decision making:

- The audience need to be placed where they can have the best sightlines.
- They also need to have access to emergency exits.
- The performers need access to the performance area from 'backstage' if there are costume changes or entrances from different sides of the 'stage'. Otherwise they might stay 'on stage' for the whole performance.
- The performance area does need to be physically and visually separate from the audience (unless it is the artistic intention to mingle the two). If possible it should be free of distractions, such as windows or passers-by, or from external noise.
- The performers will need appropriate temperatures to work in and there will need to be proper seating for musicians, plus access to power points for music stands, if required.

When creating a touring show it is far better to work with the minimum of set. There are however problems associated with this in terms of audience expectations. Inexperienced theatre-goers are frequently impressed by the technology of a performance and by the sumptuous sets and costumes of West End productions. Smaller touring productions have to find other ways of being impressive. Here are some suggestions for more portable sets:

- Make free standing units which do not need to be flown.
- Make the units on folding, adjustable frames.
- Use fabrics which can be draped, or held or hung on frames, and can be folded away.
- Avoid large flats.

- Use folding staging to create interesting levels.
- Create simple but imaginative handprops.
- Create simple and flexible furniture which can be used for more than one purpose, for example a box can be a chair or a bed or a car, depending on how it is used.

TASK

Present set design ideas (drawings and models) for a performance in a non-standard venue.

TECHNICAL REQUIREMENTS

A performance without lighting and sound is always possible but it is very difficult for the performers to create a theatrical atmosphere without these supports. Lighting separates out the performing space and focuses the audience's attention on it; it cuts out the surrounding distractions telling them that something special is about to happen. It also reinforces the drama of the action — a sudden blackout heightens the tension. Lighting alone can set the mood even before the performers come on to the 'stage'. Taped sound effects can transport the audience to another environment, deep underground for example, or tell the story – a creaky door opening might be the most effective way of telling us that there is a prowler in the house. It is relatively easy to transport and fit up a sound system in a non-standard venue, although the quality may not always satisfy the sensitive ear of the professional sound technician. It is more difficult to fit up a non-theatre venue with an effective lighting rig. The first thing you need to do is to check the electrical supply. It is beyond the scope of this book to give detailed guidance on rigging a lighting system, on what is effectively a domestic supply, but a domestic 13 amp ring main will allow you to run up to six 500 watt theatre lanterns at the same time. *Make sure that your group has someone suitably qualified/ experienced to deal with this.*

The following equipment could form the basis of a useful touring lighting rig:

- lanterns
- lighting stands with 'T-Bars'
- cables
- dimmers
- small lighting board.

The following can be a useful touring sound rig:

- cassette recorder
- domestic hi-fi amplifier
- pair 50 watt speakers
- plenty of spare leads.

When setting up the lighting and sound rigs in a non-standard venue it is important to bear in mind the following:

- The operators' desks must give a good view of the performance space.
- There must be a communication link between the Deputy Stage Manager (or Stage Manager if s/he is acting as DSM) and the operators.
- All equipment must be placed so as not to be a hazard to the performers or the audience.
- Cabling must be kept off the performance space and the out of the audience's way, or else it must be securely taped down.
- Equipment must not obstruct the emergency exits or access to them.

Space, Front of House and Box-Office

The space – safety issues

However strong the wish is to get 'to the people' by performing in unusual venues, there are some occasions when the idea should be abandoned:

- when to proceed would be dangerous for the performers
- when to proceed would contravene public liability insurance rules and be dangerous to the audience.

Performers must never be asked to perform in a space where the set is not secure, the lighting rig not properly installed, or the sound system is in any way unsafe; nor where there are hazards from external factors not normally associated with a theatre environment, such as people throwing things, or other unruly behaviour. Dancers (classical ballet and contemporary) have particular performance needs which must be met in order to prevent injury. They must have a warm environment and a clean, non-slippery surface to dance on. They also need a sprung floor, i.e. one with a little 'bounce' in it. These can be made of wood or of layers of (plastic) composite materials. Jumping or falling onto concrete or solid wooden floors will cause stress fractures. The same care should be taken for tumbling or gymnastic routines. All performers need to work on a smooth surface – all floorcloth edges, cables, and mats should be taped down. The edges of blocks should be clearly visible and they should be joined smoothly. All items of set (props), must be fire-proofed if made of inflammable material.

At any public performance, in whatever kind of space, it is vital that someone takes responsibility for Front of House management. If you are not working in a traditional venue, you may need to take on this responsibility yourself. Check in advance and do not just assume that someone will be there on the night. The FOH Manager takes responsibility for the public's comfort and safety. In the event of an accident the FOH Manager may be legally accountable.

Theatre licences

If you are intending to take your performances to non-standard venues you will need to ensure that the venue holds the necessary licence for the performance of plays under the Theatres Act 1968. Although not specifically mentioned, this includes other performance work, for example dance, mime, performance art, etc. Most public buildings like community centres, village halls and schools, and all arts centres and theatres will already hold an annual licence which is issued by the appropriate local authority i.e. district or city council. If the building does not hold the necessary annual licence then it is possible to apply for a temporary licence to cover a performance, or performances, on specific days. When you are arranging your tour you will need to ask and possibly apply for the licence yourself although this will usually be the responsibility of the venue organiser.

The appropriate local authority will supply you with the necessary application forms and guidelines which deal with issues relating to the safety of the public while they are in the building.

COMPLETING THE APPLICATION FOR A THEATRE LICENCE

The local authority will require at least 14 days notice, but you should apply as soon as you can in order to make sure that you have supplied the information they require and that any problems can be dealt with in good time. The applicant will have to provide the names of at least two people who will be asked to testify about their characters and fitness to be the holders of such a licence. This is to ensure that the licensing authority have taken reasonable steps to check that the person taking legal responsibility for the safety of the public is a fit and proper person to do so.

The application form is not complicated but it will require close contact with the person or organisation who owns the premises to be used. For this reason, it will be easier for someone connected with the venue to apply for the licence, not least because they will be local to both the venue and the licensing authority, and you may not be. The application form will require the answers to questions about:

- who owns the building
- the availability of car parking
- the number of seats provided
- the ventilation system
- the construction of the stage
- the heating system
- the lighting and electrical installation, including safety lighting
- the provision of fire appliances.

Along with the application form you will receive guidelines about what is, and what is not, permitted under the terms of the licence, and instructions about the minimum standards for various aspects of public safety and for the provision of adequate facilities for the performers. The guidelines advise about:

- times and days when performances are not permitted
- the minimum number of stewards/ushers to

be provided, depending on the number of seats available
- the number of seats allowed, the securing of seats in rows and the number and width of gangways to be provided
- the provision of emergency exits
- when and where smoking is and is not permitted; the display of No Smoking signs
- the fireproofing of seats, curtains and stage drapes and furniture
- minimum standards for the electrical equipment to be used during the performance, included the provision of suitably qualified personnel to take charge of this equipment
- fire precautions to be taken
- the statutory notices relating to safety which must either be printed in the programme or on display at the venue.

If you apply for the licence then you must make sure that you:

- understand all the guidelines
- have answered all the questions accurately and honestly
- can fulfil all the requirements of the licence issued to you.

As a licensee you are responsible in law and you should not undertake the duties assigned to you unless you fully understand what is required and can fulfil the terms of the licence.

The Association of British Theatre Technicians (ABTT) publishes guidelines on rules relating to the issue of temporary licences (see bibliography) and the licensing authority will advise and help you.

FRONT OF HOUSE

The Front of House team should consider the needs of the audience in a non-standard venue. How do they find their way from the entrance to the 'auditorium'? Is their approach clearly marked? How many ushers are needed? Where do they need to position themselves to give the best guidance? Which seats will each usher guide the audience to, and from which entrances – the seats may not be numbered. Are there any difficulties involved in maintaining security – such as other ways for interlopers to gain access to the performance space? Where should the ushers position themselves during the performance in order to maintain security and open up exits in the event of an emergency? Who will sell the programmes? Who will deal with 'on the door' ticket sales? Is there access to a phone for an emergency? Perhaps you will need a mobile phone.

There can be no set answers to these questions because each non-standard venue will have different front of house requirements, but as long as all the questions are answered, the following would be the *minimum* staff needed:

- An usher on each entrance to the 'auditorium' to guide the audience, sell programmes, and collect ticket stubs for accounting purposes.
- One spare usher in case of difficulties.
- Someone to sell tickets 'on the door'.

BEFORE THE SHOW – SAFETY CONCERNS

- Check that all emergency exits are unlocked with any safety chains or bolts removed; also check that there is not a parked van or a pile of rubbish on the other side of the door.
- All exits should be clearly marked and the illuminated signs switched on if appropriate.
- All gangways must be wide enough to accommodate a wheelchair and they should be clear and unobstructed by anything.
- All seating must be secured together in rows to prevent seats being tipped over and obstructing people leaving in an emergency.
- Fire extinguishers of the appropriate kind should be in place next to exit doors and near the lighting equipment.
- The edges of seating rostra and steps should be marked with white tape.
- There should be an edging strip on any seating rostra to prevent chairs falling off.
- All public areas of the building should be checked for potential dangers such as missing light bulbs, damaged seats, wet and slippery floors, frayed or damaged carpets and appropriate action taken.
- Remove all discarded clothing and rubbish (especially glasses) from the auditorium.
- The FOH Manager must have access to a working telephone so that help can be summoned in the event of an emergency.
- All ushers should be briefed before the performances about the emergency procedures and their part in them.
- The FOH Manager should liaise with the Stage Manager about what will happen in the event of an emergency.
- A warning notice must be prominently dislayed if strobe lighting is to be used during the performance.

BEFORE THE SHOW — AUDIENCE COMFORT AND ENJOYMENT

- Make sure that the ushers can answer questions about the time the show finishes, how many intervals there will be, and where the toilets, cloakroom, refreshments and programmes can be found.
- Supply adequate floats to the ushers selling programmes, refreshments, and any merchandise.
- Make sure that all the ushers can be easily identified by the public, by wearing badges, or T-shirts, or black trousers/skirt and a white top.

- Make sure that they know who the FOH Manager is and where to find him/her.
- Make sure that the ushers realise their important role in the team. They should be polite, helpful, and smiling. A surly usher, or a rude box-office assistant, can ruin someone's evening, even if the show itself was brilliant.
- Check that the toilets are clean and that there are adequate supplies of paper towels and toilet paper.

DURING THE SHOW

- At least one usher will need to sit in the auditorium to check that there are no problems with patrons drinking or smoking (if they are not permitted), being disruptive, or falling ill.

- Check the public areas of the foyer including the toilets after the interval and before the end of the show.

AFTER THE SHOW

- Check the auditorium for lost property.
- Be available to talk to patrons as they leave.

A well-organised Front of House team will operate smoothly and efficiently. The audience will collect their tickets, be shown to their seats, buy programmes and refreshments at the interval, and leave at the end of the evening, unaware of the amount of effort which goes into looking after them. They will however, be aware of the work if they are not well looked after.

TASK

Draw up and present a plan for the Front of House team of a performance in a non standard venue.

BOX-OFFICE — BEFORE THE SHOW

Budgeting is dealt with in more detail in Chapter 5)

- Make sure that the box-office staff know how many seats are available and at what prices.
- Organise a simple system for recording ticket sales as full price, concessions or complimentary. Figure 4.5 below shows the simplest method of recording if the seats are not numbered (called a 5 bar gate).

- If there are numbered seats there should be a seating plan with tickets sold, tickets reserved and house seats (those to be held until the last minute) clearly identified. Figure 4.6 on page 61 gives an example.
- Make sure that the box-office staff have an adequate float.
- Draw up a box-office return sheet for them to complete and the FOH Manager to check after the performance.

Fig. 4.5 *A simple box-office return (five bar gate)*

Date: 26 May 1996 Title: Cosmetic Surgery	Perf. No: 2

Full Price (£5)	Concession (£3)	Complimentary
27	IIII 44	7

TICKETS SOLD

27	@	£5	135.00
44	@	£3	132.00
			267.00

CASH		CASH BREAKDOWN	
Float	10.00	£10	130.00
Takings	267.00	£5	75.00
Total Cash	277.00	£1	57.00
			262.00
		Cheques	15.00
		Total	277.00

Signed .. Box-Office Assistant Date................

Signed .. F.O.H Manager Date................

Fig 4.6 *A simple box-office seating plan with reserved seats*

Figure 4.7 on page 62 shows a simple box-office return sheet for a reserved seat show with sales in advance. It also shows how what percentage of the seats were sold and what percentage of the total possible cash was taken at this particular performance. This is how it is done:

Calculating the house percentage

Divide the total number of seats sold (86) by the total number of seats available (100) then multiply this by 100.

$86 \div 100 = 0.86 \times 100 = 86$

The percentage of the seats sold for this performance is 86.

Calculating the cash percentage

Divide the total cash taken for this performance (£322) by the maximum possible cash, i.e. all the seats sold at the full price, (£500) then multiply by 100.

$322 \div 500 = 0.64 \times 100 = 64$

The percentage of the possible money taken for this performance is 64.

Fig. 4.7 *A simple box-office return (reserved seating)*

Date: 26 May 1996 Title: Cosmetic Surgery Perf. No: 2

TICKETS SOLD IN ADVANCE

27	@	£5	135.00
44	@	£3	132.00

TOTAL (ADVANCE) 267.00 267.00

TICKETS SOLD ON DOORS

5	@	£5	25.00
10	@	£3	30.00

TOTAL (DOOR) 55.00 55.00

TOTAL BOX-OFFICE INCOME 322.00

CASH FROM DOOR

Float	10.00
Takings	55.00
Total Cash	65.00

CASH BREAKDOWN

£10	30.00
£5	25.00
£1	10.00
	65.00
Cheques	
Total	65.00

SEATS SOLD	86
COMPS	7
UNSOLD	7
TOTAL CAPACITY	100

HOUSE PERCENTAGE (CASH) 64%

HOUSE PERCENTAGE (SEATS) 86%

Signed ... Box-Office Assistant Date..............

Signed ... F.O.H Manager Date..............

TASK

Draw up a box-office return sheet to be used for a performance by your group.

BIBLIOGRAPHY

Advice on Standards for Occasional Licences, Association of British Theatre Technicians, London, 1981.

Model Rules for Management for places of Public Entertainment, London District Surveyors Association Publication, 1989.

Stage Management and Theatre Administration, Pauline Menear and Terry Hawkins, Phaidon Press Ltd, Oxford, 1988.

At a very early stage in the organisation of any project, event, or performance, you will need to know how much it will cost and how you will get the money to make it happen. You will also need to calculate how much money you can raise yourself and where it might come from. This process is known as budgeting. In order to do this you will need a calculator to help you. It is not difficult, even for people who hate maths. All you will need to do is addition, subtraction, multiplication, division, and percentages; the calculator will provide all of these functions. A budget will be divided into sections. They are:

- expenditure
- income.

Budgeting works in exactly the same way, whether you are dealing with your pocket money, your grant for the term, or the funds needed for your first arts project. You need to know how much you have to begin with (your LEA grant for the term), how much more you might expect to receive (additional help from your parents or wages from a part-time job) – this amount is your **income**. You also need to know what expenses you will have to meet (rent, food, bus pass, books, clothes, entertainment) – this amount is your **expenditure**. You need to decide how long the money needs to last (until the end of term or until the beginning of the next term when your next grant cheque arrives) – this is the period of time to be covered by this particular budget.

When drawing up a budget, you will need to separate it into these two sections: *Expenditure* or how much the costs will be (the money going out), and *Income* or the money you will need to cover these costs (the money coming in). When you have a finished budget, your expenditure total may equal the income total, in which case you will be able to cope. If the expenditure total, is higher than the income total, you will need to look again at the figures and make alterations. If the income total is higher than the expenditure total you will have something in reserve to put towards next term.

Before you start to calculate your budget, you will have to do a considerable amount of research in order to make your figures as accurate as possible. While you are calculating the budget, you will have to make alterations and cor-

rections, and the final budget will almost certainly not be the one you first prepared. It is a good idea to begin by making two budgets: one you would like 'in an ideal world,' and one which represents the cheapest way things can be done – a 'worst case'. You will probably find that the final budget falls somewhere in between these two.

Expenditure

We shall look at drawing up a budget in two halves, firstly by identifying the costs, the expenditure side of the budget. The most expensive part of any arts project will be the people involved. Start by making a list of who they are. The list may include all or some of the following people: writer, composer, choreographer, director, designer(s), performer(s), technician(s), workshop leader(s), set builder(s), costume maker(s), props maker(s), stage management, administrator, publicity manager. You may have other roles to add to the list. When you know who will be involved, work out how long they will be needed and when. Figure 5.1 shows a way of doing this for a large project:

Figure 5.1 *Personnel planner*

Personnel	Wk 1	Wk 2	Wk 3	Wk 4	Wk 5	Wk 6	Wk 7	Wk 8	Wk 9	Wk 10
	Pre	Pre	Reh	Reh	Reh	Reh	Prod	Perf	Perf	Perf
Director	✓	✓	✓	✓	✓	✓	✓	✓	✓	✓
Administrator	✓	✓	✓	✓	✓	✓	✓	✓	✓	✓
Composer			✓	✓	✓	✓	✓			
Designer	✓	✓	✓	✓	✓	✓	✓			
Choreographer					✓	✓	✓			
Actors			✓	✓	✓	✓	✓	✓	✓	✓
Dancers			✓	✓	✓	✓	✓	✓	✓	✓
Musicians						✓	✓	✓	✓	✓
LX Technician						✓	✓	✓	✓	✓
FX Technician						✓	✓	✓	✓	✓
Costume Maker			✓	✓	✓	✓	✓			
Prop Maker				✓	✓	✓	✓			
Van driver						✓	✓	✓	✓	✓

You will also need to decide if the people involved will receive a fee or a weekly wage for their work, as this will affect how you calculate the costs and when you will need to have the money to pay them. If you establish a company and pay people on a weekly basis, you will need to talk to the local tax office and DSS office about calculating and deducting income tax and National Insurance contributions. In this case you will need to add approximately 10% onto your wages bill calculation. As paying staff will be the single most expensive item on any budget, you may have to compromise in this area.

If it is your first project, you may only be able to pay expenses rather than a reasonable wage to all, or some of the people, working on the project. Some, or all, of you may be employed either part-time or full-time, or you may be registered as unemployed. The project may only involve one or two people. You need to take these individual circumstances into consideration. Some new performance groups will work on a 'profit-share' basis. This means that the budget will cover the costs of the project but not the wages/fees of the performers. The participants might receive some expenses; after the project, any profit left after the costs have been paid is divided between the group.

You should then look at the other costs involved in the planned project. These will vary according to the project but they may include all or some of the following:

- scenery, costumes and props (or the money for materials from which to make them)
- transport costs – bus/train fares, van hire, fuel costs, insurance
- hire of rehearsal space
- administration costs – telephone calls, stationery, photocopying, stamps, faxes
- publicity and advertising – posters, flyers, press packs, photographs, newspaper advertisements, direct mail
- hire or purchase of equipment or musical instruments
- performance licences and royalty payments for the use of scripts or music
- contingency of 5–10%.

Contingency is the amount put into the budget for the unexpected things, such as the van breaking down just before the tour.

The expenditure budget of a project for two dancers to work in a day centre for one day per week for eight weeks might look like Figure 5.2 on page 67.

TASK

Look at Figure 5.2, which shows an expenditure budget. Draw up an expenditure budget for a project you have been involved with at college.

Figure 5.2 *Expenditure budget*

	£	Total £
Wages		
2 dancers @ £25 per day × 8 weeks	400	400
Transport		
£5 (mileage) × 8 days	40	40
Administration		
Telephone calls	10	
Stationery/stamps	10	20
Equipment Hire		
Hire of video camera 2 days @ £25 per day	50	50
Miscellaneous		
3 × video tapes @ £3 each	9	
Developing/printing films	6	15
Contingency	25	25
Total Expenditure		**550**

Income

When you know what the project will cost, you will need to look at how to raise the money. This is the *income* side of the budget. In many ways, calculating this is more difficult than the calculation of the costs; you will need to start looking at possible sources of funding. Artists and companies working in the subsidised sector are likely to be dependent on grants towards some of the costs of their projects, but even with a grant you will still be expected to raise some of the money yourselves.

You will need to calculate how much you can raise and from which sources. Your project income will probably include all or some of the following:

- fees or box-office income from performances
- fees from venues or participants for workshops or residencies
- income from the sale of programmes, posters, T-shirts, refreshments
- private sponsorship from local or national businesses
- charitable donations from trusts or businesses
- grants from arts funding bodies
- your own money.

All but the last two of these sources are called *earned income*. The income side of the budget for the same project might look like Figure 5.3 on page 68:

Figure 5.3 *Income budget*

	£	Total £
Fees		
Fee from day centre	150	
Contributions from participants:		
50p per day × 20 people × 8 days	80	230
Charitable Donation		
Donation from local company	100	100
Grant		
Grant from city council	200	200
Total Income		**530**

This first draft budget does not balance as the income total is £20 less than the expenditure total (see Figure 5.2). In order to make it balance, the dancers will have either to increase the income or reduce the expenditure. There are a number of possible alternatives: they could reduce the expenditure by

- taking the contingency figure out of the expenditure which would save £25

- paying themselves a lower mileage rate of, for example, £2.50 per day, which would reduce the transport sum by £20.

They could increase the income by:

- asking the day centre to pay a higher fee of £170 which would increase the income by £20
- increasing the number of participants in the project to 25 which would also raise £20.

TASK

Draw up an income budget for the same project (your college production). Compare the income and expenditure totals. If it does not balance, draw up a list of possible ways to make it balance.

CALCULATING EARNED INCOME

Your earned income is the money which you raise from sources other than grants from organisations whose business it is to fund the arts. It will probably include all or some of the following:

- fees from venues for performances or residencies
- box-office income for performances from venues

- fees from participants in workshops or residencies
- merchandising – the sale of programmes, T-shirts, posters, refreshments.

The money from all these sources will have to be carefully calculated. As part of your project planning you should have decided how long your project will run for. If it involves performances, you can then decide how many performances you can realistically expect to give. In making these decisions you will need to calculate the time needed to prepare the venue for the performance, the distance you can travel to your venues, and an adequate number of rest days per week for the company.

CALCULATING PERFORMANCE FEES

The income you earn from fees or box-office should be the largest component in your earned income calculations. In an ideal world, a touring company would identify a number of venues interested in booking the show and would persuade the venue managers to pay a fixed rate fee per performance to the company, with the venue keeping the money from the tickets sold at the box-office. This arrangement is preferred by touring companies because they are guaranteed payment for the show even if the number of tickets sold is small. It is less popular with venue managers because they risk losing money if the income from ticket sales is too low to cover the fee which the touring company has negotiated. A venue manager will only offer a fee which s/he calculates can be covered by the tickets sold at the box-office, so it is important that a touring company does their research before approaching venues.

A venue manager who is intending to book a new and unknown company will probably not be prepared to risk offering a fee per performance and may well suggest that the financial arrangement is in the form of a 'box-office split'. This means that the venue and the company divide the box-office income from ticket sales between them, according to an agreed percentage. This means that both the venue and the touring company are sharing in the risk that a show will not sell very well, but they will both benefit from a show which sells well. If you are offered a 'box-office split' you will need to ask the venue a number of questions in order to calculate how much you will be likely to receive after the performance(s):

- What percentage deal is being offered? for example 50:50, 60:40, 70:30. The touring company should receive the higher percentage.)
- How many seats does the venue hold?
- What are the ticket prices, including the price(s) of concessionary tickets? Remember to ask which groups are entitled to concessionary tickets.
- How many seats would the venue usually expect to sell for this kind of work ?

Armed with the answers to these questions, you can then make some calculations about the possible potential income available to you. There are several important points to remember:

- The venue will deduct Value Added Tax (VAT) at the current rate (at the moment this is 17.5%) from the total income before it is split between company and venue (see page 71).
- The venue will hold a number of seats back for each performance as 'house seats' in case of any problems such as double bookings, for audience members who need to change seats, or for important visitors arriving at

short notice. It is unlikely that they will be sold unless the show is fully booked, and then only at the last minute.

- You may need a number of complimentary tickets for your guests or for the press.
- Most venues sell more tickets for performances at the end of the week than at the beginning.
- Will details of your performances be included in the regular brochures and/or venue advertisements? The answer to this question will affect ticket sales.

For example, if the venue holds 70 people and the tickets are priced at £5 with £3 concessions, the maximum income would be £350 if all the tickets were sold at the full price. This would give £297.87 after VAT is deducted. On a 60:40 box-office split, the company would get £178.72: see Figure 5.4.

Figure 5.4 *Calculating a 60:40 box-office split on a sold out show*

Ticket Sales	Gross Box-Office Income	Less 17.5% VAT on Income	Net Box-Office Income
70@£5.00	£350.00	£52.13	£297.87
60% of net income to company	£178.72		
40% of net income to venue	£119.15		

A more realistic estimate for a show which would appeal to a student audience would be to calculate the income on the basis of selling 75% of the tickets, with two-thirds sold at the concessionary rate. This would mean selling 17 tickets at £5 and 34 tickets at £3 which would give a gross income of £187, leaving £159.16 after VAT is deducted. On the same 60:40 split this would give the company £95.50: see Figure 5.5.

Figure 5.5 *Calculating a 60:40 box-office split on a 75% capacity show*

Ticket Sales	Gross Box-Office Income	Less 17.5% VAT on Income	Net Box-Office Income
17 @ £5.00	£ 85.00	£12.65	£ 72.35
34 @ £3.00	£102.00	£15.19	£ 86.81
	£187.00	£27.84	£159.16
60% of net income to company	£95.50		
40% of net income to venue	£63.66		

As a new and unknown company you may not be able to negotiate either a fee or a box-office split. In this case you may have no option but to hire a venue and keep all the box-office income yourselves. If you make this kind of arrangement with a venue manager, you must get a clear explanation of what you will get in return for the hire of the venue. You will need to ask:

- What is the earliest possible arrival time at the venue? Does this allow adequate time for you to set up for the performance?
- By what time must you be out of the build-

ing (this means after your Get Out has finished, not after the show has finished)?

- What equipment, if any, is available for your use?
- Will any of the venue staff be on duty before, during and after the show? Are they available to help you with the Get In and preparations for the show, or just to oversee you and your staff?
- Will the venue sell tickets from their box-office on the night and/or in advance?
- Will the venue provide Front of House staff for the performance(s)?
- Will there be any additional charges and if so what will you be paying for?
- Will the venue include information about your show in their publicity?

When you have the answers to these questions you will need to make similar calculations about the potential box-office income available to you. You should take the advice of the venue manager about the average ticket prices charged and your tickets should be at that level or slightly lower. If you are performing for more than one night you can probably expect an increase in audience numbers on the second and third performances as word of mouth publicity spreads and if you get a good review from the local media. Whatever the financial arrangements, try to ensure that your shows are included in the venue's own brochures and leaflets. You may be offered what looks like an attractive financial deal for a late booking but if you are not in the venue's regular publicity, which people check to see what's on, then you will have to spend more time and money advertising your show.

If you are running workshops in conjunction with your performances or residencies, you will need to decide how much to charge. This might be a set fee for a school or college for a certain number of their students, or an amount per participant if the event is open to the public. Get as much information as you can about the appropriate amount to charge from the school, college or venue involved, so that your budget is as accurate as it can be. Never be tempted to over-estimate the income from fees or box-office deals. It is better to err on the negative side and be pleasantly surprised than to fall below an over-optimistic target and end the project with a deficit.

A BRIEF INTRODUCTION TO VAT

In Figures 5.4 and 5.5, there is a deduction from the gross box-office income of an amount to cover Value Added Tax (VAT). This section provides a short introduction to the ways in which VAT affects the sale of theatre tickets and therefore the way in which a box-office split is calculated. VAT is a tax which is paid by the purchaser on most goods and services, including theatre tickets. It is collected for the government by the suppliers of the goods or services, in this case the theatre box-office, and has to be paid over to the Customs and Excise department every three months. A VAT registered company can also claim back the VAT it has paid out, and so the quarterly payment to Customs and Excise will be the amount of VAT collected from sales of tickets and other income, less the amount paid out, in VAT for other goods and services. The current rate of VAT is 17.5%.

In the calculations above the cost of a full-price theatre ticket is £5. This is made up of the ticket price plus 17.5% added on for VAT which will be paid to the government in due course. In order to calculate the amount of VAT included in the £5, divide it by 117.5. This is the cost of the ticket (100%) plus the

additional 17.5% VAT. You then multiply by 100 to get back to the cost of the ticket, before VAT was added. The figures are then rounded up or down to the nearest full penny.

Figure 5.6 *Calculating VAT*

Ticket Sales	Gross Box-Office Income	Less 17.5% VAT on Income	Net Box-Office Income
17 @ £5.00	£ 85.00	£12.66	£ 72.34
34 @ £3.00	£102.00	£15.19	£ 86.81
	£187.00	£27.85	£159.16

Using the example from Figure 5.5, the amount in the gross box-office income column, £85, is divided by 117.5 then multiplied by 100, to give a net box-office income of £72.34.

$$85 \div 117.5 = 0.7234 \times 100 = 72.34$$

The difference between the net box-office income (£72.34) and the gross box-office income (£85) is the amount of VAT.

$$85 - 72.34 = 12.66$$

In order to check your arithmetic multiply the net box-office income (£72.34) by 17.5% and add this on to give you the gross box-office income.

$$72.34 \times 17.5\% = 12.66 + 72.34 = 85$$

TASKS

Calculate the potential box-office income for a show at your college in the following circumstances.

1 The show sells out completely and all seats are sold at the full price.

2 The show sells out completely with half the seats sold at full price and half sold at the concessionary price.

3 Using the figures from calculation **2**, work out the percentage due to the company, and the percentage due to the venue, if the agreement was for a 70:30 split of the gross box-office income.

CALCULATING INCOME FROM MERCHANDISE

The income you can raise from merchandise sold will depend on the audience numbers you attract. When you have estimated your income from fees, or from the box-office, you can use the predicted audience numbers to help you decide on realistic income figures from sales of programmes and any other merchandising where appropriate. As a rule of thumb, work

on selling one programme for every three members of the audience. If you expect a high proportion of concessionary ticket sales, work on one programme for every four audience members. You should try to make the programme self-financing if possible. You can do this by selling advertising space to cover the printing costs, and then any income from sales will help you to reach your earned income target figure. Approach companies from which you purchase or hire equipment, to see if they will buy an advertisement in the programme. Tell them how many performances you will be giving and the venues you will be playing, as

well as the number of programmes you will be printing. Some venues will take a small percentage (usually around 10%) for their staff selling your programmes and/or merchandise. You will need to account for this in your estimated income, unless you ensure that someone from your company takes on this role instead.

If you plan to sell T-shirts or mugs, it is better to use the company name and logo rather than the name of a particular show. That way you can continue to sell them during your next project as they will not be out of date.

OTHER SOURCES OF EARNED INCOME

You may be able to put in some of your own money to get the project off the ground. This should be included in the budgeted income and will count towards the earned income part

of your statistics. Raising money from business sponsorship and charitable donations is covered in detail in Chapter 6, and this too counts towards your earned income.

GRANT AID FROM PUBLIC SUBSIDY

Your work may be eligible for funding from a local authority, a Regional Arts Board, or the Arts Council, whose role it is to support arts projects with public money raised through the tax system. This kind of fund-raising is also

covered in Chapter 6. When you have investigated possible funds from grant aid you can add them into your budget. You should budget to raise about a third of the cost of your project from grant aid in most cases.

Balancing the budget

When you have made your first draft budget, look at the total expenditure and the total income. You will probably find that the two figures are different and you should try to make

them the same (or if possible the income should be a higher figure). You should by now have done a great deal of research in order to calculate the costs, likely sources of income

and the amounts usually given by funding bodies. At this point you should try different ways of making the figures balance by increasing the income:

- Could you sell more performances?
- Could you raise the price of tickets for performances or workshops?
- Could you reduce the expenditure?
- Could you reduce the cost of your publicity?
- Could you tour in a smaller van which would be cheaper to hire and run?
- Could you reduce the number of people involved?

You may have to adjust both your projected income and expenditure in order to make the budget balance. If the income total is higher than the expenditure total you may want to look at the ticket prices, to see if they could be reduced slightly, or the costs, to see if you can afford to spend more on someone or something else. If the income is only slightly higher than the expenditure you may want to hang on to this as a contribution towards the next project you organise. In the field of the subsidised arts, any funding body you approach will look carefully at your budget. If the figures indicate that you will have a large surplus, they will almost certainly reduce the level of grant aid offered for the project. For this reason it is better to aim for a budget that balances, where the income total and the expenditure total are the same.

Because you will be working on the budget of a project some time ahead, calculating income and expenditure is a tricky business and is often based on the best estimates available to you at the time. For this reason it is better to under-estimate on the income figures you put into the budget, as the equivalent of including a contingency figure in the expenditure.

If you cannot make the figures balance then you will have to shelve the project until a later date or go back to the drawing board and re-think. If you do have to make radical alterations then you must be sure that the project is still one you wish to produce. Try not to get to the point where you are working on something you do not believe in and want to do, just because it is affordable, or the kind of work the funding bodies wish to support.

Managing the budget

Let us assume that you get to the stage of having a project you are committed to producing; you have a workable budget to make it happen; you have convinced the funding bodies and business sponsors to provide the required finances; and you have the bookings for the project. Now you will need to establish some systems for controlling and monitoring the budget throughout the project. There are several reasons for this:

- At the end of a project receiving public funds, you will be required to account for the money you have received.
- Proper records will ensure that no-one can be accused of dishonesty.
- It will provide valuable information which will help you to plan future projects and to learn from your mistakes.

Firstly, decide who will have overall responsibility for financial matters. Even though it will probably be the case that different people involved in the project will have to spend money

on different things, in order to avoid over-spending somebody must have the ultimate responsibility for saying 'no'. Having one person in charge of the finances means that accurate checks can be made at any time during the project. Everyone who spends money on the project must keep their own records in an agreed form, and should report back to the person in overall charge of the budget on a regular basis. It is important that you stick to the amounts you have budgeted to make sure that the expenditure stays on target. Decide who will be responsible for which parts of the budget and stick to the decisions made. You may find that costs in one area are higher than you

first thought, in which case you must be able to reduce spending in another area to keep on target. The person in overall control of spending should monitor each budget heading regularly to make sure that there are no nasty surprises around the corner. You must have a system for keeping an accurate record of the money which is being spent. It is a good idea to have regular meetings about the project, in order to keep track of progress, and to make sure that deadlines are met and that budgets are under control. Keep notes at these meetings so that everyone remembers to do what they said that they would do. This is covered in more detail in Chapter 8.

BANK AND BUILDING SOCIETY ACCOUNTS

You will almost certainly need to open a bank or building society account for your company or project in order to keep track of the funds, to keep them separate from anyone's personal money, and to ensure that you can produce the accounts which will almost certainly be required by funding bodies. Shop around for the right kind of account, bearing in mind the sort of service you will need, and the need to be able to get to the bank to withdraw or deposit money. Explain what you require and then compare different branches to see which will be the best for you. Take advice about the number of signatures required to withdraw money/sign cheques and remember to ask about the scale of charges which will be applied to your account. Any kind of cheque account will mean that you can arrange to receive regular statements which you will need to check against your cash book and against the budget for the project.

Decide who will be allowed to order goods and arrange for services, like the hire of a van, and ensure that there is an agreed system for keep-

ing a record of what arrangements have been made. It is very important for the person in charge of the budget to know that only certain people are committing the company to spending money, in order to avoid going over budget. In an established company you should organise a system of official order forms. These can be completed and signed by an authorised person and can be taken to a supplier with whom you have an account. The supplier will provide the goods on the strength of the official order and they will send an invoice which can be paid by a company cheque. If your project is on a small scale, or for a limited period of time, you may not be able to organise this, but in any case you should keep a written record of what spending has been committed and when the bills need to be paid. When invoices are received they can be checked against the initial record to confirm that the right goods have been supplied, by the agreed date and at the agreed price.

Buy a large cash book with ruled columns and write into it the budget headings you used

when you originally drew up the budgets for your project: see Figures 5.2 and 5.3. The cheque stubs, bank statements, and cash book will allow you to cross-check these with the invoices when you come to the end of the project and compare the initial budget with the final actual spending. This cash analysis book should be used to record all spending, both via the cheque book and through the petty cash system, as well as the income from box office, fees and grants. These can be purchased from an office stationers and the information held will enable you to keep accurate records throughout the life of the project.

Figure 5.7 *(a) Expenditure*

DATE	DETAILS	REF NO	WAGES		TRANSPORT		TELEPHONE		STAMPS		EQUIPMENT HIRE		MISC				TOTAL	
1–9–95	STAMPS	PC 01							8	00							8	00
4–9–95	PHONE CARD	PC 02					14	00									14	00
8–9–95	WAGES WEEK 1	CHQ 01	50	00													50	00
15–9–95	WAGES WEEK 2	CHQ 02	50	00													50	00
22–9–95	WAGES WEEK 3	CHQ 03	50	00													50	00
29–9–95	WAGES WEEK 4	CHQ 04	50	00													50	00
3–10–95	VIDEO HIRE	CHQ 05									25	00					25	00
3–10–95	VIDEO TAPES	PC 03											6	00			6	00
3–10–95	MILEAGE WEEKS 1–4	CHQ 06			20	00											20	00
6–10–95	WAGES WEEK 5	CHQ 07	50	00													50	00
10–10–95	MILEAGE WEEK 5	CHQ 08			5	00											5	00
13–10–95	WAGES WEEK 6	CHQ 09	50	00													50	00
13–10–95	MILEAGE WEEK 6	CHQ 10			5	00											5	00
20–10–95	WAGES WEEK 7	CHQ 11	50	00													50	00
20–10–95	MILEAGE WEEK 7	CHQ 12			5	00											5	00
23–10–95	FILMS	PC 04											3	00			3	00
27–10–95	WAGES WEEK 8	CHQ 13	50	00													50	00
27–10–95	MILEAGE WEEK 8	CHQ 14			5	00											5	00
30–10–95	FILM DEVELOPING	PC 05											12	00			12	00
30–10–95	VIDEO HIRE	CHQ 15									25	00					25	00
			400	00	40	00	14	00	8	00	50	00	21	00			530	00
	REFERENCE NO.'S																	
PC =	PETTY CASH VOUCHER NUMBER		CHQ	=	CHEQUE NUMBERS													

Figure 5.7 (b) Income

DATE	DETAILS	REF NO		GRANTS		DONATIONS		FEES		WORKSHOP PARTICIPANTS' FEES						TOTAL	
1–9–95	CITY COUNCIL	01		200	00											200	00
3–9–95	THE BLOGGINS TRUST	02				100	00									100	00
6–9–95	WORKSHOP DAY 1	03								10	00					10	00
13–9–95	WORKSHOP DAY 2	04								10	00					10	00
20–9–95	WORKSHOP DAY 3	05								9	50					9	50
27–9–95	WORKSHOP DAY 4	06								8	00					8	00
4–10–95	WORKSHOP DAY 5	07								9	00					9	00
11–10–95	WORKSHOP DAY 6	08								10	00					10	00
18–10–95	WORKSHOP DAY 7	09								10	00					10	00
25–10–95	WORKSHOP DAY 8	10								8	50					8	50
30–10–95	PLYMTOWN DAY CENTRE	11						150	00							150	00
				200	00	100	00	150	00	75	00					525	00

PETTY CASH

Wherever possible you should try to avoid spending cash. There are several reasons: it is easier to make mistakes and/or lose track of cash purchases, and it is difficult to keep money safe. Record keeping is more efficient if there is a system of paying by cheque and invoice.

However, no matter what form your project takes, there will be certain items which either can only be bought using cash or which are significantly cheaper to buy in this way. Examples would be buying fabric for costumes from a local market or buying a supply of books for set-dressing from a charity shop or a car boot sale. This kind of cash spending is called petty

cash and should, as far as possible, be reserved for comparatively small amounts of money.

Decide how much money is reasonable to start with as a float. In making this decision you will have to consider how often you will have the time to balance the petty cash and get more money from the bank, against the amount you feel it is prudent to have in the office in cash. Depending on the size of the project, you may have a float of between fifty and several hundred pounds. You must have a secure system for keeping the money and restricting access to it. Always keep the petty cash in a locked cash box for which only the person responsible has the key. Keep the box somewhere safe in a

locked desk, filing cabinet or safe if available. Keep a record of how much you have put into the box as a float to begin with; at regular intervals, perhaps a week or a month, check that you have receipts and cash which balance to the amount of the original float. When someone needs cash to go shopping, make out a slip stating name, amount issued, and budget heading, and ask them to sign and date it. When they return they will hand over the receipt(s), and any change, adding up to the same amount as the float they received, and the slip can be destroyed. Remember to note on the receipt the goods purchased and for which budget heading. Mark each receipt with a number and write this number alongside the entries in the petty cash book and in the main cash book (see specimen pages in Figure 5.7 and 5.8). This system ensures that at any time you can 'balance the petty cash' by showing how much cash is in the tin, how much has been issued as 'floats' for spending, and how much has been spent and accounted for by receipts. The total of cash, floats, and receipts, should equal the amount originally transferred to the tin. When you have spent all of the original float, and have receipts for this total amount, you should balance the petty cash book and replenish the original float. Be sure to keep the receipts, clearly marked, in a safe place, such as a ring binder file or envelopes for each week or appropriate period of the project.

Buy a cash analysis book with various columns, in which to record petty cash spending, and enter the details from all the receipts into this on a regular basis. This will allow for someone to check the accounts when necessary and will enable you to see how much money was spent, and on what, at any stage during a project. The money spent in this way will also have to be recorded in the main cash book (see above) which will show all spending involved, whether in cash or by cheque.

Figure 5.8 *A specimen petty cash book page*

Date	Item	Ref. No.	Postage	Phone	Props	Travel	Misc.	VAT	Total
1/9/95	Stamps	01	7.50						7.50
4/9/95	Phone card	02		11.96				2.04	14.00
3/10/95	Video tapes	03					5.53	0.97	6.50
27/10/95	Films	04					2.55	0.45	3.00
30/10/95	Film develop	05					10.21	1.79	12.00
			7.50	11.96			18.29	5.25	43.00

Figure 5.8 illustrates a simple petty cash book system. By adding up the amount in each column it is possible to see how much has been spent to date under each budget heading. The sum of the budget heading columns added together across the page should total the same amount as the sum of the total column down the page.

Although you will probably not be eligible to register for VAT it is a good idea to ask for VAT receipts and to keep a record. If you become a company and your income reaches a specified level, in due course you will be able to become VAT registered. From then on you can claim back the amount of VAT you have paid out. The Customs and Excise department will advise you on the necessary steps to take. The VAT calculations in the specimen petty cash book shown here are made in the same way as those in Figure 5.6 above.

The headings in both your petty cash book and your main cash book should be taken from the initial budget which you prepared before the start of the project, so that you can compare the actual spending with the forecast both during the project, and at the end.

After the project

It is extremely unlikely that the final actual spending on the project will match exactly the figures you originally budgeted and submitted to funding bodies. This is not particularly significant if you did the project you were given funding to do, and you managed to make alterations during the course of the project, so that the overall total expenditure and income came to same totals; or if you were so very successful that the income exceeded the expenditure. For example you may have spent less than you first thought on costumes because you were able to borrow some of them rather than buy them. You might have spent more than you originally budgeted on publicity but in doing so have increased your income from ticket sales. By careful monitoring of the project you should not have any nasty shocks when you come to do the final figures, but you must be prepared to amend or change things at an early stage, if you realise that you are in danger of over-spending. You must not rely on a funder to make up the difference, if you have a deficit at the end of a project: they will not.

When the project is complete you will need to produce the final budget. Go back to your initial agreed budget and draw in another column called ACTUAL, then fill in the new form so that you can show where the actual spending differed from the original predictions. In some cases you will have spend more than you planned, but this should be balanced out by the areas where you managed to spend less than you planned. If you have been properly monitoring your spending during the project you will know where and why these changes happened and will be able to explain the differences to both the company/group and the funding bodies.

Figure 5.9 *The expenditure budget for the completed project*

	Budget £	Actual £	Difference £
Wage			
2 dancers @ £25 per day × 8 weeks	400	400	
Transport			
£5 (mileage) × 8 days	40	40	
Administration			
Telephone calls	10	14	
Stationery/stamps	10	8	+2
Equipment Hire			
Hire of video camera 2 days @ £25 per day	50	50	
Miscellaneous			
3 × video tapes @ £3 each	9	6	
Developing/printing films	6	15	+6
Total Expenditure	**525**	**533**	**+8**

Figure 5.10 *The income budget for the completed project*

	Budget £	Actual £	Difference £
Fees			
Fee from day centre	150	150	
Contributions from participants:			
50p per day × 20 people × 8 days	80	75	−5
Charitable Donation			
Donation from local company	100	100	
Grant			
Grant from city council	200	200	
Total Income	**530**	**525**	**−5**

The original budget on pages 67 and 68 did not balance because the expenditure was £20 higher than the income. However, there was a contingency figure of £25 included in the expenditure. The final actual budget shows that the expenditure was £8 higher than anticipated and the income figure was £5 lower than anticipated. Added to this is the £20 difference in the original budget. This means that the project was overspent by £33, but using the

contingency of £25, the final figure makes a deficit of £8.

Original budget difference	£20
PLUS higher expenditure total	£ 8
PLUS lower income total	£ 5
TOTAL	£33
LESS contingency budget	£25
TOTAL DEFICIT	£ 8

Although the project did not manage to break even it was only overspent by £8 which is un-likely to cause major problems and would not worry the funding body unduly. The main reasons were the increased costs of buying and developing films to record the project and a reduced income total when attendances fell slightly in the middle weeks of the projects. The conclusion to be drawn is that relying on full attendance by all 20 participants over an eight-week period is optimistic. With hindsight it may have been wiser to try to negotiate a higher fee from the venue rather than relying on the contingency budget to cover any losses.

chapter six

FUND-RAISING

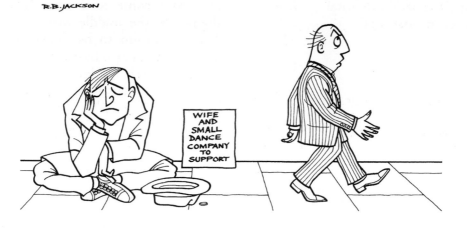

As you have seen from Chapters 1 and 2, a significant proportion of arts activities and events could not be entirely self-financing unless the ticket prices were at a prohibitively high level. There are also many projects which are designed for a very small target group, for example, a week-long residency by a dance company in a special school, and which could not be effectively run on commercial lines. There are various organisations who can and do provide money towards the presentation of arts events, and to whom you may be able to apply for help. These organisations fall into three groups:

- The public funding bodies described in detail in Chapter 2, namely the Arts Councils of England, Scotland, Wales and Northern Ireland, the Regional Arts Boards, and the local authorities at county, city, town and district level.
- Charitable trusts who offer grants to individuals and companies working in the arts as part of their aims and objectives.
- Companies, businesses or individuals who pro-

vide funds for arts events either as a form of business sponsorship or as charitable donations.

Traditionally, by far the largest share of funding for the arts has been through the public funding bodies, but it has been the policy of national government for many years to encourage arts promoters and providers to raise a significant proportion of their costs through business sponsorship, and thereby cut the cost of the public expenditure. The first part of this chapter looks at the overall priorities of each of the groups and the different methods they use to distribute their funds; the second part offers you step-by-step guidance to making funding applications.

Public sector arts funders

THE ARTS COUNCILS OF ENGLAND, WALES, SCOTLAND AND NORTHERN IRELAND

The Arts Councils primarily fund the large national companies of England, Wales and Scotland, such as the Royal Shakespeare Company, the Welsh National Opera and the Scottish Ballet. They also fund smaller companies, and even individual artists, to produce work and tour nationally, but there must always be a *national* emphasis. Each Council has a portfolio of clients whom it funds regularly. However each client has to apply annually for funding because the Councils do not know from year to year exactly what their budgets will be. The government changes the size of its grant to the Councils from year to year which means that there can be no definite, legally binding commitment for ongoing funding. Even the largest of clients such as the Royal Opera House only has annual funding. It knows the Arts Council of England will continue its funding over the next year, but it does not know how much it will receive until the month of January before the April which starts the next financial year. This creates great uncertainty and insecurity, especially in years like 1995, when the Chancellor of the Exchequer announced a cut in November which resulted in the Arts Council losing £5 million. All the Councils' clients know that they will then only have four months to budget for a major cut in their finances.

In addition to their portfolios of national clients, the Arts Councils operate a number of different schemes and projects which they advertise. In other words, they invite artists, arts workers and organisations to apply for money for a specific purpose. The purpose would re-flect an area of work which the Council particularly wanted to develop at that time. We have seen in Chapter 2 that the Arts Council of England (ACE) has set up a committee to encourage the participation of the non able-bodied in the arts. To achieve this, ACE might set up a scheme whereby a company works in colleges, for example, and researches the opportunities for the physically disabled to study dance. Having decided on this initiative, ACE would then advertise its scheme; interested artists with appropriate experience would then apply for the money. The schemes change every year, so it would not be worthwhile describing them here. However, the Arts Councils keep lists and publicity materials for all their schemes and will provide up-to-date information on request.

It is worth bearing in mind that the Arts Councils will only fund work with the following characteristics:

- the work is of national interest and is not duplicating the work of other Arts Council clients
- the work is of the highest artistic quality and is innovative in some way – pushing forward the boundaries of the art form, or having a new approach to audience development or education
- previous work by artists, company or organisation has been seen by the Council's art-form officers and advisers/assessors
- the work is developing an area which has been identified by the Council as an urgent priority for that time.

If your work meets these criteria, it is worth sending away for the detailed guidance notes and application forms which the Councils pro-vide for each of their schemes. These will give more detailed information about the Council's criteria.

TASKS

1 Nominate five representatives from your class to write to your Arts Council for an infor-mation pack and application forms for their projects and schemes.

2 In a group, select one of the schemes to study in detail. List the criteria and decide what type of project would be appropriate for that scheme. Present your findings to the rest of the class and write up the project for your file.

REGIONAL ARTS BOARDS

The Regional Arts Boards (RABs) also have a portfolio of clients working in their respective regions whom they fund on a regular basis, but with the same degree of uncertainty as the Arts Councils, since they too are dependent on the government for their funding. The RABs fund a range of clients to do different types of ac-tivity, including:

- regional theatres
- arts centres
- performing companies to make work
- performing companies to tour work
- individual artists to make work
- individual artists to tour work
- artists and companies to work in education
- artists and companies to work in the com-munity
- organisations to have residencies, festivals and performances
- artists, arts workers and companies to have training
- artists, arts workers and companies to give training
- community arts workers to undertake pro-jects of different kinds.

These break down into two groups: those clients who receive annual funding which cov-ers their running costs and which gives a de-gree of stability from year to year, and those who operate on a project basis. Like the Arts Councils, the RABs also create projects and schemes as a way of assisting the process of their developmental objectives. An objective may be to create new work or develop edu-cational work; one such scheme devised by West Midlands Arts was called *Breakthrough*. It was aimed at creating an opportunity for young musicians working in the region to cre-ate new compositions. The RABs keep packs containing information about their projects and schemes which they will send out on re-quest. These contain essential information and (usually) very thorough guidance so that you are able to tell if your project matches up to your RAB's requirements.

Work which is funded by the Regional Arts Boards usually has the following character-istics:

- it is of high artistic quality

- it is of regional or local significance
- it is innovative either in its development of the art form or in bringing the arts to new audiences
- it does not duplicate the work of other artists

- it is in an area which is seriously under-represented in the region
- it is in an area which the RAB has earmarked for development
- it meets the criteria laid down by the RAB for that particular scheme.

TASKS

1 Nominate five representatives from your class to write to your Regional Arts Board for an information pack and application forms for their projects and schemes.

2 In groups devise an imaginary project which meets the criteria for one of the schemes. Present your findings to the rest of your class and write up the project for your file.

LOCAL AUTHORITIES

Local authorities tend to work in partnership with the local RAB on funding a portfolio of clients jointly; for example, all regional theatres are funded in this way. There might be different arrangements for companies. For example, the local authority might provide the premises, the RAB might provide the revenue funding.

To date it has not been obligatory for local authorities to provide funding for the arts, although many of them choose to do so. You will need to do some research in order to find out if the council which covers your area has an arts budget. Look in the local telephone directory or ask at your local library to see which is the appropriate local authority to approach. This may be a district council, a city council or a county council. Depending on the situation in your local area, you may need to contact more than one local authority; for example, you may live in an area where a district council provides some services and a county council provides the others. Either, or indeed both, may have a department which covers the arts. The appropriate department will probably be

called Recreation and Arts, or Leisure Services, or Arts, Libraries and Museums, or something similar. Again by looking in the local telephone directory for a list of council departments you should be able to find out which title your authority uses. Many local authorities employ one or more Arts Development Officers who will be able to help and advise you. Call in to the offices or telephone them; they should be able to put you in touch with someone who can help, and if necessary, send you the application forms and information sheets about their funding policy.

Some local authorities operate funding systems similar to the RABs. They have a budget, (usually small) which local artists, companies, arts workers, schools, colleges, and community centres, can apply to for projects. Such authorities usually have an arts officer to manage this process, whom you can approach by letter to find out what schemes are available. If there is not an arts officer, the process will be more difficult. You may have to work through the different council departments. If your project

is aimed at work in schools or youth clubs you may be eligible for help via the education department of the council. You may be able to attract funding from the social services department if you want to work in residential homes for elderly people, or at day centres run by the council. But there is no easy way to find this out!

In general, local authorities will have slightly different priorities from the Arts Councils and RABs. Urban councils might be looking to the arts to provide opportunities for young or unemployed people to spend their time positively and creatively; they might want to set up activities which will bring people into the city centre at night; or they might want to provide activities which celebrate a particular ethnic community. A rural council might be concerned that, because of poor transport in the evenings, the people who live in outlying villages have no access to performances or arts workshops. In other words, the council's priorities will reflect the life, interests and expectations of the people living in the locality. It is therefore impossible to generalise about the characteristics of work funded by local authorities. Each one will have to be researched individually.

TASKS

1 Read carefully through the information you received from your local authority when you completed the tasks in Chapter 2.

2 In groups, compile a list of projects which you think the local authority might fund. Discuss this with the rest of the class.

Charitable trusts and foundations

Trusts and foundations are organisations which have been set up by a benefactor or a company for altruistic reasons. The trust manages a portfolio of investments and uses the interest from these to fund worthy causes. Two well known examples of these are the Gulbenkian Foundation and the Prince's Trust. The best source of information about trusts and foundations is *The Directory of Grant Making Trusts*, which should be available in libraries. It lists trusts together with information about the kind of projects they support, their annual budget, and the size of grant they give. It also tells you how and when to apply. The trusts are listed in categories such as education, the arts, welfare, which enables you to find and apply to the appropriate ones and avoid wasting time in applying to trusts which are not interested in your kind of work. Even so, there are thousands of trusts listed and it is time-consuming to work through all the relevant categories.

Trusts can also be found through local authorities who manage local funds for local projects. This might be helpful if you are intending to work within a small geographic area, as there are often historic funds for work within a particular town or county.

Many well-established companies like Marks & Spencer and J Sainsbury also have budgets for charitable giving which are usually organised on a regional basis. Contact the local branch in your town for further help and information about what kind of work they support, and how and when to apply. Do remember, however, that the larger the company the greater the competition will be for their funds. You may get ideas about businesses which have these charitable aims by looking at publicity and by reading magazines, journals and newspapers. Local papers may have a picture and a story about a cheque being handed over to a group to support a particular project.

Business sponsorship

As noted at the beginning of the chapter, the government is particularly keen to see arts organisations increase their share of business sponsorship. In order to encourage this, they set up the Association for Business Sponsorship of the Arts (ABSA). ABSA is a national independent organisation whose role is to promote and encourage partnerships between the private sector and the arts. It administers the 'Pairing Scheme' (formerly known as the BSIS scheme) on behalf of the Department of National Heritage. Through this scheme, arts organisations can receive additional funding if they are successful in raising business sponsorship. If the sponsor is a first-time sponsor, the arts organisation matches its sponsorship money on a pound-for-pound basis. That is, for every pound received in sponsorship, you will receive the same amount through the pairing scheme. For a second time sponsor the ratio is 1:2 (for every £2 raised in sponsorship you will receive £1 through the pairing scheme). For an established sponsor it is 1:4 (for every £4 raised in sponsorship you will receive £1 through the pairing scheme). As well as helping the arts, the sponsoring company will be invited to a ministerial reception to receive a commemorative certificate, and they will receive publicity through the Department of National Heritage. ABSA do not match up arts organisations and potential sponsors, but they do advise both groups. Nevertheless you still have to find your sponsor first and that is not easy.

Unlike charitable trusts, companies or businesses offering sponsorship to arts activities will be interested in what the sponsorship will do for them, as well as how it will help your project. Most of the large national and multinational companies receive literally thousands of requests for help every year and it is extremely difficult for small locally based projects to compete against the bigger companies, who themselves have a national remit for their work and staff whose job it is to raise sponsorship for their company. It is vital, therefore, that you spend plenty of time on the research stages of raising sponsorship. A useful reference book to help you with this task is the *WH Smith/ABSA Sponsorship Manual* which should be available in libraries. A business may help an arts project with money or by giving, lending or selling equipment cheaply to them, for a variety of reasons:

- they may believe that your target audience is the same as their target market for a particular product
- they may be about to launch a new product or to test the market for it

- they may benefit from good publicity by helping a project in an area where they have a factory or office and where their employees live
- they may see your performances as an opportunity to entertain their clients or to reward their staff with free tickets

- they may see it as an opportunity to put something back into the community to improve the quality of life for everyone in the locality
- there may be a similarity between the name of the company, or one of its products, and the name of your event or company.

> ## TASK
>
> Read over the lists you have made in your file of the projects which might receive funding from public funding bodies. In groups, see if you can think of any businesses which might be approached for sponsorship. Discuss this with your class.

Applying for funding

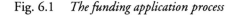

APPLYING FOR PUBLIC FUNDING

Applying for funding from the Arts Councils, the Regional Arts Boards or local authorities with arts departments tends to follow the same process. Figure 6.1 shows the process.

Fig. 6.1 *The funding application process*

RESEARCHING THE FUNDERS

↓

PLANNING THE PROJECT

↓

COMMUNICATING WITH FUNDERS

↓

ADJUSTING THE PLANNING

↓

WRITING THE APPLICATION

Research

It is vital that anyone who wishes to apply for funds to help in the presentation of an arts event researches thoroughly into the possible sources of funding. Whether the funding body works on a national, regional, or local level, it is a part of their job to publicise their schemes for funding arts projects. They have to make sure that potential applicants for funds are able to find out if they are eligible and also that they know how to apply for funds.

The first step is to send away (by phone or letter) for guidance notes about their various schemes deadlines for submitting applications and standard application forms. Spend plenty of time studying it before you make your application. Remember that these are organisations whose job is to help artists and groups to produce high quality performances and arts events. The guidelines are meant to help you to decide if you are eligible and if you are, to help you to complete the necessary paperwork; they are not aimed to to put you off.

Any organisation which receives and/or spends public money will have to account for the way it spends this money. In the case of the Arts Councils and the Regional Arts Boards, this is done by publishing an annual report. This document will tell you about their total income and expenditure and about which groups, artists and companies they have funded in the past. By reading such a report you will get an idea of the number and size of grants which were given, and who received them. You can also find out how much they received from any local authorities in your area and how they spent the money in your region. These annual reports relate to financial years, which in most cases run from 1 April until 31 March, and they are usually published in the following September or October. Statistics relating to spending between 1 April 1995 and 31 March 1996, (the financial year 1995/6) will be available in the autumn of 1996. As well as looking at the total income and expenditure figures, there will be spending breakdowns to show how much money was spent on each different art-form, and under each of the different schemes which the organisation funds. For an RAB there will also be statistics about how much each local council gave and how much was spent in each county or district within the RAB area. These annual reports can be consulted at the headquarters of the organisation and may also be available in your local library. *The Regional Arts Funding Handbook* should be available in libraries. This lists all the RABs, with details of which area of the country they cover, and details of all the funding schemes. It also contains useful information about the local authorities in each RAB region and gives the names of their arts officers, and details of their funding priorities.

It is especially important to research local authorities thoroughly. Each one has different priorities and they are strongly influenced by the political composition of the council. Find out about the political composition of the local authorities in your area. Have there been local elections in the last year? If so has the political balance of power changed? Different political parties will have different attitudes towards funding the arts, and a recent change in the balance of power may have an effect on the future arts funding policy. A trip to your local library should give you this information.

When you have the relevant information, read it thoroughly to be sure that you fulfil all the criteria set by the funders. None of the public bodies which support the arts has enough money to support everyone who applies, so they almost always decide on their priority groups and schemes. These priorities may change annually, or at two to three year intervals, so it is vital that you get the most up-to-date information from them before deciding whether or not to apply for a grant. If you do not meet the criteria for funding, it is a waste

of time and effort to put in an application form. You should look to other sources of funding, or at any other projects which your group have been discussing, which may meet the guidelines of the funding, bodies. Before you complete the forms, check that you can meet the deadlines for submitting your application and for completing the project. You will usually need to apply several months in advance of running the project, and in some cases nearly a year ahead.

Planning the project/event

Before you proceed with the funding application, it is essential that you have a very clear idea of how the project or event will take place. You need to know:

- what you are trying to achieve – your aims and objectives
- where the project or event will take place – your venues
- who will take part in your project – your personnel
- how much your project will cost and how much income you will make – your budget.

The last two, personnel and budgeting, are covered in detail in Chapter 5, so this section will focus on aims and objectives, and venues.

You will need to tell the funders your aims and objectives and it is important to be clear about the difference between the two. Broadly speaking your aims are the more general statements about the project and the objectives will be the more specific steps which you intend to take in order to achieve your aims.

Aims and objectives

An example of an aim might be:

'To increase awareness of contemporary dance by users of local sports centres.'

The objectives which take you towards that aim could include:

'The provision of a series of practical workshop sessions led by dancers for participants in sporting activities at the local sports centre.'

'The creation and performances of a new dance piece to be performed at the sports centre.'

Another example of an aim might be:

'To encourage residents of elderly persons' homes to take part in music making.'

The objectives could include:

'A one-day workshop in an elderly persons' home in making musical instruments from everyday objects, led by a composer.'

'A second workshop in composing music using home-made instruments.'

You may also be asked about the aims and objectives or the policy statement of your group or company. These may be difficult questions to answer if your group is newly formed and this is your first project, but you should have some statements about why you have chosen to work together and what your long-term strategies will be.

Your venues

Funding bodies are always more interested in projects which have already built a relationship with the venues in their region. They will not be interested in funding you to make a dance, a play or a piece of music if it will never be seen or heard by an audience. During the planning stage you will need to contact potential venues and try to interest them in your work.

Communicating with funders

It is a good idea to make contact with the funding body before you send in your appli-

cation for funding. Do not be afraid to telephone and ask to speak to a member of staff in the appropriate department. Explain who you are, and what you hope to do, and ask to meet up and discuss the project if possible. By doing this you should be able to confirm your own eligibility for funding and to find out if there are other groups in the area doing similar work. You may also find out if there are other possible sources of funding for your work. It may be the case that an RAB can offer funding from a different scheme to the one you originally looked at, or they may be able to fund you in conjunction with another department if, for example, your project integrates two or more art-forms working in a collaborative project.

Adjusting the planning

After your meeting with the funding body you may need to make adjustments to your project/event. These could be financial. They might have suggested an additional source of funding, or they might say that your application is interesting but too big. Alternatively, the funding body might have made suggestions about target audience or venues which cause you to rethink certain artistic or presentational aspects of your work. You should always try to incorporate suggestions made by funding bodies.

Writing the application

Whether you are applying to a local council, a Regional Arts Board or the Arts Councils, there are some general rules which you should follow.

- Always meet the deadline for submitting your application. If this is not possible, and with their agreement in advance, send in as much as you can by the deadline, with the rest following later. However, only do this if you have let the funder know in advance and told them when the additional information will follow.

- Contact the funding body before you send in the form. It may well save you a lot of time and effort, and most funders will have some questions to ask you about your plans.
- Think the whole project through before you start to complete the application form. Make photocopies and complete these in draft form first.
- Be absolutely clear about the aims and objectives of your project. What are you trying to achieve and how are you going to achieve these aims?
- Know who your project will reach. You should have expressions of interest, if not firm bookings, from venues, participating organisations, or target groups.
- The funders are there to help. The questions they ask are to assist them in funding the right projects for their own community, not to make life difficult for applicants. Try not to give the same answers to different questions.
- Do not expect your aims to be identical to the funders' aims, but don't waste time and effort on applications if your project does not meet the criteria and guidelines.
- Prepare your budget carefully and accurately. Do not inflate the figures because you expect to receive less money than you have asked for. Double-check your figures before sending in your form.
- Assume that the person receiving your application will talk to other people. Regional Arts Board officers will talk to their opposite numbers in the local authorities throughout their area so do not be tempted to lie about expressions of interest by other funders and venues.
- Work hard to find additional sources of money. Funders do not like projects which are entirely dependent on them.
- Be both flexible and imaginative in planning your projects and making your applications.
- Be accurate. Double-check spelling, especially the names of people and places. Wherever possible, type or word-process

your work. It will make it easier to read, especially when photocopied.

There are some questions which most, if not all, funding bodies are likely to ask on their application forms, and particular attention should be given to the answers you give. All the information requested will be used to assess the viability of your project and its suitability for the target audience proposed. The funders will also be looking to see how it relates to their own stated aims and targets and if it fulfils a need which is not being met within the district or region.

You will also be asked about your *equal opportunities policy*. If you have a written policy statement, include this with your application. If you are a new company, and have yet to formulate a policy, give this some attention now. Most equal opportunities policies state that the company will not discriminate against people on the grounds of race, colour, creed, religion, gender, disability, or sexual orientation, either as employees or as participants, in their projects. They indicate how the company will work to make sure that they stick to these policies and how they will monitor them in order to keep them relevant to the work they are doing. Most funders will be pleased to help you find suitable 'model policies' to consult when devising your own policies.

You will certainly be asked about the ways in which you will evaluate your project both during and after its completion, and this is dealt with in detail in Chapter 9. Funders will see this as a way of helping you to grow and develop in your work and as a means of assessing the future viability of your company. It does not mean that you are not allowed to make mistakes but if you do you should be able to say why they happened, what you learned from them, and how you will avoid a similar thing happening in future.

The budget forms which you will be asked to complete will vary from one funder to another, but they will all expect to see a full account of your proposed income and expenditure, with the total income equal to the total expenditure. Accuracy is important. Check and double-check the arithmetic with a calculator before sending off the form.

TASK

Read through the list of potential projects you now have in your file. Select one which would appeal to the RAB or to the Arts Council. Photocopy the relevant application forms and fill them in. Submit them to your tutor for assessment. Keep them in your file.

APPLYING FOR TRUST FUNDING

Applying for funding from trusts takes as much research as applying for public funding but it is of a different kind. As noted earlier in this chapter, the principle source of information is the *Directory of Grant Making Trusts* which you can find in your library. In it you will find all the trusts listed under generic titles such as *Education, the Arts, Welfare*. There is no substitute for working through these lists to identify your own shortlist of relevant organisations.

In addition, when you go to see the work of other small companies and attend arts events,

buy and read the programme. Almost all organisations which give grant aid will expect to get a credit in the programme, and sometimes on the publicity. Make a careful note of these trusts and make enquiries to see if your project or group would be eligible to apply. Do not look only at trusts which support the arts. Think about the subject matter of your activity. Could you attract help from a trust which supports environmental projects, works in health education, or one which is aimed specifically at older people or those with special needs? The timescale for applications is very important and you should make enquiries to see how long it takes for a particular trust to process requests. Some of the smaller trusts may only meet a couple of times a year and so you will be wasting your time if your project will begin before the next meeting and you will be extremely unlikely to get funding for a project that is already underway.

You may be sent an application form, in which case the rules outlined above about reading the criteria and answering the questions apply. If you are asked for a letter of application, give this the same kind of careful thought and planning which you devoted to the applications to funders. There are almost always more applications than any trust can support, so make your case as clearly and concisely as possible. Make sure that you stress that the project you plan to do conforms to the criteria set by the trust, and explain exactly how any money you receive will be used in the project. Be direct about the size of grant you are requesting and make sure that this falls within the usual bands of grants given. If it is available, include publicity material, and it may be helpful to give a summary of previous work you have done. Include as much detail as you can but if there are aspects of the project which have not yet been decided, say so, or do not mention them. Always type or word-process your letters and, again, check for budget accuracy and spelling mistakes.

TASK

Read through the list of potential projects you now have in your file. Select one and read through the Directory of Grant Making Trusts to find a trust you could apply to. Write a letter of application and submit to your tutor for assessment. Keep the letter in your file.

APPLYING FOR BUSINESS SPONSORSHIP

This is the hardest of all and takes even more research than applying for public funding or trust grants. To find the companies and businesses in your area, ask the local chamber of commerce for a list of the biggest employers, and keep in mind the need to find an organisation that can gain some benefit from you. There will be an entry in the telephone book, or you could ask at your local library. Read the local newspapers to see which businesses are moving into your area, or which have had a recent success. Even a company which has been getting bad publicity, and which might wish to improve its image with the local media, could be a possible source of help, although one which is making employees redundant would not be a good target.

Ask your family and friends for the names of individuals who run their own businesses and who might be able to help. Be imaginative. One touring theatre company earned sponsorship for their local schools tour by approaching a local butcher who had just gained the contract to supply meat for school dinners in the county. A regional repertory theatre persuaded a hairdresser called Stags and Hens to support their production of Willy Russell's play, *Stags and Hens*.

Do not assume that asking for money is the only option. Small arts organisations have in the past been given or loaned cars, photocopiers, fax machines and telephones, as a form of sponsorship. Local printers have produced glossy publicity packs free of charge to be used to help an arts organisation gain sponsorship from other businesses. The company sends out high quality brochures, and the printers are able to advertise their services via a whole page advertisement in the brochure, while being seen to help an arts organisation.

If this is a second or third project by your company or group, ask the suppliers you have used in the past if they can help. Many small- to medium-sized local businesses will be run by people who are interested in the arts, and they may be surprised and flattered to be approached. Explain to them how you would use the money and what you would be able to offer in return. They may be delighted to find out that by sponsoring an arts event they could become eligible for an award through the Association for Business Sponsorship for the Arts, which operates several government schemes to promote and encourage partnerships between businesses and the arts (see page 87). Such an award through the pairing scheme would also increase the money your organisation receives.

Put yourselves in the place of the company you are going to approach. Ask yourself what they are trying to do for their business. Think about what you could offer which would help them to achieve their aims.

It is important that you have a clear understanding about both your organisation and the project you intend to undertake, before you approach a potential business sponsor. Any successful business will have a thorough knowledge of its product, its place in the market, and its customers. They will expect you to be able to demonstrate a similar understanding of your work and your target audience, and to be able to explain clearly how both groups would benefit from a business sponsorship agreement.

Approaching a potential business sponsor

Think carefully about which companies to approach. Banks and breweries will potentially be interested in work aimed at people in their late teens and early twenties. A holiday company, or an insurance company selling to older people, might consider supporting a reminiscence theatre tour aimed at senior citizens. A summer playscheme project might appeal to a toy manufacturer or a soft drinks supplier.

Ring up, or write, to find out who in each business deals with applications for sponsorship; wherever possible, find out the name of the person who deals with requests. You may be asked to contact head office or the regional headquarters directly. Find out if they have a standard application form, and if so, obtain a copy. They may ask for a letter or even invite you to come in to talk to them.

When you write or meet the company, make sure you have done enough research. Explain about your group or company and give brief details about your aims and policies. You will also need to give details about the project you will be organising, including dates and venues, if you know them. You should also be able to give details about your target audience for the activities you are planning.

If you are offered an interview, or a chat, write out the information as if you were sending it. Do not expect to turn up and 'play it by ear'. Without notes you will forget important aspects and will risk looking disorganised and sloppy in your approach. Do not take the whole group with you. One or two people, properly prepared, can present your case. Think about the impression you wish to create. This does not necessarily mean wearing a business suit, but look as if you have made an effort. As with any meeting or interview, do not arrive late. Listen to what is said and make notes. At the end of the meeting summarise what has been decided and what will happen next. You should state clearly what you are asking for, whether it is money, equipment, or services. Outline what you are offering the company in return for their help. This is likely to include some or all of the following:

- credit/company logo on posters, flyers, press releases
- an advertisement in the programme
- free tickets to performances
- a display of the company's publicity in the foyer at venues
- mention of their help in all press releases/ press interviews
- use of the company product in the performance
- opportunities to sell their products to participants/audiences
- eligibility for a Department of National Heritage award through the pairing scheme

run by ABSA (which doubles the money going to the arts organisation, and rewards the sponsoring company).

Tailor your requests to match the company you are approaching. Small local businesses will not be able to offer large sums of money. You may have more success asking several local suppliers you have used in the past for a modest sum, rather than asking a major national company for a large amount. While it is important to list the areas in which you may be able to offer help to the business, be careful not to oversell yourselves. Do not tell a major supermarket chain that by giving £500 to your project they will gain a significant marketing opportunity. Be prepared to be flexible and amend your ideas in order to reach a compromise if necessary.

You will also need to decide what the limits are both in terms of who to approach, and how far you are prepared to accommodate the demands of the sponsors. The largest employer in your area might be a tobacco company but you may feel that it would be unethical to take their money and advertise their products, especially if you intend to tour schools and youth clubs. A sponsor for a concert may ask for some choice in the selection of the programme, or a company supporting a new play might ask to see the script in advance. Your group will have to decide if you are willing to agree to such terms.

TASKS

1 Read through the list of potential projects you now have in your file and select one that you feel might have an angle that would appeal to a business sponsor. Write a letter of application to your imaginary business sponsor and submit it to your tutor for assessment.

2 In groups carry out a role play in which an arts organisation approaches a potential business sponsor.

Other sources of arts funding

NATIONAL LOTTERY FUNDING FOR THE ARTS

The arts are one of the five so-called 'good causes' which are receiving funds via the National Lottery. The distribution of this money is administered by the Arts Councils of England, Scotland, Wales and Northern Ireland. By applying to the relevant Arts Council lottery department, you will receive a large information pack which will help you to decide if you are eligible to apply for funds.

The money to be distributed is subject to certain conditions which are explained fully in the information pack. The main stated aim is to give the maximum benefit to the public by supporting projects which make an important and lasting difference to the quality of peoples' lives. The lottery funds must be used to support capital projects and are not available to cover the day-to-day running costs. This means that a request for help towards building or buying new premises, improving existing buildings, buying equipment or carrying out feasibility studies would be eligible for funding, but help towards paying the wages of staff, the running costs of your premises or vehicles, or the production costs of a new show, would not be eligible. You must also be able to show

that you have been successful in raising partnership funding from other sources for the project, and there is advice in the information pack about potential sources of such funds.

You may apply to the Arts Council of England, Scotland, Wales or Northern Ireland for lottery support for capital projects in their area if you are either a registered charity or an organisation which does not distribute profits. Most arts organisations will fall into these two categories. Other organisations who may apply are local authorities, schools, colleges or universities, amateur or voluntary groups and public sector agencies.

You will also be able to approach your local RAB for help and advice about applications for lottery funds. Many offer a range of support services which may include advice surgeries and one-day workshops and help in identifying potential sources of partnership funding. They will also be aware of other submissions from their region which might either conflict with or work in partnership with, those of your group. If your local authority has an arts officer s/he may also be able to offer similar help and advice on lottery applications.

THE FOUNDATION FOR SPORT AND THE ARTS

The Foundation for Sport and the Arts is an independent trust which distributes money provided from the companies who run the football pools. It does not seek to improve standards in either area, because that is the

business of the Sports Council and the Arts Councils. It states that 'it seeks, through the encouragement and funding of sport and the Arts at every level, to enhance the quality of life for the community generally'. They will send

you an application form and detailed notes about what arts projects they will consider supporting, but they emphasise their aim of promoting the maximum levels of participation and enjoyment, rather than the development of excellence. They will not consider applications for revenue funding i.e. day-to-day costs like rent, rates, wages, but will fund capital projects. They also expect arts organisations to raise a proportion of the required funds themselves.

Because their income relies on the funds provided from the football pools, which of course will vary from week to week, they do not have a timetable for receiving and processing applications, and will on occasion have to stop giving grants while the income of the foundation is replenished. They provide clear guidelines and a refreshingly simple application form. As with other funding bodies you will save yourself time, effort, and potential disappointment, if you read the guidance notes fully to check your eligibility for funding before you apply. They also state clearly that they are not able to meet with applicants or to give advice by telephone. Take note of such instructions.

CONCLUSION

While the organisations we have been looking at above deal with formal applications for arts funding, you may be able to raise smaller but significant sums of money from private individuals, including your regular audiences. As your group becomes established you should be building up a mailing list of people who have been to your performances on a regular basis. Some of them might be willing to make a financial contribution to the work of the company. This could be in the form of a small donation paid at the same time as the purchase of tickets. You could devise a booking form to be mailed out with information about a forthcoming show that includes a request for a small donation to help with the work of the company.

It might be helpful to think about forming a support group of 'Friends of.......', if you build up a significant following for your work. These groups can help to publicise your work and may in due course be able to undertake fund-raising activities on your behalf. You could charge a small annual fee for membership and in return offer discount on tickets, priority booking and talks with the performers before or after shows. The 'Friends' groups of larger companies are usually co-ordinated from outside the company's staff but maintain close links with it. Regular patrons may consider including a legacy in a will which could benefit the company. Put a paragraph in your programme which gives information about whom to contact to make such arrangements.

Some companies and arts organisations encourage individuals or companies to become patrons by making either a one-off, or an annual, donation towards the work. In return you could offer complimentary tickets for shows and a listing in the programme acknowledging this help.

However you decide to approach fund-raising for your work, you will need to be prepared to spend a significant amount of both time and energy, and in the early days you may end up with little or nothing to show for your efforts. If this happens do not give up. Try to find out why you were not successful by making polite enquiries to the people or organisations you approached. Take heed of the answers you receive and use the information to improve your future submissions. Some funders give priority to groups who are working on their second or

third project as this demonstrates that they have a certain level of organisational skills and that they have identified a market for their work. You may receive a small amount of funding, possibly less than you requested. If so, use this success to help you to gain access to others funds for future work by mentioning it in your submissions to other bodies.

When you are successful with an application, make sure that you read and understand any conditions attached to the offer of financial support. Any funder may require all or some of the following:

- written acknowledgement and acceptance of the terms of the offer
- credit on your publicity
- a full set of accounts after the completion of the project
- an evaluation report about the project from you and from others involved, e.g. venues, participants in a workshop.
- the opportunity to see the work in rehearsal and performance.

Make sure that you can fulfil such requests before you start spending the money.

Whether or not you receive help from the organisations you have approached, consider inviting them to come to your performances. This is particularly important with public sector funders, who may be able to offer support in the future, and who will be better able to judge your suitability for funding if they have seen your work. Never make disparaging comments about people or organisations who have turned down your requests for funding. The arts world is a small one and you may be talking to someone who has a close working relationship with the person you are being rude about. However soul-destroying the process of fund-raising may become, do not give up after the first attempts. Perseverance will pay off and the more practice you have at putting in applications, the better they are likely to be.

When you do succeed, make sure that you work at maintaining a good relationship with the people who are helping you. As well as meeting any conditions they apply to your grant, keep them informed about the progress of your work. Send them press cuttings which mention the support you have received. Invite them to first nights of your shows, whether or not they are supporting that particular production. A company may only be able to offer occasional help in business sponsorship but the managers will meet and talk to other business managers. A good experience working with your group may mean that they will recommend the idea of arts sponsorship to their colleagues in other firms and this could help you in the future. Arts officers working for local authorities will be in touch with their opposite numbers in the immediate vicinity and with the staff at the RAB for your region. If they are satisfied with the way in which your company or project is progressing then the word will spread.

The usual pattern for gaining funding is that a new or young company will receive a small amount of funding, probably only from one source. If the project meets its aims and objectives, and the people involved prove to be reliable and competent in running the project, then they may succeed in getting a larger grant for their subsequent work, and/or additional funds from another source. Over a period of time it is possible to become an established part of the arts provision in a particular area, and for the work and the company to grow in scale, from one which presents occasional projects, to a company with some full-time staff and an ongoing programme of work. At this stage you may be eligible for funding over a two or three year period. Eventually, as your organisation grows, you may be successful in becoming a revenue-funded client of one of the larger funding bodies.

The alternative may be that your company runs on a project funding basis for a number of

years and then folds or changes into a different kind of company. This could be because the key or founding personnel leave, or because of changing local demand for the kind of work you offer, or through changes in the local funding structures. Whatever happens, any company which completes two or more projects will have learnt to be flexible in adapting to change and imaginative in developing its creative ideas, and these skills will stand you in good stead for working in the arts.

BIBLIOGRAPHY

Regional Arts Funding Handbook, Angus Broadbent (ed), Boundtech Ltd, London, 1993.

Directory of Grant Making Trusts 1995, Anne Villemur (ed), Charities Aid Foundation, Tonbridge.

StARTing Out, Lynne Burnham, Debbie Kingsley, Coventry City Council and Coventry University; an information pack for artists and arts organisations.

ABSA/WH Smith Sponsorship Manual, ABSA/WH Smith.

A Guide to the National Lottery. A practical handbook for applicants, Howard Hurd Directory of Social Change, London, 1995.

The Arts Funding Guide, Anne-Marie Doulton, Directory of Social Change, London, 1991.

Writing Better Fundraising Applications, Michael Norton, Directory of Social Change, London, 1992.

How to Raise Funds for the Work You Want to do!, Susanne Burns, Contemporary Dance and Mime Foundation, Leicester, 1993.

chapter seven

MARKETING AND PUBLICITY

So far we have looked at the methods used in the performing arts of organising and managing performances. In this chapter we shall look at the ways in which performing arts groups attract audiences for their work. However satisfied you may ·be with the artistic value of your work it will be a wasted effort if you cannot attract an audience to see it. The methods and strategies you use in order to persuade people to come and see your work are included under the headings of:

- *marketing*
- *publicity.*

It is vital that these important aspects of promoting arts activities are not seen as separate from the artistic policy of your group or company, or as something that happens after the creation of the work. In the first instance it is necessary to understand the differences between the development of a marketing strategy, and defining the specific marketing plan you will follow in order to implement that strategy.

Marketing

The principles relating to the marketing of arts events are similar to those which relate to the selling of any other commodity or product. Firstly it is vital to know your product, in this case your company and the work you intend to perform. A marketing strategy for your group can provide practical ways of achieving differ-

ent aims which may include all or some of the following:

- persuading your target audience to see your work
- attracting business sponsorship for future projects

- increasing awareness about your company and its work amongst other arts organisations
- increasing awareness about your company and its work amongst arts funding bodies.

Before you can begin to develop a strategy you must first have clear ideas about yourselves and your product:

- self-analysis – what do you have to sell?
- market research – who will want to buy it?

The marketing policy you decide on must be seen as a fundamental aspect of the work of the company if it is to be successful. In order to develop your marketing policy, you must put time and effort into answering these questions.

SELF-ANALYSIS

A commonly used method to help with this is called SWOT Analysis. SWOT stands for *Strengths, Weaknesses, Opportunities, Threats*. This involves making lists of the *strengths* and *weaknesses* within your organisation (the internal factors) and the *opportunities* and *threats* to your organisation from external sources. The whole group should be involved in this process which must be honest and thorough. A newly formed company might include the following examples in its SWOT analysis exercise:

Strengths	Weaknesses	Opportunities	Threats
good production	no admin staff	interest from	cuts in local arts
committed performers	small budget	venues	budget

The answers you get from your completed SWOT analysis can be used to develop a marketing strategy which is appropriate for your company or project.

TASKS

1 Draw up a SWOT Analysis for a project you have been involved with.

2 Devise an audience questionnaire which will help you to understand more about your audience.

In order to devise a marketing strategy which you can put into practice to bring in an audience, you must have a clear understanding about the current production. You will need to know the answer to questions about the production which may include all or some of the following:

- Does the show incorporate two or more art-forms?
- For how many weeks will the performance/residency be available?
- How much money do you need to raise from each performance/residency/workshop?

- What makes your production different from the work of other companies ?
- What is the target market for this production ?

By the time you begin to develop your marketing strategy, some or all of these questions may have been answered in response to the planning of the project, the process of budgeting, and applying to funding bodies (see Chapters 5, 6 and 8). If not, you will need to decide on the answers now. The development of a marketing strategy needs to happen alongside the development of the project, although it is part of the administration and support of the artistic work. If the artistic and supporting work are treated as two entirely separate entities there is a danger that the person responsible for 'selling the project' will be presented with a set of fixed ideas about the performance but no clear picture of the intended audience or means of selling it. Those responsible for marketing a project to potential venues and/or potential audiences need to be involved in discussions from the earliest stages in order to ensure that there are clear ideas shared by the whole group about who will be interested in the work. You do not want to be in the situation of having a show which is artistically successful but is seen by only a handful of people. It is equally important not to be in the position of creating work which you hope will be popular but which you do not believe in.

If the people who will be marketing the show are consulted from the earliest stages, they will be able to develop a marketing strategy which complements and reflects the creative work, and which appeals to an identified target group. In practice, in many small projects there will not be sufficient money available to pay someone to deal exclusively with publicity and marketing; the work may become part of the job of the administrator, or be delegated to one of the performers. In this case it will be important to ensure that this job is not left to the last minute, after the devising/creation of the work.

MARKET RESEARCH

It is important that you have clear ideas about where your potential target audience for your work will be found. To do this you will not only have to consider the answers to questions about your company and its work, but you will also need to consider other similar companies in the area and the work they are producing. You should be able to answer the following questions:

- Is there another organisation offering similar work to your group?
- If so, will there be sufficient venues/audience for you as well?
- What makes your group different from/better than your competitors?
- Will local funders be willing/able to support your group as well?

Marketing arts events and activities differs from selling other products in several important ways. People who work in the arts are creating performances which they believe in and are committed to, and they need to inform potential audience members about their work and hope to persuade them to buy a ticket. This is different from a manufacturer creating a new product which is designed to meet the needs/desires of a potential customer. Unlike product manufacturers, arts organisations have to work with small budgets and they cannot afford to waste their resources. For this reason it is important to know about your target market. A newly formed group working on its first project will have to make intelligent assumptions about who will come to their perform-

ances, based on interest from venues and funders and the general interest in other arts activities on offer in their area. This will be difficult at first, but your initial planning will have taken into account why you want to do the work and who you hope it will appeal to.

Decisions about the target audience for a particular project should follow in a logical sequence as the planning of the project progresses. If this is your second or third piece of work, you should have built up an audience of people who have seen and, hopefully, enjoyed, your earlier productions. At least some of these people should be on a mailing list so that you can keep them informed about your work.

There are several ways of doing this. You may ask patrons to complete a questionnaire which asks them how they heard about your show, how regularly they attend arts events, whether or not they enjoyed themselves. You can also ask for other comments on the venue and the work. Such questionnaires usually ask for names and addresses for the company/venue mailing lists and occasionally offer the chance to win a small prize as an inducement. You may be able to work with the venue in devising a suitable questionnaire and sharing the information from responses to it.

In most venues where the box-office takes advance bookings, patrons will be asked to give their names and addresses for inclusion on a mailing list. Almost all box-office computer systems provide information about patterns of attendance which can then be used as part of a marketing strategy for the venue. This means that specific letters can be written, aimed at different interest groups on the mailing lists. In this way the publicity campaigns for different events can be directed to those people most likely to be interested. The computer records can also help a venue to monitor the success or otherwise of its efforts.

Particular projects may be created with a specific target market in mind; for example, a reminiscence theatre tour which will visit day centres for older people and elderly persons' homes. In this case your marketing strategy will be designed to attract the attention of people who organise and provide facilities for older people; or you may wish to obtain bookings from a number of small arts centres within your region, in which case you will need to be clear about any particular groups who may be attracted by the subject matter, or the incorporation of several art-forms within your production. For example, your company may be devising a play which incorporates live folk music. You may use this aspect of the production to try and obtain bookings at small arts centres which programme concerts as well as plays. You might use this 'selling point' when talking to the programmers at the arts centres.

MARKETING MIX

The methods you use to attract your target audience once you have decided who they are, will become your 'marketing mix'. This is made up of four elements:

- product
- price
- place
- promotion.

Product

You should by now have a thorough understanding about the product or event you are working on. The next stage is to develop a marketing plan which attracts your audience.

Price

We have looked at the ways in which you fix

the price of the show with regard both to venues and to audiences in the process of budgeting covered in Chapter 5.

Place

As we have seen in Chapters 3 and 4, it is important to find the right venue for your work. It is equally important to consider your place in the market in relation to other companies doing similar work and the arts events available at other venues in the area.

Promotion

Promotion of your work covers the various methods you will use in order to sell your work to potential audience members and these are covered in detail in the next section on methods of publicising your event.

TASKS

1 Draw up a marketing plan for a forthcoming event at your college.

2 Describe the target market for this event.

Publicity

These are the methods chosen as part of your marketing plan in order to attract the attention of a potential audience, or audiences, to an event or performance. They are likely to include all or some of the following activities:

- press releases
- direct mailing
- posters
- flyers
- special events
- advertising
- direct selling.

PRESS RELEASES

A press release is a specialist mailing aimed at journalists who work in both the print and the broadcasting media. Its purpose is to persuade the newspaper journalist to write about your event or production and include this article in the editorial part of the newspaper. The advantage over paid advertising is that editorial coverage is free. With a journalist working in television or radio you will be hoping for a mention in a listings guide or, if you are very fortunate, an invitation to come in to the station and be interviewed about the project.

A good press release is one which provides sufficient information to allow the journalist to write about your work in such a way that the readers of his/her paper will be interested in coming to see the project. A well-written press release may be used virtually as it was written, which means that the paper prints what you

want to say about your work. In order to achieve this you will need a thorough knowledge about the project in question. You will also need to write about your work in a way which will appeal to the readers of the newspaper or magazine to which you send your press release. There are certain important certain conventions which you should follow when writing a press release.

Presentation is important. You should make your press release attractive to look at, as it will undoubtedly be one of many which the journalist has to choose from. It should always be typed or word-processed with double spacing to allow for notes to the printer to be written on it. It should cover one side of A4 paper and should have a clear and informative title. It should be clearly marked as a press release.

The first paragraph should answer the basic questions which all journalists ask when preparing a story: Who? What? Where? When? Why? How? An example might be:

The Whizz Kids Theatre Company (who) will be presenting the world premiere of their new show *The Dark Side of the Sugar Cube* (what) at the Shoe Factory Arts Centre (where) on Friday 7th and Saturday 8th August at 8.00 pm (when) before they travel to the Edinburgh Festival for a two week run (why). Tickets can be obtained from the Shoe Factory Arts Centre Box Office (how).

It would then give more details about the company, the new show, their previous successes, the Edinburgh performances, future touring, or whatever else is relevant. Because a sub-editor on a newspaper will often have to cut the length of an article and the easiest way to do this is to 'cut from the bottom' it is vital that the important facts are in the early part of the press release. If possible, make your closing paragraph one which could be discarded without affecting the sense of the rest.

At the end of the press release put the word 'Ends' to show that there are no more missing pages. Then include a contact name and telephone number for further information. Do this even if you are sending your press release on headed notepaper. The journalist may want to ask you some more questions or to arrange to send a photographer to a dress rehearsal and it is vital that you make it as easy as possible for him/her to do this.

Make sure that you have checked your work for accuracy and spelling, especially people's names. Journalists work with words and they will notice your mistakes which will look unprofessional and sloppy. Use the spellcheck facility on your computer or ask someone else to check your spelling for you.

Before you send out your press releases, find out who on the relevant newspapers covers the arts. There may be an Arts Editor, or the work might be covered by a number of junior reporters. If possible, find out the name of someone to write to. Check when the arts coverage appears in the paper. In many local evening papers this will be on Thursday, Friday or Saturday. Read the coverage and write your press release so that it will attract the attention of the reporters on that paper. All local papers like a local angle so if there is a 'local boy/girl makes good' story, emphasise this. Look for more unusual angles – do you need help in finding an unusual 'prop' or an old photograph of the area? This kind of request may get coverage in the news/gossip section of the paper, as well as on the arts page.

Check the print deadlines of the local newspapers and magazines and make sure that your press release arrives in time to meet them. Ideally you will aim for coverage in the two weeks leading up to a performance, so make sure that the journalist receives the information a week or so before this. If there is a

monthly *What's On* magazine in your area, make sure that you check their deadlines. They usually work a month ahead, so you may need to be working six weeks or two months ahead of the show.

DIRECT MAIL

If this is your second or third project then you should have begun to build up a list of those people who have been to see your work in the past. You may have distributed questionnaires to the audiences to help you to evaluate your project, and if you have people's names and addresses you can write to tell them about subsequent shows. The advantage of this kind of publicity is that it is targeted to people who already have some knowledge of your work and/or groups who are members of your target audience.

Depending on your target market for a particular event, you may be able to identify potential audience members and get in contact with organisations in which they are involved. For example, if your event is aimed at senior citizens, you could write to your local Age Concern group, day centres which cater for older people, elderly persons homes, luncheon and social clubs.

Work with any venues you will be visiting to devise suitable direct mail letters which could be used in your publicity campaign. In a show which includes a live folk band, a mail shot could be planned which involved publicising the play at folk concerts at the venue in the months preceding the show. Sending press releases to music papers might appeal to an audience which does not normally attend plays but does go to concerts. In this way you and the arts centre programmer may be able to increase the audience size and bring in people who would not normally consider themselves play-goers. The arts centre might book your show on the strength of this in order to help them increase their audiences for plays by encouraging concert-goers to try a different kind of show. You might perhaps offer a cheaper ticket for a concert for those people who purchase a ticket for the play.

If you have access to a computer, use the facility it can provide by creating a database which will allow you to send personalised letters to individuals, as well as allowing you to update information to take account of their patterns of attendance at your productions.

POSTERS AND FLYERS

For some projects, printing posters and leaflets or flyers can be an effective publicity tool, while for others it may not be necessary. A tour of primary schools will not require posters if the school is booking a show and supplying several classes of children to watch. On the other hand a show at a senior citizens' social club may benefit from a few posters being displayed in places where they will be seen by potential audience members. Most established venues will have a list of local shops and businesses who will sometimes display their posters in return for free tickets. Local libraries, community centres, schools, colleges and other

venues will probably be willing to put up posters if asked. The best size for posters for most events is A3 and for leaflets A5, unless you have access to very large display sites. The image you choose for your event posters and leaflets should reflect the work. It is important for the person who produces the publicity, whether a professional graphic designer or a member of the company, to have a clear understanding of what the project involves and where the target market for it lies. It is possible to produce high quality artwork on a computer with a desk-top publishing package even if you do not have drawing skills.

If you are producing print in large quantities, it is cheaper to go to a local printer than to have the posters reproduced on a colour photocopier or directly from the computer. The cost will depend on the quantities involved, the number of colours you require, the quality of the paper used, and the deadline you are working to. If you need the printing done in a hurry, the cost will be significantly higher than contacting the printers with weeks to spare and allowing them to schedule the print run to fit in with their other work. High quality posters can be produced in two colours if you are imaginative and use a fairly simple image. Think about printing on coloured paper which can make posters and leaflets look like three or four colour rather than one or two. If your show will be performed at a number of venues, leave a space at the bottom of the poster for each venue to over-print with their details and the date(s) and time(s) of performances, as well as prices and the box-office phone number.

It will be cheaper and more effective to use the same image on the leaflet or flyer and the poster, as it will be cheaper to print. Bear this in mind when briefing your designer, who will need to produce a design which will look equally good when reduced to a quarter of the size of the poster. For the back of the leaflet, make sure that you include the important information, the who, what, where and when clearly. If you are playing in several venues, list them all on the back of the leaflet and they can be used at all of the venues. Make sure that you include the cost of tickets and the box-office phone numbers.

When organising a tour, negotiate with the venues to see how many posters and leaflets they will require before you talk to the printer. As it is very expensive to print a small additional number after the main print run, it is better to over-estimate the number you require. They can always be offered for sale during the tour.

SPECIAL EVENTS

For some projects or events it may be possible to arrange for a special event or 'stunt' of some kind to which the press can be invited to take pictures and which could be covered as a news event. This might include borrowing a costume from a museum for a period show or taking part in a street parade or carnival. For a production of Dario Fo's *Can't Pay? Won't Pay!* which is about a riot in a supermarket, you might persuade a local supermarket to let you organise a photocall for the actors in the store. Think about any opportunities of this sort that your work may present. You will need to be well organised and make sure that everyone involved is happy to take part before you invite the press. If you wish to busk or do a street performance to publicise your event, you will need to contact the local authority to obtain permission.

ADVERTISING

Press advertisements which have to be paid for may be beyond the resources of your organisation and in any case may not be the most appropriate form of publicity. If you aim to attract students and young people, an advertisement in the local daily paper may be less effective as a means of attracting their attention than handing out flyers at a concert in the local college Students' Union building. On the other hand, if the venue you will be performing at regularly takes an advertisement in a local paper or *What's On* guide, try to negotiate with them for your show to be included.

DIRECT SELLING

The staff selling tickets for your performances, whether they are working in a permanent box-office or as part of a temporary one-off operation, need to realise that they have an important role to play in actively encouraging interest in the work and literally selling the company and the event. Make sure that they have sufficient information to enable them to be able to talk about your work if potential patrons ask questions. If at all possible they should have seen the show or earlier work by the company, although this is not always feasible. Make sure that they understand the important role they play in developing good customer relations. Often the box-office assistant will be the first point of contact between a venue and the audience. Make sure that they are polite and friendly, as well as efficient and helpful, and the patron will have a positive first impression of your organisation. The best publicity of all is 'word of mouth' from patrons who tell their friends how good a production was and how much they enjoyed themselves.

TASK

1 Write a suitable press release for a production you are involved in.

2 Design a suitable poster for the production.

3 Write a direct mail letter aimed at your target market for the production.

Monitoring your marketing plan

Whatever decisions you make about the appropriate marketing plan for your event or production, it is vital that you monitor its progress. Keep copies of any press coverage you receive as a result of your press releases or special events as well as any reviews. Use them as a source if you need quotations on future publicity. You will also be able to see what

kind of press release works best in different publications.

When you devise audience research questionnaires, ask how people heard about the show and use this information to help you improve your future marketing plans. If people make favourable comments about the work, use these in future press releases or on leaflets. If you have offered special concessions, like two for the price of one, or cheaper tickets on a Monday night, or a later start time on certain evenings, check the box-office returns to see how many people took advantage on those evenings and use the information as a selling point if it was popular.

After a show has finished, look carefully at all aspects of your marketing. You may discover that your budget could be better spent in a slightly different way in future. Look at the techniques used by other companies and venues. Always collect and read the publicity produced by other companies and compare them to your own. You might find a cheaper/better printer or get an idea about colours which work well together on posters.

Good marketing does not require large budgets and glossy print. It is possible to run a very successful campaign fairly cheaply if you are prepared to do some thorough research and use your imagination. If you care passionately about the work you are doing then it will be easier to convince other people of its worth and to persuade them to buy a ticket for the show.

BIBLIOGRAPHY

StARTing Out, Lynne Burnham, Debbie Kingsley, Coventry City Council and Coventry University; an information pack for artists and arts organisations.

The Arts Promoters' Pack, Jo Hilton, East Midlands Arts, Loughborough, 1991.

The Marketing Manual, Heather Maitland, Judith Meddick, Arts Council of Great Britain, London, 1990

chapter eight
MANAGING A PROJECT

Working in the arts in the 1990s does not often mean working for a large organisation on a long term basis. Most people working in the arts and cultural industries are self-employed freelance workers, or work in small to medium sized enterprises. You might find yourself working in a relatively large company, such as a national or regional theatre, an orchestra, a recording studio, or an arts funding body, but most likely you will be working on short-term contracts on arts projects.

Even in a larger organisation such as an arts centre, the concept of the project is still relevant. The centre may have its on-going programme of work, supported by its revenue funding, but it may apply for additional funding for projects – a community project or a school's tour, for example.

If you are able to set up and run a project on your own, with a small group or on behalf of a larger organisation, you will increase your opportunities for working. Not only that, you will be able to set up the kind of work that interests you. It is easier to secure funding for a project, because the funders are not committing themselves to supporting you over a long period of time. If you are

a small group, without a track record of successful performances behind you, and are interested in doing innovative and risky work, then Regional Arts Board project funding is your best hope. Moreover, there are other sources of matching funding to try for, depending on the nature and context of your project.

What is a project?

A *project* is short term. It has a defined life span which could be as much as a year, but which is more likely to be of a shorter duration – perhaps a week, a month or three months. The project funding (together with any income made from box-office, sales, or residency/ workshop fees) should cover the costs of wages, transport, materials, design publicity, administration etc., but only for the length of the project. It is important to have a very broad definition of what a project is. Here are some examples:

- A small scale theatre company devising, rehearsing and touring a new production.

- A musician working in a community centre to create music with non standard instruments for a community play.
- A South Asian storyteller working with a community group in a temple to make a performance for a festival.
- An experienced choreographer working with a young group of dancers who have recently finished training.
- An *a capella* rock group creating a new programme of work.
- A group of Afro-Caribbean dancers and drummers carrying out a six-week residency in a number of schools to create material for a joint performance at a local arts centre.

The project process

There are six stages in the process of devising and managing a project, each requiring a range of different skills. Figure 8.1 on page 112 shows the different stages you will have to go through to plan and carry out your project. Each stage is then discussed in detail and there is a variety of tasks for you to carry out on your own, in a group or with your tutor.

INITIAL RESEARCH

In other areas of work people talk about product research. Before a company launches a new product, it will undertake thorough research to make sure there is a market for it. There is no point in making something new to sell if the market is already saturated with similar items and existing manufacturers are struggling to sell their products. There needs to be something special or different about a new product that will make it attractive to people. If it is similar to other existing products then it must be *better* and the customers have to be *persuaded* that it is better. It might seem strange to apply these ideas to the arts – artists do not like to think of their work as a product, and would not wish to compromise their artistic ideas to create something which sells, but which is not artistically interesting.

Figure 8.1 *The project process*

1 Initial research
- reviewing background/current practice in the type of work
- researching the context – audience/participants/clients/venues
- researching the material for performance/presentation/teaching
- researching funders

2 Preparing the project funding submission
- identifying potential funders
- describing the project
- creating the budget
- approaching the funders

3 Managing the creative process
- good and bad practice in the creative process
- applying prior research
- setting up a creative working environment

4 Managing the project
- allocating roles and responsibilities
- forward planning
- the tools of good planning

5 Managing the presentation
- preparing the venue
- liaising with technical staff and/or setting up and operating technical equipment
- taking care of the audience/clients/participants

6 Evaluating the project
- collecting responses, formally and informally
- analysing responses
- assessing success, identifying weaknesses
- planning for the future

However, when planning a project, it makes sense to undertake some basic research in four areas:

The background/current practice.

You should try to build artistically on what has gone before. Artists and arts workers never stop learning throughout their working lives and they learn by doing their own work and by watching, analysing, interpreting and evaluating the work of other artists.

The context

You need to understand who your audience will be if you are creating a performance project. Your understanding of the audience will affect your choice of subject matter, themes, and style of work. A performance designed for youth centres would not deal with the same ideas as a reminiscence project. A performance for young offenders might have a very different style to a performance in a National Trust stately home. You must find ways to gather in-

formation about your audience, and of course, the venue itself. Composers and visual artists also have to consider where their work will be heard/seen, and by whom. They may also have to respond to the requirements of a 'client' who has commissioned their work. For example, a housing association might commission a mural, or a video company might commission some accompanying music. If you are undertaking a participatory arts activity in a community context, such as a young people's centre, you will need extensive research with the group to find out what *they* want to do.

The material

Some research will have to be undertaken before you begin the creative process, to help you generate material. Issue-based drama or dance might require background reading and/or discussions with people who have had relevant experiences. Doing this will help you deal truthfully with the subject. Musicians might want to research different ways of making music, such as electronic sampling, or to open themselves to world music influences. Dancers wanting to create an integrated performance using participants with a wide range of physical abilities would need to research different approaches to choreography. Artists using mixed media ap-

proaches would need time to explore new ways of integrating the art-forms.

The funders

Who would be the most appropriate funders for the project. The Regional Arts Board? A local council? A school? Social services? A local firm? Chapter 6 has introduced you to the range of arts funding bodies and should have given you some ideas about the types of arts activities they support. It provides a useful starting point for your research and suggests other sources of information for you to follow up. However, when it comes to finding local funders, it is no substitute for your energy and imagination. Only you can decide if your project has elements attractive to potential funders and the more creative you can be, the better! Perhaps your project raises awareness about disability issues and could attract support from a local voluntary group or local authority department; perhaps your project will result in more people coming into an area and bring additional business for a local coffee shop or pub – they might be prepared to sponsor; or perhaps your project could offer lunchtime workshops/performances for employees in a local firm or for their children – there could be sponsorship opportunities here.

TASKS

Working in a group, decide which of the following imaginary projects you would like to undertake;

1 A small-scale drama production on the theme of road safety to tour local primary schools, commissioned and funded by the police.

2 A one-day arts festival for the local park.

3 A participatory arts event for a mixed South Asian/white European youth centre.

4 A dance performance for a shopping precinct.

5 Your own idea.

Draw up a plan for the initial research and share it with the whole student group. Make sure you say who you will consult with and why, where you will look for information, and how you will use it.

PREPARING THE FUNDING SUBMISSION

Identifying potential funders

A range of potential arts funders is outlined in Chapter 6, together with their main areas of interest and priority. It would be naive to assume that you should, or could, write applications to them all. You need to decide which are the most appropriate for your project and target your applications accordingly. Answering the following questions should help you to decide if you should apply to the major public arts funders; the Arts Councils of England, Wales, Scotland and Northern Ireland, the Regional Arts Boards and the Local Authorities:

- Is your project going to be seen nationally?
- Does your project make an innovative contribution to the art form/s?
- Is your work in an area which has been identified as seriously under-represented nationally?
- Can you prove that your work is of the highest artistic standard in its field?
- Are you beginning to develop a national reputation for the quality of your work?

Unless you can answer yes to these five questions, there is no point in applying to the Arts Councils of England, Wales, Scotland or Northern Ireland. Even if you can answer yes, there is still the problem of fighting for recognition in an environment of established and respected companies/artists chasing smaller and smaller funds as the government reduces its grant to the Arts Councils.

- Is your project going to make a useful contribution to the arts activity within a region? A region is the area covered by one of the Regional Arts Boards. The West Midlands Arts Board for example, covers the West Midlands Metropolitan areas (areas around Birmingham and Coventry) Staffordshire, Shropshire, Hereford and Worcester, Warwickshire.

- Does your project make an innovative contribution to the art-form/s?
- Is your work in an area which has been identified as seriously under-represented nationally?
- Can you prove that your work is of high artistic standard?
- Are you beginning to generate local and regional interest in your work?

If you can answer yes to these questions, it would be appropriate for you to apply for support from your Regional Arts Board. Their concern would be in balancing the range of provision across the whole region. So if, for example, you want to set up a dance project in an area without dance activity, but where organisations and people were clamouring for dance, the RAB might look with interest at your application. On the other hand, if you appeared to be duplicating existing provision, they would be unlikely to support you. The funds are too limited.

- Does your project make an important social or artistic contribution to the lives of people in your neighbourhood, district, town or city?
- Can you prove that you have the artistic, teaching, facilitative, interpretative skills needed for the context?
- Are you beginning to generate local interest in your work?

If you can answer yes to these questions, then it would be appropriate for you to apply for funding from your local authority (district, county or city council).

It is difficult to be specific about other sources of project funding, since these are more likely to derive from the nature and location of the project, but the following questions and answers should be helpful:

- Does your project meet the objectives of one

of the major charitable trusts? For example, try the Prince's Trust if your project is by and/or for young people; try the Gulbenkian Foundation if your project is developmental in terms of arts and education.

- Does your project meet the requirements of any of the national sponsorship schemes initiated by large companies such as Digital or Sainsburys? If so, apply!
- Does your project have a strong education focus? If so, a school or consortium of schools might provide some funding.
- Does your project have a strong social focus? If so, there might be support from your local social services department.
- Does your project raise awareness about a

particular social issue, such as disability, or equality, or domestic violence? There is likely to be an association in your area which is committed to providing help, advice or education work in the field. Look for them in your local library and contact them for your research, as well as for your funding strategy.

- Are there any benefits for local companies in your project? Local businesses might want to advertise in your publicity or might be prepared to donate or loan equipment to you.
- Does your project involve building or purchasing large equipment for an organisation? If so the Arts Council National Lottery scheme might be appropriate.

TASKS

Working in a group, decide which are the most appropriate funders to approach for the following projects:

1 A community centre performance of original music, created and performed by a local musician and a group of people with disabilities.

2 A tour of regional theatre venues by a well respected and popular middle-scale, London-based theatre company.

3 A 'family' musical, touring seaside resorts and other tourist venues.

4 A puppet show touring village halls in rural areas.

5 A black dance company from the north-west of England performing issue-based dance about black British urban life in regional theatre venues across the country.

6 A schools project by the Welsh National Opera, based in secondary schools in North Wales and Shropshire.

7 A music and drama performance (with workshops) about the problems of drug addiction, touring local youth centres.

Share your ideas with the other groups and compile a joint list of all the suggested sources for each project.

Describing the project

It is not easy to write a project funding submission. It means that you have to work out most of the project details before you even start, and you have to write it in such a way

that it will persuade the potential funder that you are able to meet their criteria. As noted in Chapter 6, different funding bodies have different priorities, and you must plan your strategy carefully. You may need to target your applications in slightly different ways if you are

applying to more than one funder. Before you start you should always read through the funding body's application forms and guidelines very thoroughly. Despite differences of emphasis, most funding bodies require information in the same areas. Even if they do not follow the exact headings shown below, you will find it helpful to use them for planning purposes:

The project description

This should be a very brief description of what you intend to do, where, when and with whom. Before you can write this you will need to have worked out how long the project will last, how long the devising/creative process will take, and where it will be performed/presented. If you can name venues or host organisations for workshops or your client, this will strengthen your case greatly. But make sure you have their agreement first.

The aim/s of the project

What do you hope to achieve through this project? Your aim or aims should be big statements such as 'to use practical workshops to develop the audience for Afro-Caribbean dance' or 'to use music to underpin the emotive qualities of a video about third world pov-

erty,' or 'to explore innovative ways of combining dialogue, visual images and music on video,' or 'to use documentary drama to change people's attitudes about violence in the home'. Your aims should be compatible with those of the funding body. If they are not, there is no point in applying.

The objectives of the project

These should be simple statements about very specific things you want to achieve, such as:

- to develop two new venues for drama
- to ensure a minimum of five performances for my composition
- to bring more young people into the theatre audience
- to secure local and regional press coverage
- to raise local private sponsorship
- to raise awareness about a specific issue
- to raise awareness of the arts in a non-arts venue.

The statements you make should be measurable and compatible with the aims, objectives, and criteria, laid down by the funding body. At the end of the project you (and they) will want to know if you have been successful in achieving your objectives, and if not, why not.

TASKS

1 Working in pairs, devise an imaginary project and write a statement of aims to discuss with the rest of the student group. Write a minimum of four objectives and decide how you could measure them.

2 See if your tutor can contact the Regional Arts Board and persuade them to send copies of old project applications – with the names blanked out – so you can read and discuss a range of project aims.

The budget

Costs

It is easy to underestimate the amount of money you will need for your project. Here is

a list of potential project costs, based on those identified in Chapter 5:

- fees for the director, writer, composer, designer, performers, lighting technician,

sound technician, costume maker, prop-maker, administrator.

- Copyright fee for music, and script
- Scenery, props and costume materials
- Transport costs
- Hire of rehearsal space
- Administration costs
- Advertising and publicity costs
- Equipment/instrument hire or purchase
- 5-10% contingency

Very few projects would require all of the above but equally, there may be other requirements not mentioned here.

Having determined what the project needs in terms of artists and personnel, you need to decide how long you want these people on the payroll, and how much they should be paid. Directors, composers, and choreographers would normally be paid a fee and this would have to be negotiated with them. They might be working for different amounts of time. In the following ten-week project, there are eight weeks of devising and two of touring. Remember you might need to budget for overnight accommodation for a large group of people on tour. Use the personnel planner from Chapter 5 to help you work out the personnel costs.

The cost of the materials will, of course, depend upon how ambitious the project is. Remember that large and complicated sets are not only costly to make in terms of materials. They will also need a large workshop space for construction, they will put up your transport bill, and they will restrict the number of venues possible. The cost of costume materials can be reduced if you use ready made items or shop for fabric at your local market. Some early research is needed to estimate this cost. Transport costs will depend upon the size of the vehicle required and the amount of distance you need to cover on the tour.

Unfortunately most performing arts projects

need access to rehearsal space and this usually means hiring. Schools, colleges, church halls, and community centres sometimes have spare space. Some venues are prepared to do a deal – free rehearsal space in exchange for free workshops or a reduced performance for their students/community groups.

Many people overlook the costs of administration. Phone calls to venues and personnel, stationery and postage and contracts, photocopying, perhaps even hire of office space, might need to be included. Advertising can cost a lot or a little. It does not have to be expensive to be effective (see Chapter 7). Press and media interviews take initiative and imagination, not cash, but you will still need a minimum of a basic leaflet, and/or poster and a programme.

Once you have added up all your estimated costs you need to see how much income you can generate.

Income

Your project should make some money, but probably not enough to cover your costs. That is why you are making a funding application/s. But nevertheless you should be generating some income from fees from venues, fees from workshops or residencies, and/or box-office takings. Established venues normally pay a fee to established companies for their performance or performances. Non-standard venues and unknown companies sometimes make an arrangement called a box-office split. They decide that the venue will keep a percentage of the box-office takings, and the company can have the rest. This has to be negotiated.

If the company is able to offer workshops and residencies as part of their project, this can be another useful source of income. If a school is booking a performance, they often like to book a workshop for their pupils which will also help the pupils to understand what they will

see in the performance. A residency usually involves some of the company staying in an institution for a set period, for example, a week, and teaching workshops during that time. The week would probably finish with a performance by the whole company.

Once you have worked out your expenditure and your estimated income you can draw up your funding application budget. As noted in Chapter 5, this should always balance, with the grant request being the balancing figure as shown in Figure 8.2.

Figure 8.2 *Sample dance project – funding application budget*

Expenditure	£
Fees	
Choreographer	3,000
4 dancers @ 1,500	6,000
Musician	2,000
Designer	1,000
Lighting and sound technician	800
Hire of rehearsal space	450
Materials	650
Transport	500
Admin	500
Marketing and publicity	1,250
Total expenditure	16,150
Income	
Performance fees 8 @ £1,000	8,000
Workshop fees 5 @ £200	1,000
Barnshire County Council Grant	2,000
Melkshire County Council Grant	1,500
Sponsorship by Cream Puff Cakes	500
Grant requested from Regional Arts Board	3,150
Total Income	16,150
GRANT REQUESTED FROM REGIONAL ARTS BOARD	£3,150

Approaching the funders

It is not wise to send your completed funding submission to a potential funder without prior contact, no matter how carefully you have read their forms and guidelines. Once you have an outline idea of the project (and have read any available guidelines) you should write to arrange a preliminary meeting. Regional Arts Boards and local authority arts organisations have officers who will usually want to discuss your idea and their priorities. It is very helpful if they can see/hear your work, so invite them

to performances whenever you can. Otherwise, try to provide a sample on video or sound recording. If you have reviews of previous work, send or take them with you to the meeting. If you have done your homework well you can already begin to point out how your project meets the funding body's criteria and will further its objectives. Listen carefully to what is said and if suggestions are made that you could incorporate, for example a link with a different venue, or a development of your approach to increasing access, they should be taken seriously.

If you approach a private sponsor, remember to focus on what they will get out of the deal.

They may be only marginally interested in your artistic ideas but will have many different reasons for wishing to invest in an arts project – from building a good community image to straightforward publicity. Chapter 6 will remind you of the main issues involved in approaching private sponsors.

Make sure you prepare yourself for your meetings with all potential funders. They will only spare you a small amount of time so you need to be clear about the (few) points you want to get across. Be concise, but let them see your enthusiasm and commitment, and above all – *listen!*

TASKS

Written below is a description of an imaginary project called *Childwise*. Read it through carefully and then, in small groups write a funding application for it. Follow the steps outlined here:

1 Write out the project description.

2 List the projects aims and objectives.

3 Cost the project.

4 Estimate the income.

5 Decide on potential sources of funding.

6 Draw up a funding application for one funder (assume you have money from at least one other).

7 Submit your application to a panel (tutor, other students, real representatives from local funding bodies, if possible).

PROJECT CHILDWISE

A young group of recently trained performers, four actors, two dancers, and three musicians, want to work with an experienced director and choreographer to make a mixed art-form devised piece about communication and autistic children. Two special schools, one college, and two community centres, have expressed interest in taking the production

for one night each, so have two studio theatres, approximately 200 miles apart. The schools, college and studio theatres have each agreed to pay the performance fee. The two community centres, both of whom hold a capacity audience of 100, have arranged a 50% box office split. They usually reach 90% capacity and charge an average of £5 per head as ticket price.

The schools have booked ten half-day workshops between them. The college wants a two-day residency, leading up to the performance, and the community centres want a whole-day workshop each.

The group has decided that they want to make their own music/songs for the performance but that they should bring in a respected local musician to give some guidance and feedback in the later stages of the project. A local technician will be available to set up and operate lighting and sound for the tour. Three of the performers have agreed to share the administrative work between them. One of the actors will take on the role of company director.

The company plans to rehearse for eight weeks and tour for three. A church hall is available for three weeks' rehearsal, a local sports centre for two, and a school for the remaining three. Only the church hall is free of charge.

They have decided that all performers should wear everyday clothes for most of the show but that the two dancers should also have costumes which flow and change colour under the lights for some scenes. These need to be designed and made by a local art school student for a small fee. The musicians will need to purchase black T-shirts and trousers. The plan is to use a free standing framed gauze (approximately 6 metres by 4 metres), which will fold down for transport. This will be made by the cast. All the props will be *found*.

Eleven people, the costumes, the set, the musical instruments, and a portable PA system, need to be transported on tour. The director, technician, and company manager have to visit the non-standard venues to ensure that the piece can in fact be performed.

The company director's house is to be used free of charge as the company address. It is equipped with a phone, a photocopier and a word processor, whose usage, together with postage, must be paid for. Letterheads with the company's name and address on have to be printed. Press releases and programmes can be produced in-house but glossy A5 leaflets and matching A3 posters will have to be produced for the venues.

A portable PA system will have to be hired for the rehearsal period and the tour.

MANAGING THE CREATIVE PROCESS

Good and bad practice

Each art-form has its own processes, devices, structures and forms, for the composition of music, the choreography of dance, the devising of theatre, and the creation of artefacts. These are subject-specific and therefore beyond the scope of this book. This section is not about the applications of artistic creative processes. Rather it is designed to help you manage the process as an individual, or as is more common in the performing arts, as a group.

Working as an individual to paint a picture, or compose a piece of music, can be a lonely experience. It is easy to lose your sense of direction and to lose confidence in what you are making. Without the obligations involved in working with others it can be difficult to manage your time or meet deadlines, and it is tempting to be satisfied with the easy or obvious artistic solutions.

Working creatively in a group brings different challenges. It can be a very rewarding experi-

Figure 8.3 *Good and bad practice in the creative process*

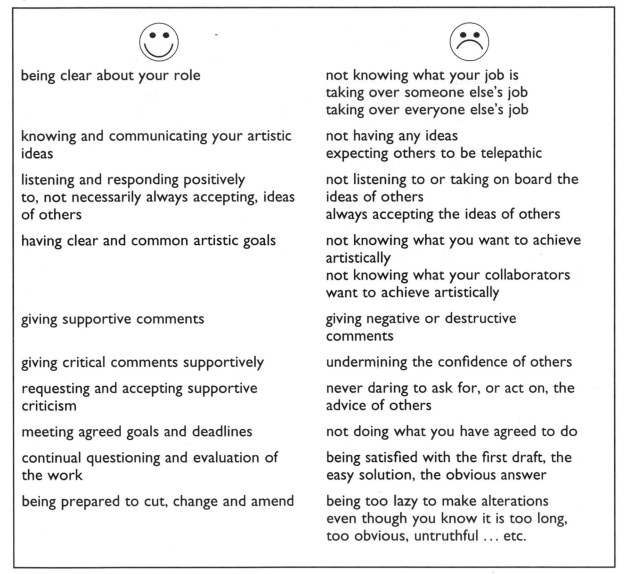

:)	:(
being clear about your role	not knowing what your job is taking over someone else's job taking over everyone else's job
knowing and communicating your artistic ideas	not having any ideas expecting others to be telepathic
listening and responding positively to, not necessarily always accepting, ideas of others	not listening to or taking on board the ideas of others always accepting the ideas of others
having clear and common artistic goals	not knowing what you want to achieve artistically not knowing what your collaborators want to achieve artistically
giving supportive comments	giving negative or destructive comments
giving critical comments supportively	undermining the confidence of others
requesting and accepting supportive criticism	never daring to ask for, or act on, the advice of others
meeting agreed goals and deadlines	not doing what you have agreed to do
continual questioning and evaluation of the work	being satisfied with the first draft, the easy solution, the obvious answer
being prepared to cut, change and amend	being too lazy to make alterations even though you know it is too long, too obvious, untruthful ... etc.

ence since a group of imaginative people working together can very often achieve far more than they could as individuals. If there is good interaction, your ideas might be picked up and turned into something you never would have imagined, and others can provide areas of new skills and knowledge. Sadly, the collaborative creative process can also be a nightmare when personalities clash and individuals remain uninvolved or try to dominate the process. Even when all the individuals in the group are thoroughly committed, reliable, supportive and talented, there can be disagreements about artistic content and style. There will be occasions when individuals feel insecure and threatened – especially when searching for new solutions to artistic problems, and for more truthful interpretations. A shared artistic vision is achieved through trust, respect, hard work, and communication. Good working relationships are maintained by knowing when to insist, when to let go, and when to compromise.

There is no blueprint for managing the creative process but it is possible to identify factors which contribute to good practice and those which do not; Figure 8.3 above outlines these.

Applying prior research

In setting up your project you will have undertaken initial research into some of its aspects (see pages 111–13 above). You will already have ideas about what type of work you want to produce, what other work there has been of a similar nature, and how yours will relate to, or build on, current practice in the field. You will know the context for the performance, who the audience will be, and where it will take place. You should have a good understanding of any narrative, character, or thematic content, you want to use and you will probably have ideas about the type of devising, choreographic, compositional or other creative processes to use. All of this should guide you in the making of the work but as we all know, the best creative process is a voyage of discovery. Your initial research should not be a railway line taking you to a predetermined destination but it should:

- help to give you a sense of direction about an appropriate style and structure for your work
- remind you to consider the interests and needs of your audience
- remind you of the possibilities, challenges and constraints of the performance space
- ensure the accuracy and truth of any narrative/thematic content.

It could be that you will generate vast amounts of research material and that it would be very difficult to apply your findings to the creative process. Try to decide which parts can be used directly, for example, historical information into script and costume designs, sampled sounds onto referenced tape files, performance space dimensions marked onto rehearsal floor.

Research material relating to the audience could be summarised into a few key points and pasted up on the wall, or on the front of folders, to act as a constant reference point in evaluation discussions. Research material relating to devising, compositional, choreographic, and other creative processes, should be kept in a file for you to refer to. There are always moments in the creative process where you feel blocked. There are many different reasons why this happens (see below) but sometimes looking over your list of potential devices, methods and processes can help.

Setting up a creative working environment

A creative working environment depends to a small extent on the physical surroundings, resources, and facilities, and to a *very large* extent on the attitudes and working practices of the people involved. Each art-form has special requirements in terms of its physical environment and access to equipment, but all creative activities require as a minimum a degree of privacy, quiet, space, and freedom from cold or overheating. Both as a student and as a professional you will find that access to appropriate working facilities is limited. Colleges, schools and centres must cater for large numbers of students and therefore booking systems will be in place. Professionals will either have to invest in purchasing or renting their facilities. In neither case is unlimited access likely. This means that the best possible use must be made of the time available and this reinforces the need for good planning – do not go into the studio cold!

The keys to maintaining good creative working practices are planning and communication. You are more likely to be successful if you:

- ensure that as an individual you understand what you are trying to achieve artistically through the project
- ensure that all collaborators on a project share the same understanding of what the project is about, even if they have different roles within it

- ensure that all collaborators understand their roles and how they fit in to the project as a whole
- break down the making of work into manageable sections to give a sense of achievement
- have a rough, outline plan for working on each of the sections identified
- agree some deadlines, goals, and targets, for the making of the work as a whole and for the sections
- have more than one section to work on in the event of getting 'blocked'
- plan the process so that it includes times for creating new material, for developing it, for reviewing material already created, and for 'polishing'
- review what has been done after each session and decide what should be tackled in the next session.

All of this suggests that time be set aside for discussion beyond the precious studio time. Groups could programme in meetings, or could deal with it informally over coffee, as long as there was sufficient privacy to maintain concentration and focus. If you are working alone you will need to set your own schedules, but it is wise to arrange for a trusted friend, tutor, or professional, to act as a sounding board and to give constructive feedback.

The other key factors in determining the creative working environment are *motivation* and *attitude*. The ideal is to work in an atmosphere in which (alone or in a group) you feel empowered to experiment, take risks, fail occasionally and admit to the failure, succeed and acknowledge the success. When working in a group you want to feel free to make contributions, offer suggestions, comment on your own work and the work of others and feel that you are all developing and growing as artists. The reality is often carrying on doggedly despite feelings of inadequacy as an individual, and struggling with problematic group dynamics in a collaborative situation.

As an individual there are a few strategies you can employ to help maintain motivation. Most of them have been mentioned already:

- being clear about what you want to achieve
- planning to work in sections
- having more than one section 'on the go' at once
- arranging regular feedback sessions with someone you trust
- avoiding going into the studio 'cold'; do some thinking and planning in advance.

Beyond this, if you find yourself 'blocked' it could be because you are unhappy about the direction of the work, or some part of the work, you have been dealing with. This takes time to work through and talking to other people helps a great deal. Concentration problems occur for all of us from time to time. Sometimes we simply need to discipline ourselves to sit down and get on with it. At other times it may seem impossible to shut out the problems (or good things) of real life. Creative work is difficult at times like these and a good strategy is to review and develop, or polish, something already created. There are some more 'mechanical' or technical tasks to do sometimes.

As a group you have all the problems of the individual as well as those caused by interaction with others. Assuming you have implemented all the appropriate working practices described above and there are still difficulties in working together creatively, the following pointers might help to create more appropriate working relationships:

- Make sure all voices are heard.
- Do not allow one individual to dominate the direction of the project, unless it has been agreed by everyone that s/he has a different role to the others, e.g. Artistic Director.
- Make sure that everyone knows and sticks to schedules. Persistent lateness or non-attendance are disruptive and cause ill-feeling. In the professional world anyone who cannot

achieve this basic self-discipline is out of a job!

- Support each other through crises of confidence and help others find solutions to artistic, interpretative or technical problems.
- Be sympathetic to personal problems but encourage others (and yourself) to set them aside once work begins. We all have to learn how to do this if we want to survive in the profession.
- Be generous with praise when someone overcomes a major difficulty, exceeds expectations or finds a particularly imaginative solution.
- Recognise that in times of experimentation you must not judge others. You may not

understand what they are trying to do and could undermine them.

- Encourage the group to recognise when the experimentation has to stop and the decisions have to be made.
- Do not think of mistakes, errors of judgement or unsuccessful experiments as *failures*.
- Give critical responses at appropriate times – preferably in designated discussion times and never when someone is feeling vulnerable.
- Be the first to criticise your own work – without cringing or grovelling.
- Make sure everyone uses non-confrontational language when giving critical responses.
- If there are problems with one individual not pulling his/her weight, deal with it as a group.

TASKS

1 In groups discuss strategies for dealing with the following situations:
 a Your friend is trying to compose a piece of music but is not making any progress and keeps giving his electronic music studio time to others. He does not appear to be worried but you know he is covering it up. What do you advise him to do?
 b One member of your theatre group does not make any contributions to the devising process although she works fairly efficiently on her own roles. You have just heard that she has been complaining to other students that no one ever listens to her. What do you do?
 c One member of your group refuses to try out new ideas – she insists that they are 'rubbish' but has very little to contribute herself. You find out that she is bullied and dominated by her father at home. How can the group handle this?
 d Someone in your group keeps missing sessions and always arrives late. What does the group do about this?
 e You have a member of your dance group whose contributions to the creative process are bland and obvious. You know she is a talented choreographer but she is not doing any preparation for the sessions. What do you do?
 f One of the musicians/dancers performing your composition/choreography does not have the technical mastery. What do you do?

2 Discuss appropriate ways to say the following:
 a You should have learnt your lines by now.
 b Your character is not convincing.
 c You should have finished the music for my dance by now.
 d Your choreography is wrong for my music.
 e You are trying to upstage the other performers.

f Your last suggestion is completely inappropriate/no good.
g You are only interested in having your own way.
h You are not listening to my ideas.

Bear in mind that these things do have to be said from time to time.

MANAGING THE PROJECT

Managing the project requires planning and organisational skills. Most established professional artists and companies would employ an administrator to deal with the day-to-day project management, but as noted in Chapter 1, work in the performing arts is increasingly funded on a project basis and new companies often cannot afford the cost of an administrator. In these circumstances it is essential to set up structures to ensure that the project is managed effectively. As suggested in Figure 8.1, the project process (page 112), there are three areas to consider:

1 allocating roles and responsibilities
2 forward planning
3 the tools of good planning.

Allocating roles and responsibilities

The artistic roles required for a project are

Figure 8.4 *An ideal project management structure*

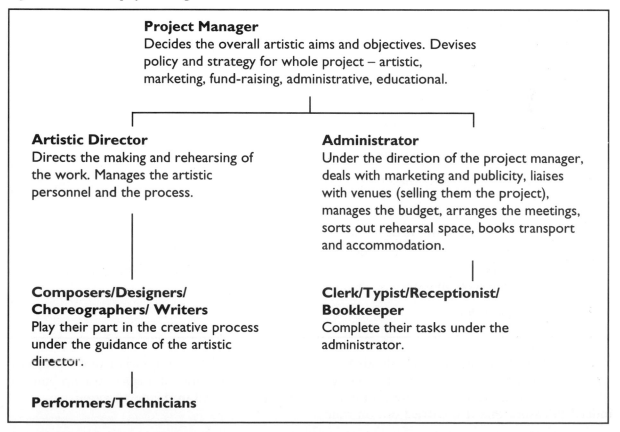

Project Manager
Decides the overall artistic aims and objectives. Devises policy and strategy for whole project – artistic, marketing, fund-raising, administrative, educational.

Artistic Director
Directs the making and rehearsing of the work. Manages the artistic personnel and the process.

Administrator
Under the direction of the project manager, deals with marketing and publicity, liaises with venues (selling them the project), manages the budget, arranges the meetings, sorts out rehearsal space, books transport and accommodation.

Composers/Designers/ Choreographers/ Writers
Play their part in the creative process under the guidance of the artistic director.

Clerk/Typist/Receptionist/ Bookkeeper
Complete their tasks under the administrator.

Performers/Technicians

fairly easy to identify. They might be theatre director, composer, musician, actor, dancer, designer, technician etc. There might even be someone taking on the role of project director. the project management and administration roles are more difficult to predict. In an ideal world the project management structure would look something like the one in Figure 8.4 on page 125.

But the reality could be very different. Although all of these jobs still have to be done, they may have to be shared out among the performers. This is especially true of small-scale performing arts projects, where the income simply will not support so many personnel. The project manager could well be the artistic director, one of the actors could take on the venue liaison, the stage manager might also deal with the publicity and so on. If you are a solo artist you have the unenviable task of doing it all yourself or perhaps teaming up with other artists on a project to 'sell' your work together in a joint exhibition/demonstration.

It is important to set aside time at the beginning of the project to decide firstly, what will need to be done on the project management and administration front, and secondly, who will do it. Every project is different but it is likely that your project will include most if not all of the tasks identified on Figure 8.5, the project task checklist. You could use this checklist as a basis for creating one for your next project.

Figure 8.5 *The project task checklist*

- writing the funding applications
- selling the work to venues
- securing performance, workshop, exhibition or demonstration dates
- marketing the work to audience and/or participants
- ensuring that VIPs (programmers/funders etc.) are invited
- raising sponsorship
- designing and printing the publicity materials
- distributing the publicity materials
- managing the budget
- purchasing materials and props
- paying people
- arranging rehearsal space
- project evaluation

If all of these tasks have to be divided up among a number of different people, everything will have to be managed very carefully indeed to ensure that it is carried out on time and in a way that is appropriate to the project's character and aims. Strategies to help you do this are discussed in the next section.

Forward planning

Before an individual can begin working on his or her tasks, the project group as a whole needs to have agreed the following:

- the marketing and evaluation strategies
- the time-scales
- how the finances are to be managed
- the meeting schedule.

Marketing

This simply refers to selling your performance, workshops, exhibition or demonstration, firstly to potential venues, and secondly to your audience. Chapter 7 tells you about the relationship between marketing and publicity and gives you detailed information about how you can sell your product. It also tells you about marketing strategies in general. For your project you will already have a clear idea about the audience you want to reach, what kind of methods you can use to reach them, for example radio, posters, workshops, mailout, and what sort of images and designs will attract their attention. A few group discussions should help you to clarify these ideas and get them written down in note form. This is your marketing strategy and it will help guide the person responsible. It will ensure that he/she does not rush around primary schools with posters of Mickey Mouse if your performance is about the psychology of an axe murderer. As a group you need to agree on what the publicity material should look like, where it should be distributed, what other methods could be used, for example a shopping precinct demonstration, how the media should be approached, and when everything should happen. As far as venues are concerned, you should work together to produce a list of appropriate contacts and then decide what type of information should go out to them and what kind of follow-up there should be.

Evaluation

This is about deciding whether or not your project has been successful. Chapter 9 covers this subject is some detail. It basically tells you not to rely on your own judgement but to collect and make use of your audience responses. You need to make some decisions at the very start of the project about whose opinions you would wish to have and how you can get them. Audience questionnaires need to be devised and critics may need to be invited. All you need to do is to make a list at an early meeting of the different ways you will collect responses.

Timescales

Timescales are the dates by which you want to have things done. It is a very good idea to have a forward plan – the dates can always be changed later on if necessary, but it is a useful tool to ensure that everyone at least tries to make the targets. Although constructing a forward plan seems time-consuming in the early stages of a project, it certainly saves a great deal of time later on. After all, it means you only have to make the decision once, it is recorded and you can focus your mind on other things. Figure 8.6 on page 127 is an example of a project forward plan.

Managing finances

Chapter 5 covers this topic, and should help you with the methodology of managing cash flow and keeping your budget account. However, in a project situation there are ground rules to establish. The person who takes on this job must have control over all the paying of fees and the purchasing of materials and equipment. Usually, two signatures are required for company/project cheque accounts. One of these should always be that of the person keeping the account.

The meeting schedule

This should be outlined on the forward planner so that everyone can attend. Once the creative work has started it can be difficult to focus people's minds on administrative tasks and if you do not schedule meetings in

Figure 8.6 *A project forward plan*

	Week 1	Week 2	Week 3	Week 4	Week 5	Week 6	Week 7	Week 8
Mon		Meet sponsors			Press release out			Radio interview Tech'cal rehearsal
Tues	4pm Meeting	4pm Meeting		4pm Meeting	VIP invites out	4pm Meeting Programmes agreed		Work-shops 4pm Meeting Dress rehearsal
Wed	Letters out to venues	Posters to print				Program-mes to print		Preview Perform-ance. Party for sponsors.
Thurs								Perform-ance and workshops
Fri	9am Meeting Posters agreed		9am Meeting Press release agreed	Posters out	9am Meeting		9am Meeting	
Sat								
Sun								

advance, you might find that people are suddenly 'unavailable'. Regular meetings are essential to the smooth running of a project.

The tools of good planning

The tools of good planning are:

- clear identification of roles and responsibilities
- shared understanding of project aims,

objectives and strategies
- good forward planning documentation
- regular well-run meetings to plan and to monitor progress.

The first three items have been discussed above, so this section will focus on what is meant by 'well-run meetings'. A well run meeting will have the following:

- A purpose or set of purposes – *an agenda*

- A record of main decisions and actions to be taken – *minutes*
- Someone to guide the meeting effectively – *a chair*

Ideally, the meeting should stick to the main issues but still allow room for discussion and the introduction of important last minute items. It should be concluded within an agreed time. Meetings which have no sense of purpose, in which people follow personal preoccupations, or in which decisions are not reached; which consistently run over time or in which individuals dominate; in which decisions are not recorded, leaving room for later confusion and argument – all of these are counterproductive.

The agenda

The agenda is simply a list of items for discussion. It should be constructed and distributed before the meeting. One person should be responsible for making the agenda and chairing the meeting but all others should have the opportunity to put items on the agenda in advance, or to discuss issues that have come up at the last minute, through an item called 'AOB' – *any other business.* The agenda should reflect the most important issues of the moment. These will obviously change as the project proceeds. Items on an early agenda might be about raising sponsorship and forward planning, for example. Later agendas might be about the delay at the printers and arranging the technical rehearsal. Some common threads would run through all meetings – opportunities for people to report on their tasks (so that their progress can be monitored and they can have the support of the group in dealing with any problems) and regular budget and cash flow reviews. Figure 8.7 is an example of an agenda for a meeting half-way through a project.

Figure 8.7 *Agenda example*

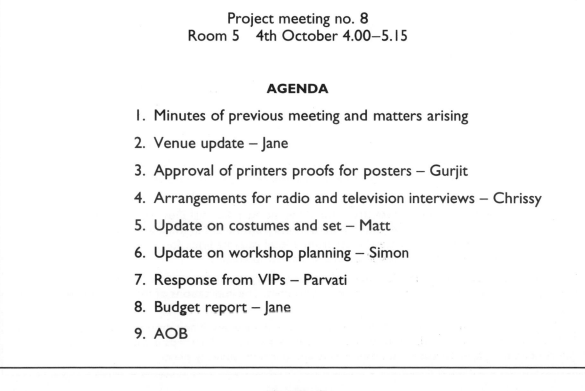

Project meeting no. 8
Room 5 4th October 4.00–5.15

AGENDA

1. Minutes of previous meeting and matters arising
2. Venue update – Jane
3. Approval of printers proofs for posters – Gurjit
4. Arrangements for radio and television interviews – Chrissy
5. Update on costumes and set – Matt
6. Update on workshop planning – Simon
7. Response from VIPs – Parvati
8. Budget report – Jane
9. AOB

The minutes

The minutes of a project meeting do not have to be a full or formal record of the proceedings. This would take up far too much time and probably no one would read them. The group needs a succinct and readable record of the de-cisions made and the action to be taken. If they can be circulated soon after the meeting, they can act as a reminder to those who have agreed to undertake tasks. Figure 8.8 shows the minutes that might have been from the meeting described in Figure 8.7.

Figure 8.8 *Example of minutes*

Minutes of Project Meeting no. 8 4:10:96

Present: Jane, Gurjit, Simon, Chrissy, Matt, Mike, Parvati

Chair: Nessa

1 Minutes approved.

Matters arising – Coventry van sponsorship fallen through. Matt to investigate city council community transport department and local school for lowest cost and availability for performance on Dec 12th. Report to next meeting.

2 Jane's contact with Northampton Arts Centre successful. 2 performances and 4 workshops now con-firmed. Tour schedule now as follows:

28 – 30 November – MAC, Birmingham
 4 – 9 December – Phoenix Arts Centre, Leicester
12 –14 December – Belgrade Studio Theatre, Coventry
16 –18 December – Northampton Arts Centre

3 Group approved proofs of the posters and congratulated Gurjit on his designs. List of places to distrib-ute circulated for people to add on their ideas.

4 Chrissy confirmed that she was available on 27th to do Birmingham local radio interview but felt that other members should be present at Central TV interview on 28th. Parvati and Matt agreed to have their duet ready to present if required.

5 Matt showed an example of a completed costume and confirmed that they were coming in under budget because of generous sponsorship from a local textile firm. He apologised for delay to set, promised work-shop space turned out to be not available. Chrissy stressed the urgent need for the set to be in place for next week's rehearsals. This was identified as a serious problem. Nessa offered to contact the local col-lege for access to workshop space and suggested that the set be marked out on the rehearsal floor for next week.

6 Simon talked the group through his plans for workshops. It was agreed that they would be suitable for 14+ age group. Parvati and Simon to work together on material for younger participants and bring to next meet-ing.

7 Parvati reported that a representative from the RAB, the Arts Council Development Officer, a County Arts Officer and a City Arts Officer and 2 Programmers from venues in the South-West were coming to the preview performance. She had estimates from 2 local catering firms for refreshments for the group to consider. The group agreed 'Eatwell Caterers'. Parvati to confirm.

8 Jane presented a budget report (attached). Finances are largely on target, an overexpenditure on trans-port being balanced by an underexpenditure on costumes. The implications of the Northampton gigs not yet worked out.

9 AOB – Nessa showed copies of article in last night's evening news. Many errors, a fairly joky approach, and the wrong photo printed. Felt to be conveying wrong image and perhaps damage local audiences. She will contact the paper to ask for another article and our own publicity photo.

The chair

The chair needs to guide the meeting and make sure the business gets done efficiently but without stifling discussion of important issues. This is a balancing act that can only be learned through doing.

MANAGING THE PRESENTATION

Chapter 4 deals in detail with the presentation of performances. The sections relating to touring and presenting in non-theatre venues are particularly appropriate to the presentation of a project performance. The key issues for the project company are to do with allocation of roles and responsibilities – because the standard backstage support of Stage Manager, DSM, ASM, lighting and sound technicians may simply not be available. Equally, the project company may find itself in a position of having to arrange the Front of House support. The company must ensure that the following tasks are covered effectively:

- preparing the venue
- liaising with technical staff and/or setting up and operating technical equipment
- taking care of the audience/clients/participants.

EVALUATING THE PROJECT

Evaluation is an important part of the project process. Your funders will expect you to evaluate the success of your project objectively and honestly. More importantly your evaluation will help you to learn and grow both as an artist and as a manager of projects. The process of evaluation is dealt with in some detail in Chapter 9. In managing the project you will need to allocate the following tasks:

- collecting responses, formally and informally
- analysing responses
- assessing success, identifying weaknesses
- planning for the future.

TASKS

1 Devise a management structure for your next project, for assessment.

2 Make a project task checklist and discuss with your tutor.

3 Create a project forward plan, for assessment.

4 Write and circulate a meeting schedule for planning your next project. Keep a copy in your assessment file.

5 Keep an example of an agenda you have constructed for your assessment file.

6 Write up the minutes of a project planning meeting and circulate. Keep a copy in your assessment file.

chapter nine

EVALUATION

'You were wonderful darlings!' is comforting to hear after the show. Artists are very vulnerable after a performance, exhibition or demonstration of their work. Friends and relatives know this and will usually produce a flattering and supportive comment or two – albeit less gushing than the 'luvvie's' cliche. It is tempting to bask in the glow of such subjective responses and to fool yourself that the event has been an unqualified success. It may have been – it is more likely to have been successful in parts. The point is that you cannot rely on their responses alone or indeed on your own responses in this situation. You need more evidence from as many different points of view as possible. Only then can you identify the strengths and weaknesses of your work and develop strategies for improving it.

Evaluating is the collecting of different points of view about your work, analysing them and drawing conclusions in order to measure how successful it has been.

In this book we have mentioned many different types of artistic activity: the programming of an arts centre, the composing of music, the setting up of a dance project, the marketing of an event, the devising of a small-scale theatre performance, the setting up and delivery of an audience development or education project etc. How do we measure success in all these different situations? In fact the process of measuring is very similar in most situations. What changes is what we count as success. An education project will have different objectives and therefore a different definition of success than a pantomime or a marketing campaign. Evaluation starts right at the beginning when we make decisions about what we want to achieve – when we decide what our objectives are.

This chapter looks at the evaluation process, from the setting of objectives and indicators of success, to the drawing of conclusions and recommendations for the future. It will include information about methods of collecting responses from different sources using questionnaires, interviews, and informal discussion. It will suggest ways to collate data and present findings. Figure 9.1 shows the process of evaluation from start to finish.

Measuring success

Figure 9.1 *The process of evaluation*

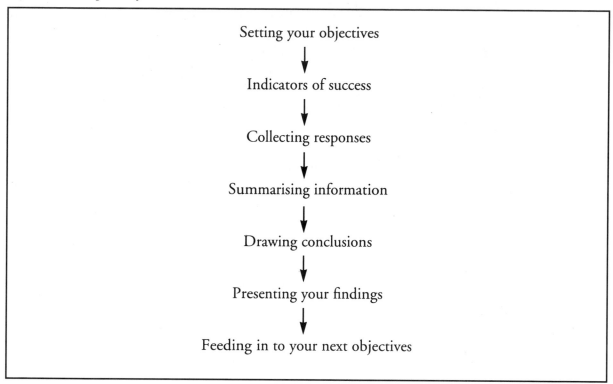

Setting your objectives

↓

Indicators of success

↓

Collecting responses

↓

Summarising information

↓

Drawing conclusions

↓

Presenting your findings

↓

Feeding in to your next objectives

SETTING YOUR OBJECTIVES

It was noted in Chapters 6 and 8 that aims are general statements of what you want to achieve. They usually reflect your artistic values, and it is very difficult to devise ways of measuring whether or not you have achieved them. For example, our aim as authors of this book is:

'To help to generate an understanding of how the arts can be managed and administered in the current social and economic climate of reducing arts subsidies. By so doing we hope that more artists will survive and therefore more people can have a better quality of life by experiencing the arts.'

It would be very difficult to determine whether or not we have succeeded in this. Nevertheless, this aim is what guides us and we can look at smaller steps along the way which we can measure. These would be our objectives. Examples of these might be:

- to complete the book on time for the publishers
- to make our book readable and understandable

- to make our book look attractive
- to enable future artists to secure funding
- to enable future artists to run projects effectively.

We could certainly find ways to measure our success against these statements – getting responses from other people – the publishers, the students who read the book, their tutors, and artists who have tried out the ideas. In this way we could build up a reasonably objective picture of our successes and failures.

Objectives are simple, measurable statements, but much thought is needed before deciding what they should be. They should be measurable, guided by your overall aims and should reflect what you really want to achieve.

There are so many different types of activity in the arts, it is difficult to generalise about aims and objectives. Each event or project will have a different purpose, a different reason for being, and therefore different aims and objectives. The following are just a few examples:

1 A venue programmer planning a season of alternative theatre in the studio

Aim: To provide a contrasting programme to that of the main house and develop a new audience for more adventurous and challenging work.

Objectives: – to achieve a 75% capacity audience for each of the four performances
– to encourage a younger audience
– to encourage non-regular theatre goers to attend.

2 A contemporary dance company education officer planning a series of workshops in schools

Aim: To build an understanding and appreciation of the company's work and of contemporary dance in general in order to develop an audience for the company's autumn tour.

Objectives: – to secure workshops in a minimum of 20 schools in each region of the tour
– to increase students'/pupils' practical understanding of contemporary dance
– to increase students'/pupils' appreciation of the choreographer's work
– to increase audiences at tour performances.

3 A composer creating a demo-tape of video music to get the attention of a local production company

Aim: To demonstrate a clear and individual musical style which enhances the subject matter and mood of the video, and which is in keeping with the image and style of the production company.

Objectives: – to produce work which secures a contract
– to complete the demo video before the company's deadline
– to produce work which has coherence and structure
– to produce work which communicates with the video audience.

4 A small theatre company planning a project about violence against women in the home

Aim: To produce a powerful and moving piece of theatre which will educate audiences to be alert to signs of domestic violence amongst friends, relatives, and acquaintances, and which will encourage and support the victims of such violence.

Objectives: – to make a 'truthful' and compelling piece of theatre
– to involve victims, ex-perpetrators and help agencies in the project
– to secure performances in six appropriate venues
– to attract 75% capacity audiences (minimum)
– to attract female sufferers of violence to see the performance
– to develop awareness of domestic violence.

INDICATORS OF SUCCESS

This is a grand phrase for: 'How will you know if you have succeeded?' The arts centre programmer described in example 1 above will know she has succeeded in her first objective if the box-office returns for the four performances show over 75% capacity. This is her first 'indicator of success' and it is simple because all theatres keep records of the numbers of tickets sold for each performance. The second two objectives might take a little more work. She needs to know the composition of her audiences – are they younger than, and different from, the usual main house audience? Since she attends most of the performances at the arts centre herself she might be able to gain an impression of the audience simply by looking. This however, is not very reliable and the funders want accurate information. The box-

office do not keep the kinds of records she needs, although there are reports showing a breakdown of average ages of regular theatre goers, so she will have to survey her audiences. The most effective and quickest way to do this is by leaving questionnaires on the seats which ask the questions:

- 'What age are you?'
- 'How many times in the past year have you attended performances in the Main House Theatre?'

Her 'indicators of success' will then be audience questionnaire responses showing a percentage increase in younger audience members and audience members different from those of the Main House Theatre.

TASK

Read through the aims and objectives shown in examples 2, 3, 4 above and make a list of potential indicators of success for each of the objectives. Discuss these with the rest of your class.

NB Some of the indicators of success are so obvious you might miss them!

COLLECTING RESPONSES

Objective evaluation usually requires the collection of responses from a number of different sources. The audience (if there is one) is the

most obvious source of information. Others might include the venue programmer, gallery administrator, workshop participants, the

client (if there is one), the commissioner of the work (if there is one), peers (other artists or students), the local arts officer or officer from a funding body, other venue programmers, representatives from relevant agencies or support bodies (as in example 4 above), sponsors, specific representatives of the target audience/group, record producers, television, film and/or video producers etc. Discussing the indicators of success for the above examples should have given you some ideas for the range and diversity of your sources of information. But a word of warning – it is important to be selective. Firstly, producers, arts officers, and funding body officers are busy people and secondly, you do not want to bore your audiences with numerous, long, or complicated questionnaires. You should choose only those sources which are genuine indicators of success for your objectives. Once you have chosen your sources you need to think creatively about how to extract the information you need with the minimum of inconvenience to all concerned. There are six obvious ways to collect responses:

- informal discussion
- formal discussion
- interviews
- questionnaire
- written evaluation and assessment
- self-evaluation.

Informal discussion

Informal discussion often takes place after a performance, exhibition or demonstration, when people are keen to analyse what they have experienced and air their views. They might continue to talk about it for at least the next few days while it is still fresh in their minds. Opportunities to hear peoples' views might arise naturally in the bar after a performance and although this is the performer's most vulnerable moment, and friends and relatives are not always to be trusted, some peers, arts officers, and others, can be relied upon to give you the supportive criticism you need. You can also sit unobtrusively and overhear audience comments – sometimes a very salutary experience! If this is too daunting, you can always phone people a day or two later to ask for their responses. If you jot down the main points made, even this informal data can make a useful contribution to your evaluation information.

Formal discussion

Formal discussion needs a slightly different approach. Many performing companies now hold a post-performance discussion session, enabling the audience to question them about the work they have seen. The situation is also used to collect feedback from the audience and to gauge their response to the work. Of course, it is usually those members of the audience who have enjoyed the work, or are studying the artists, who stay behind, so this is not a representative sample. Nevertheless, it adds to the available information. Once again, notes should be made of the main points made and the areas of apparent strength and weakness identified. Some preparation is needed to ensure that the discussion flows smoothly and that specific areas of concern for the artist/s are brought up.

Interviews

Interviews require much more preparation if they are to be successful. The questions must be few and simple and thought must be given to the range and number of interviewees. Answers can be noted on a recording sheet, as they are on questionnaires or on audio tape, in which case they will have to be transcribed later. Sometimes, interviews are used instead of questionnaires because some people prefer to talk, rather than write, and also the interviewer can ask for clarification or a more in-depth answer. Audience interviews could be held after the performance, exhibition or demonstration. Alternatively, peers, arts offi-

cers, venue managers etc. could be approached in the following days. Interviews are time-consuming and cannot be used with large numbers of people, so it is wise to target the interviewees.

Questionnaires

Questionnaires are more impersonal means of collecting responses and can be used with large numbers of people. They can be produced fairly cheaply and used to gather immediate responses. They can be left on seats, inserted into programmes and catalogues, sent off with demo tapes, sent out with publicity materials (brochures etc.), sent off to venue managers or schools, or even handed out in the interval with the drinks. Unfortunately some audiences are suffering from *questionnaire overload.* Holidays, banks, hotels, leisure centres, theatres, concerts, transport systems, and many other areas of our lives, seem to require us to fill in questionnaires and it can become a serious chore. If you want people to fill in your questionnaire you must make it attractive and simple to fill in and you must only ask what you think are the most important questions. Below are some points for you to bear in mind when you design a questionnaire.

Designing a questionnaire

- Decide how this questionnaire can be an indicator of success for your objectives.
- List the things you really need to know that cannot be found out in any other way.
- List the questions you need to ask to find out those things.
- Make sure you only ask one question at a time.
- Decide if questions can be answered with a simple yes/no response.
- Decide if they should be answered on a scale of response, for example 1 = poor, 5 = excellent.
- Decide if you want a preference list, for example 1 = first choice, 2 = second choice etc.

- Decide if you need people to write a couple of sentences to give their views.
- Frame as much as you can so that people can tick answers/boxes or delete answers.
- Structure a simple layout using only the most important questions.
- Group the questions that take *yes/no* answers.
- Group the *scale of response* questions.
- Group the *preference* questions.
- Design the questionnaire layout in big, bold typeface, so that it is easy to read, attractive to look at and easy to fill in.

Written evaluations and assessments

These come in a variety of forms and most of them would not be solicited by you. For example, the critic of a local (or even a national) newspaper, magazine or journal might write a review of your work. These can sometimes be negative and occasionally expressed in a way which causes pain. Reviews written by perceptive and well-informed critics for serious publications can be illuminating and are very valuable. It is important to remember that some editors place the need to entertain their readers above that of giving the artist a well-balanced and thoughtful review. If you have received funding from one of the Regional Arts Boards or from the Arts Council of England, Scotland, Northern Ireland or Wales then there is likely to be an *assessor* in your audience. You will know from reading Chapter 2 that these bodies rely on unpaid expert advisers to write assessment or evaluation reports of their clients' work. These will be sent to you as anonymous reports in due course and are a useful source of evaluation information. There is nothing to stop you from asking for reviews of your work by other artists or respected peers or even from ex-tutors! They might be too busy but they might also be pleased to know that you value their opinions.

Self-evaluation

Self-evaluation is an essential part of evalu-

ation. Your own views are important in determining whether or not you have met your objectives, although you cannot always be sure you are being honest and objective after a performance, and so self-evaluation is most useful during the setting-up and making periods. Time should be set aside throughout the whole of the creative and the planning processes for discussion about whether goals and targets are being achieved. Honest debate with fellow artists can be both painful and rewarding but it

is essential to review progress and to decide if any changes need to be made, or action taken. Maybe new goals and targets need to be renegotiated, working methods should be altered, the performance material needs restructuring or the performance style altering. Time should also be set aside for you to review your progress as an individual. Are you meeting your goals? Can you enhance your performance? Could you give more support? There are many questions to ask yourself.

TASKS

Working in groups, read through the aims and objectives given for example 4 on pages 134–5: a small theatre company planning a project about violence against women in the home.

1 Design an audience questionnaire which gives feedback on these objectives.

2 Using a word-processor, copy your design for discussion with the rest of the class. If you prefer, you could draw up a questionnaire for one of your own performances/exhibitions/demonstrations.

SUMMARISING INFORMATION

If you used all the methods for collecting responses suggested above, you would have amassed a large amount of raw data. Before you can begin to draw conclusions, you will need to find ways of summarising and presenting your information. Some responses will be in the form of verbal, or written, discursive answers. For example, in interviews you might have asked the question: 'What was it you enjoyed about the performance?'. This would leave you with a number of different points of view to collate in a discursive format using the headings you have decided on, such as 'music', 'design', 'acting', 'storyline'. You might summarise these as follows:

Of the 25 people interviewed, 12 enjoyed the music and made reference to 'exciting', 'atmospheric', 'better than *Top of the*

Pops'; 10 found the design and setting effective, some commented 'Worth seeing for its own sake', 6 felt that it dominated the narrative; 22 commented favourably on the strength of the acting, with 15 saying they had been 'moved' or 'affected' by the performers portrayal; 8 people found the storyline 'depressing' but 13 found it 'relevant' and 'powerful' and felt that it should be seen more widely.

Some information, especially that from questionnaire responses with YES/NO, or tick box answers, can be calculated mathematically. Moreover, there are many user-friendly software applications with which you can convert your figures into bar graphs, pie charts, and other diagrammatic forms, to make the information clear and easy to read. But you need to

do some number-crunching first of all to get the figures together. Figure 9.2 shows a list of questions from a post-performance audience survey. Please note that it is not laid out in an appropriate questionnaire format. Figure 9.3 on page 140 shows how the answers can be summarised.

Once you have the information converted into figures you can present it in a variety of diagrammatic forms which give a clear picture of the audience profile. Figure 9.4 shows how bar graphs and pie charts can be used to show the data in more interesting and informative ways.

Figure 9.2 *Audience survey questions*

Q1 *Age group* 15–19*/20–29*/30–39*/40–49*/50+*

Q2 *Ethnicity* White-European*/Afro-Caribbean*/S. Asian/Other*

Q3 *How many performances do you attend in a year?*

Less than one*/one*/two to five*/six to twelve*/ more than twelve*

Q4 *How many performances have you attended at this theatre?*

Less than one*/one*/two to five*/six to twelve*/ more than twelve*

Q5 *Score the following in your order of preference, 12 = high, 1 = low*

☐ Popular film

☐ Art House film

☐ Pantomime

☐ Musicals

☐ Classic drama

☐ Light drama

☐ Innovative drama

☐ Alternative comedy

☐ Ballet

☐ Contemporary dance

☐ Rock music

☐ Classical music

*Delete as appropriate

Figure 9.3 *Questionnaire response summary sheet*

Q1 15–9 125 **Q2** White-European 687

 20–29 221 Afro-Caribbean 98

 30–39 78 S. Asian 203

 40–49 234 Other 36

 50+ 366

Q3 *Performances in general:* **Q4** *Performances at this theatre:*

Less than one 25 Less than one 347

one 238 one 398

two to five 351 two to five 216

six to twelve 373 six to twelve 53

more than twelve 37 more than twelve 10

Q5 *Scores per event (12 = high, 1 = low), added together:*

 14,008 Popular film

 4,422 Art House film

 8,110 Pantomime

 11,796 Musicals

 4,424 Classic drama

 6,635 Light drama

 4,419 Innovative drama

 4,428 Alternative comedy

 2,212 Ballet

 1,475 Contemporary dance

 6,636 Rock music

 5,161 Classical music

Figure 9.4 *Bar graphs and pie charts*

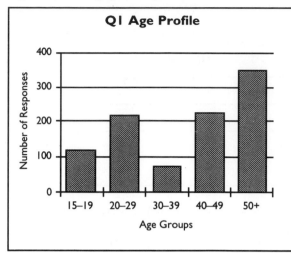

Q1 Age Profile

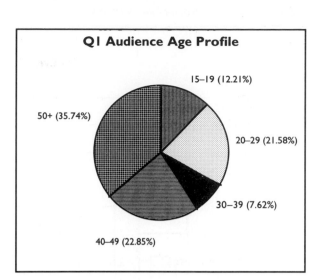

Q1 Audience Age Profile

15–19 (12.21%)

50+ (35.74%)

20–29 (21.58%)

30–39 (7.62%)

40–49 (22.85%)

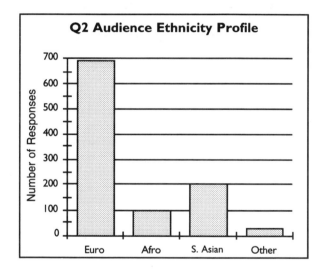

Q2 Audience Ethnicity Profile

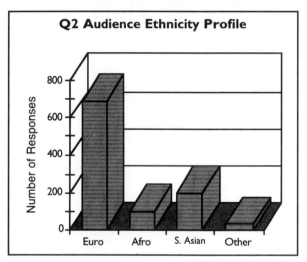

Q2 Audience Ethnicity Profile

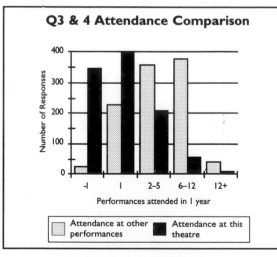

Q3 & 4 Attendance Comparison

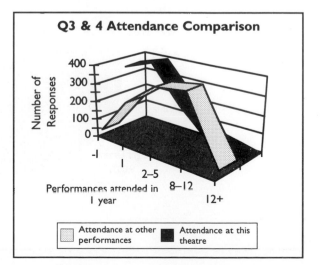

Q3 & 4 Attendance Comparison

Figure 9.4 (*Bar graphs and pie charts continued*)

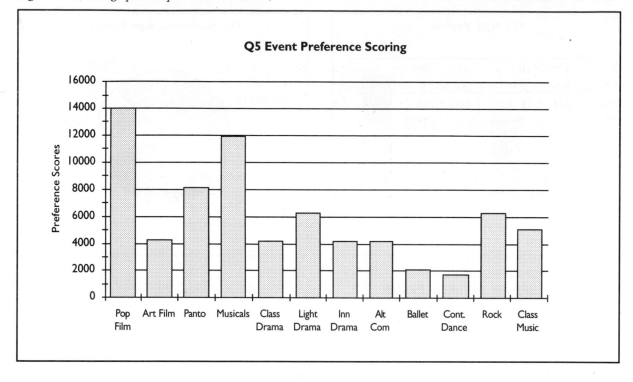

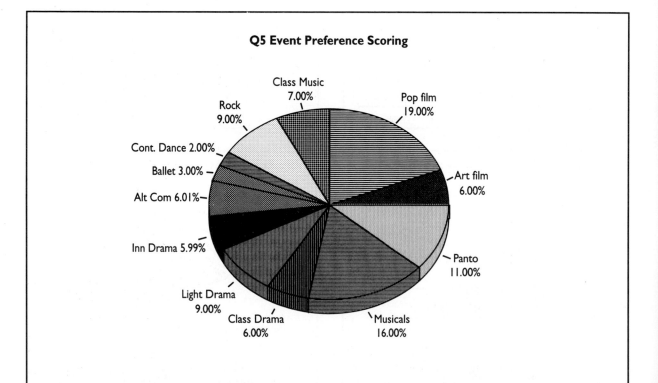

DRAWING CONCLUSIONS

The primary purpose of the process of evaluation is to discover if you and others think you have reached your objectives, thereby moving a little closer to your overall aims. Lots of other incidentals may have been thrown up in the process, some of which you might feel have great relevance for your future direction and way of working. These must be stored away for future reference. Your first conclusions must be about your objectives. The following case study of a mixed art-form project illustrates how aims, objectives, indicators of success, and summarised evaluative responses, all lead naturally to the forming of conclusions.

Case study: Park Fest

Park Fest – A mixed art-form event in a public space

Project description: The Sports and Recreation Development Officer and the City Arts Officer have jointly commissioned a performance to take place in one of the city's parks on August Bank Holiday. They have approached a group of local artists to stage a mixed art-form event which will appeal to the young people who use the park for skateboarding and roller blading. They want the group to create a mural/sculpture which will remain in the park after the show is over. The artists, called *SKIDS*, include a sculptor, a painter, four actors, a poet, two musicians, and two dancers, but all have more than one skill and all have circus skills. As well as funding from two departments of the City Council, *SKIDS* have Regional Arts Board funding because they are creating a new work. Although they do not have Arts Council funding for this project, they have sent an application in for a national project, and are hoping that the Arts Council will send an assessor to see their work.

Aims: To break down barriers between the art-forms and create work which: challenges traditional ideas, but is rooted in the traditions of street theatre; is dynamic and entertaining enough to attract a new audience for the live arts; is a celebration of local life.

Objectives:
1 to present work which appeals to the young people who use the park
2 to bring 1,000+ people into the park
3 to encourage more people to watch the live arts
4 to create and present work which is innovative and of high artistic quality
5 to generate a feeling of shared celebration amongst the different ages and cultures of the area
6 to leave a lasting reminder of the feeling of shared celebration.

Indicators of Success:
1 Large numbers of young people present, watching, staying to the end of the performance, clapping, and giving positive responses in interviews and questionnaires.
2 Gate receipts showing audience of 1,000+.
3 Questionnaire and interview answers indicating future attendance at events.
4 Good evaluation/assessor reports from funders/potential funders.

5 Positive responses in media reporting, interviews with audience, and question-naires.
6 Positive responses in the media and on-going audience for the mural and sculpture.

The Responses: Information was collected from the City Arts Officer's Report, the Parks and Recreation Development Officer's Report, the Regional Arts Board Advisor, Local Newspaper Reviews, the Arts Council Assessor, audience interviews, the gate receipts and the audience questionnaires.

THE CITY ARTS OFFICER'S REPORT

There was a very good turn out for the performance. I would estimate approx 800–900 people, with at least 30% from different ethnic groups. The performance was fun to watch and the audience responded with enthusiastic applause and by joining in the singing when asked. The noise level was very high and this was made worse by some technical difficulties. The quieter music and more subtle dialogue was, consequently, very difficult to hear. The event was well organised, apart from the technical sound problems which should have been sorted out at rehearsal.

SKIDS produced a lively, energetic performance which appealed to the younger audience members. The overall design (including the mural and sculpture) was vivid and dramatic. Many people stayed on after the performance to get a closer look at, walk through, and explore the whole installation. It is a fascinating piece of work. Many young people stayed on to talk to the performers. They seemed amazed by the fact that they could all dance, sing and juggle, as well as act! They also wanted to know how the installation had been constructed.

This project was a great success from my point of view and I am hoping to be able to work with my colleague in the sports and recreation department on a similar project for the spring.

THE SPORTS AND RECREATION OFFICER'S REPORT

This is the first arts event we have organised in the park and it was not without its difficulties. It cost a lot of money and was completely dependent on fine weather. The park superintendent was apprehensive about damage to his flowerbeds and there were four complaints from local residents about the noise level during the event. However, it must be said that the performance was an outstanding piece of entertainment. The acting, singing, music, and dancing, were all of a very high standard which the enthusiastic audience could appreciate. The set looked like a mixture between a Star Trek, futuristic planet and Postman Pat but it was eye-catching. It was fun to see the performers climbing all over and swinging down on people's heads. The young people were crawling all over the set after the show and we will have to make sure that if it is left up in the park, there is someone to supervise it in case of accident. It is a pity that the sound system was not checked before the show. There were some sections we could not hear and others that nearly deafened us.

The superintendent confirmed what I thought, that there were more people in the park that day than in two months of normal use. We estimated about 1200 people in the audience which makes this the best attended event we have organised this year, including all the sports events. None of the sports events we have held have attracted such a mixed audience in terms of age and ethnicity. My most abiding memory will be of everyone, grannies,

toddlers and adolescents, holding hands and chanting together to ward off the 'evil freeble'!

THE RAB ADVISER'S REPORT

This is the third performance by *SKIDS* in the region and the only one to receive RAB funding so far. The previous performances have been imaginative and engaging but lacking in finesse and polish. There has been no doubt about the quality of the performers – they are highly proficient in a wide range of skills and can produce work which constantly surprises with switches between traditional text-based theatre, highly polished and technical contemporary dance, and crazy bursts of street dance or techno-rock. It is a hectic mix which should not work as a coherent piece of art, but it is a tribute to the vision of the director J. J. McLean that it so frequently does work. Additional funding for this project has enabled *SKIDS* to invest in design for a set/installation and has generally contributed to better quality materials, costumes, lighting, and sound environment. The visual aspects proved highly successful and added yet another dimension to the work. The sound seems to have been a little over-ambitious and unnecessarily complicated. There were several breakdowns of sound equipment which came close to ruining the show, given the size and exuberance of the audience. It is a tribute to the performers' skill that they were able to pull the audience's attention back again.

This is very interesting work indeed. It attracted a large, supportive, and mixed audience and engaged their attention with a performance which both entertained and left behind a strong sense of togetherness. It is also of interest artistically because of the ways in which the art-forms are used together to such imaginative effect.

THE LOCAL NEWSPAPER REVIEWS

The Daily Record

'Put the *SKIDS* under 'em!'

Local residents said 'put the *Skids*' under last Saturday's Park Fest. That was Mrs Rawson's response to the shouting and screaming and thumping music that invaded her peaceful garden when the City Arts Officer and Sports and Recreation Officer got together to assail our senses with a performance called *SKIDS*. Mrs Rawson and her neighbours were shocked that the city council could spend ratepayers' money on this kind of pop rubbish. 'We used to like the brass bands that played of a Sunday – but this kind of rubbish attracts all the worst kind of riff-raff,' she told our roving reporter.

The Daily Times

'*SKID*ding towards Success!'

'More people turned out to the park for last Saturday's performance by local artists group SKIDS than for any other sports event in the city this year'. So said the City's Sports and Recreation Officer after a highly successful show. This up-and-coming company entertained upwards of 1200 people with their skilful combination of music, dancing, drama, and circus, and were rewarded by a clapping, cheering audience that kept on wanting more. The set in which they performed will be left installed in the park for a week – so if you missed the show, never mind, there is still time to catch up on the sculpture they left behind.

THE ARTS COUNCIL ASSESSOR'S REPORT

This is the first performance I have seen by *SKIDS* and it proved interesting from a number of perspectives. It is clearly rooted

in traditions of community/street theatre, with its emphasis on highly stylised movement, circus tricks, and use of audience participation. These elements provide a frame of reference and a structure for work which is anything but traditional in its approach to integrating and mixing artforms. Purists would find the constant changes of style (from contemporary dance to jazz-funk, and from mood music to punk) disorientating, and indeed there were some jarring moments. However, director J. J. McLean made skilful use of narrative – it is after all a good yarn about a group of young roller bladers taking on and triumphing over the intergalactic reactionary force, the 'evil freeble' – to weave the piece together in an entertaining and almost coherent production.

The work shows elements of pantomime but in fact transcends the medium because of the quality of artistic product and the artistry of the performers. There are some especially talented musicians working in the group and the level of acting and dance performance was very high. They created moving as well as exciting moments of theatre. They do need a better technician – especially for the sound. There were too many hiccups. The highlight for me was the design of the set/installation and the use made of it by the performers. It is not easy to create atmosphere in a public park on a hot, bright August day but *SKIDS* used their imaginative set to create a totally believable and flexible performance environment.

AUDIENCE INTERVIEW SUMMARY

Interviews held with 50 people after the show.
Age breakdown: 10 @ 12–15, 20 @ 15–20, 10 @ 20–30, 10 @ 30+

Ethnicity: 14 Afro-Caribbean, 18 S. Asian, 18 white European.

Q1 *What did you like about the show?*
Most did like the show and responded favourably to the music (45), the storyline (27), the dancing (25) and juggling (8); 33 commented favourably on the set and the costumes, 42 liked the standard of the acting; 28 liked the opportunities to sing and join in; 7 commented on the chance to share the experience with other people.

Q2 *What did you not like about the show?*
12 thought it should have been longer; 49 thought the sound quality could have been better; 4 thought the jazz funk dancing could have been tighter; 9 found the storyline silly; 11 did not like to participate; 12 thought there should be better seating.

Q3 *What kind of show would you like to see in the park?*
36 said the same again or similar; 5 said more popular bands like 'Blur' 'Pulp' or 'Oasis'; 10 said more Bhangra; 5 said more black performing groups; 8 said more young people's groups.

Q4 *Would you go to see other performances?*
38 said they would come back to the Park Fest; 37 said they would go to see *SKIDS* if they performed elsewhere; 15 said they would go to other types of performances if they knew about them.

THE GATE RECEIPTS

1026 tickets sold:		
463 adults @ £2 =	£	926
563 concessions @ £1 =	£	563
Total		£1,489

Audience questionnaire summary

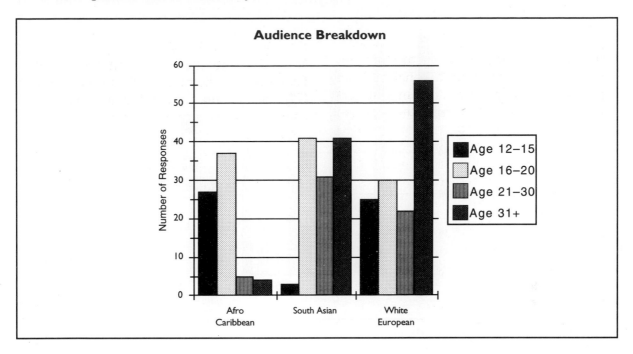

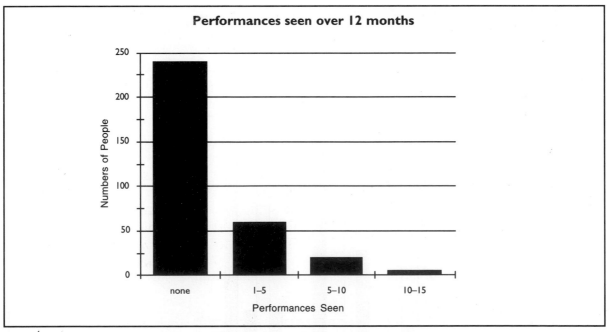

Q1. How many live performances have you seen over the past year?

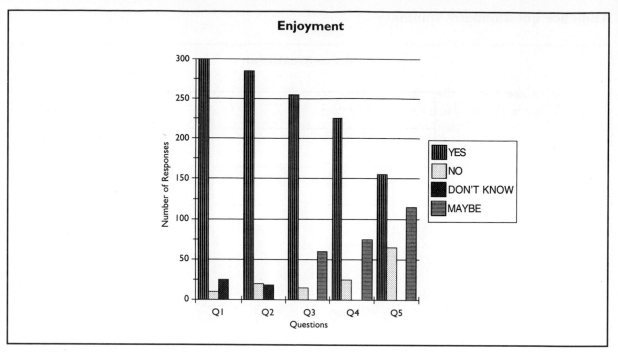

Q1: Did you enjoy Park Fest?
Q2: Did you enjoy *SKIDS*?
Q3: Would you come to events in the park again?
Q4: Would you come to see *SKIDS* again?
Q5: Would you go to see more live performance now?

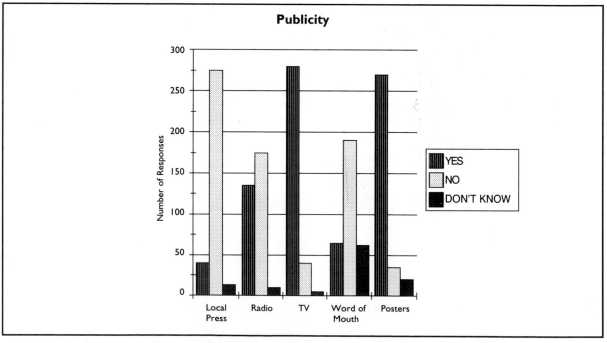

Q6: How did you find out about Park Fest?

TASKS

1 There are some very obvious conclusions to be drawn from all the data given in the case study above. Work in pairs to draw up a list of these conclusions, and discuss with the rest of the class. Do you think that *SKIDS* achieved all their objectives? What is the evidence for your conclusions?

2 What lessons could *SKIDS* learn from all this evaluative data? Could they make any improvements for the next time they tackle a similar project? Discuss this with your partner and draw up a list of recommendations to discuss with the rest of the class.

PRESENTING YOUR FINDINGS

There might be many reasons why you need to evaluate the success of your work. The most important reason is to find out your strengths and the areas where improvements can be made in the future. In fact it is you who need this information most of all, and therefore brief notes of your findings should be kept for future reference. In this case you need to record your findings simply and clearly so that you can still understand them at a later date. However, the likelihood is that you will be required to present your findings to others in the form of a report. A line manager or a funding body might want to know how successful your project has been – they need to be persuaded that they can trust you to undertake a similar project in the future. This does not mean you should present a report which covers up any areas of failure or inadequacy. If a project has not succeeded in a particular area, it is important to show that you know why and that you have identified strategies to resolve such difficulties and ensure the success of a similar project in the future.

When you write an evaluation report, you need to bear in mind that your reader may not have the time or the patience to read through a large amount of primary data. You need the data to ensure that your conclusions are valid and objective. If you are presenting material in an academic context, you would need to include your raw data, probably in appendices, so that your tutor has the evidence to verify that you have drawn logical and accurate conclusions. But a funding body representative would only be interested in your summary, conclusions and recommendations for the future. S/he wants to know primarily if you have met the objectives you said you would meet, and especially those that reflect his/her organisationís priorities. You should make sure that this information is given prominence within the report and is simple, clear and easy to read.

Remember to lay out your text in short sections, with clear headings. Use diagrams and bullet points and do not put too much text on one page. Make sure there is a contents page!

FEEDING INTO YOUR NEXT OBJECTIVES

The process of evaluation is not linear, it is circular. The lessons learnt from one project must feed into the next if you are to learn and grow as an artist or arts worker. You need to keep a

record of your evaluation conclusions as a reminder of what was successful, what did not work and why. This forms a reference point for planning your future projects. You want to be able to build on your successes and avoid making any mistakes over again. You may discover that some objectives are inappropriate, unachievable or impossible to measure – you will not want to use them again. Alternatively, you may have found through your evaluation that your project demonstrated an unexpected strength or direction that you can build on in the next project. It is important to remember that you are the one who has most to gain from good evaluation.

Appendix

Contract law

English contract law is part of the civil law of this country. That means that contract disputes may be taken before the courts to be decided but the police will not arrest someone for a breach of a contract unless they have also broken a criminal law. It is an immensely complex subject and this section provides only a basic introduction to the ways in which it is likely to affect people working in the performing arts business. You will need to know about contract law if:

- you offer or accept a contract to work for a company
- you offer or accept a contract to provide a service for a company such as directing a play, composing a piece of music, or choreographing a new dance
- you agree to perform your show at a venue or a number of venues.

WHAT IS A CONTRACT?

A contract is a legally binding agreement between two or more parties which deals with a business arrangement. To be a valid contract it must be made between two parties who are legally able to make a contract – usually this means they must be adults, and mentally fit to enter into a contract. There are exceptions but specialist legal advice would be needed.

A verbal contract is just as legally binding as a written contract, although it may well be harder to prove exactly what was agreed.

Making a contract

In order for a contract to be made there must be three elements:

- offer
- consideration
- acceptance.

Offer

An offer may be conveyed in writing or may be made on the telephone. It must be capable of being accepted. For instance, a venue manager may telephone and offer a company a booking on a certain date for their latest show. This would be an offer. It would not be an offer if the manager said s/he was hoping to include the show in the autumn season.

Consideration

In contract law something of value must pass from one party to the other. This is called the consideration. Usually it will be financial but it need not necessarily be so. An example of a consideration would be a venue manager booking your show for two nights and agreeing to pay £400 to the company. In this case the consideration is the £400 fee. A different example would be the venue manager booking the show for two nights and agreeing to allow the company to use the venue for two days to do the technical and dress rehearsals. In this case the consideration would be the use of the venue rent free for the two days.

There must be a consideration for the contract to be valid but it does not have to be of adequate value. For example a local authority may charge a theatre company a 'peppercorn rent', i.e., a token amount which is far less than the true value of the use of the premises. The law protects you from making a bad contract.

Acceptance

The acceptance of a contract happens when both parties are in agreement about the terms of the contract and there is unqualified acceptance. While the detail is being finalised the parties are still in negotiation. A contract may be accepted verbally, by signature on a written contract, or by conduct, example the company turning up to do the show on the appropriate night. Whatever the manner of the offer and the acceptance of the contract they must be capable of being enforced.

General points about contracts

You should never enter into a contract unless you fully understand and agree to its terms. In law you are deemed to have understood and agreed to the contract once you sign it or accept a verbal contract. Even if it subsequently turns out to be unfair to you or a contract which you cannot fulfil, you will still be liable.

Clearly it is vital that both parties to the contract understand the same thing about what has been agreed. For this reason a written contract is likely to be better than a verbal contract. A contract between a venue and a company should include the following:

- Who is making the contract?
- How each party to the contract will benefit?
- How the contract will operate?
- Who is responsible for what aspects of the contract?

Figure A shows a simple specimen contract between a venue and a company.

Figure A: *A specimen contract between a venue and a company*

CONTRACT

This contract is made on the day of 1996 between of the Bus Station Arts Centre, Car Park Street, Plymfield (The Manager) and .. of the New England Dance Company Cinema Road, Glenstock, Loamshire (The Company).

It is agreed that:

The Company will perform ... at the Bus Station Arts Centre on ..

The Manager will pay the company a fee of payable by cheque within seven days of the performance.

The Manager will provide all necessary box-office and Front of House staff for the performance.

The Manager will provide a groundplan and technical equipment list for the Arts Centre at least one month before the performance.

The Manager will ensure that the performance space is available to The Company from on the day of the performance until............hours after the performance finishes.

The Company will supply A3 Posters and A5 Flyers suitable for overprinting at least two months before the performance.

The Company will obtain all necessary licences and permissions relating to this performance.

The Company agrees not to performwithin miles of the Bus Station Arts Centre for weeks prior to and/or weeks after the performance date.

Signed .. The Manager

Date

Signed .. The Company

Date

Copyright

Copyright law is a complex area but it is necessary for people working in the performing arts business to have a basic working knowledge of it and an understanding of the ways in which it could affect them and their work. You need to know about copyright if you are involved in any of the following activities:

- the devising or writing of a new performance or play
- the performance of a script which is still in copyright
- creating a new piece of choreography
- the performance of a dance piece which is still in copyright
- composing a piece of music or a song
- performing a piece of music or a song which is still in copyright.

What is copyright?

Copyright is about the ownership of a piece of creative work; a dance, a song, a play, or a poem. The Copyright, Designs and Patents Act 1988 defines the rights of the creator of the artistic work and allows him/her to control how their work is used and by whom. It also enables him/her to make money through the economic exploitation of the work.

No piece of creative work can be protected by copyright until it is recorded or fixed in some way. That could mean being written down on paper, saved onto a computer disk, recorded onto audio cassette, DAT tape, compact disc, video tape or film. So the original tune you hum in the bath is not protected by copyright until you return to your room and either record it onto a cassette or write it on manuscript paper.

As soon as the original idea is recorded, the creator automatically owns the copyright in that work without having to do anything else. However, in order to be able to prove the ownership of the copyright and to establish when the protection commences, it is wise to mark the work with the symbol © and to sign and date it. You can also send yourself a copy of the work by recorded delivery or registered post and keep this copy unopened and marked with a list of the contents in a safe place so that it can be produced as evidence to support your claim to be the rightful owner of the copyright.

Copyright in a work exists for the lifetime of the creator plus 70 years. After the death of the creator the copyright becomes part of his/her estate and passes to his/her heirs. This means that the works of William Shakespeare are no longer subject to copyright, but the works of Samuel Beckett are.

The copyright in any work may be assigned to someone else by the first owner of the copyright but this assignment can only be made in writing; so it was possible for Agatha Christie to assign the copyright of *The Mousetrap* to one of her godchildren who receives the economic benefit from it.

Copyright exists as a separate entity from the created work, making it possible for an artist to sell a painting but to keep the copyright which enables him/her to allow postcards of the work to be printed and for him/her to receive the in-

come from their sale. In the same way the Churchill family were able to sell Sir Winston Churchill's papers but to retain the copyright in them.

The copyright owner can allow the use of their work under licence whereby someone else is allowed to perform or publish the work and the copyright owner receives payment for this. An author will allow the performance of his/her plays by others in return for receiving a royalty payment.

COPYRIGHT AND COMPOSERS

A composer may assign the copyright in his/her work to a publisher who will then deal with the business of granting permission for others to sell copies of the sheet music or to broadcast performances; in return the composer will receive royalties.

A composer may also become eligible to join the Performing Right Society. In doing so s/he will assign the rights in his/her work to the PRS who will deal with the granting of various licences to perform the work and who will collect the royalty payments due and distribute them to the composer. The PRS deal with live performances and also issue licences to theatres for the use of music in plays and for the use of radios and jukeboxes in places like pubs, shops, hairdressing salons and factories.

A composer who wishes to set the words of a poem for his/her new work will need to check the copyright situation relating to the poem to ensure that s/he is not infringing someone else's copyright. If the poem is published, the publisher must be contacted in the first instance to ask for the necessary permission. You should do this in good time before you begin work on the music.

If you arrange a piece of music which is no longer in copyright then you become the owner of the copyright in the new arrangement, but careful checks should be made to clarify that you are not infringing the copyright in an earlier arrangement.

A composer may also become involved with the Mechanical Copyright Protection Society (MCPS) who are responsible for administering the rights of the composer in music which has been commercially recorded. Anyone who copies any commercially recorded piece of music is infringing the copyright of the composer, the music publisher, and the record company.

COPYRIGHT AND ACTORS/DIRECTORS

An actor or director who wishes to perform a piece of work which is still in copyright will have to obtain permission and pay a royalty fee. If the work is published, details of who issues performance licences and collects the royalty payment on behalf of the author will be included at the front of the book. You should write in good time before you begin rehearsing to ask for permission to perform the work and to find out how much you will have to pay. When you write you should say where the work will be performed, by whom, stating whether it is an amateur, professional or student production, how many seats there are in the venues to be visited, how many performances you wish to give, and how much the

tickets will cost. Royalty payments are usually in the region of 7½% to 15% of the gross box-office income. For unpublished scripts you should contact the author directly.

COPYRIGHT AND DANCERS

A dancer or company who wishes to perform the work of a choreographer which is still in copyright will also have to obtain the permission of the choreographer and to pay a royalty fee. Making contact with a choreographer may not be easy unless they work permanently with an established company. You may be able to get help in contacting them through *Dance UK, Equity* or the *British Association of Choreographers.* You will need to supply information about where the work will be performed, by whom, stating whether it is an amateur, professional or student performance, how many seats there are in the venues, how many performances you will be giving, and how much the tickets will cost.

GENERAL POINTS

Whatever art-form you are working with, the issuing of a licence and the payment of a royalty, does not entitle you to change the work in any way without the permission of the copyright owner or their agent. This means that you cannot change the lines of a play, or leave out a section of a dance piece, or swap the order of the movements of a piece of music, without express written permission in advance. If you do make changes you risk the withdrawal of the licence and the refusal of permission to use other work by that copyright holder in future.

BIBLIOGRAPHY

The Musician's Handbook, Edited by Trevor Ford, Rhinegold Publishing, London, 1991.

Copyright Protection, Use and Responsibilities, Roland Miller, AN Publications, Sunderland, 1991.

INDEX